Contents

Introduction

What the 20th century has done to the image of Vincent van Gogh is seen by many as something of a cultural crime, and yet the uniquely clichéd popularisation of *The Sunflowers* (plate 1) or *The Bedroom in Arles* (plate 2) has served what may well have been a purpose very near to Vincent's own heart–that of making art 'from the people for the people' (251, end of 1882)[1]. Yet our very familiarity can only have distorted the way we see both the images and their creator. *Lust for Life*, by Irving Stone[2], was an attempt at an imaginative reconstruction of some aspects of Van Gogh's life, but its chief effect has been to sensationalise the man and his illness to such an extent that they now inescapably dominate our view of even the simplest and most straightforward of the paintings. *Les Isolés*, an article by the French critic, Albert Aurier, was the only publication on Van Gogh in his lifetime. It struck a note of empathetic understanding which Vincent himself acknowledged, though with many self-denigrating reservations. Aurier saw that, 'in spite of the sometimes baffling strangeness of his work, it is difficult, for anyone who wants to be objective and who knows how to see, to deny or dispute the simple truth of his art, the ingenuousness of his vision. Independently, indeed, of this indefinable aura of sincerity and of true seeing which all his paintings emanate, the choice of subjects, the constant harmonising of the most extreme notes, the awareness of his study of character, the continual search for the essence of each thing, a thousand significant details indisputably affirm for us his profound and almost childlike sincerity, his great love of nature and of truth–of his own truth, for himself.'[3]

Aurier had perceived the essential element in Vincent–that both as an artist and as a man he was fundamentally a Northerner, with a specific and profound commitment to his native country, Holland, yet for several of his formative and all of his last five years his compulsive search for a means by which to represent truth led him away from the relative security of Holland to isolation and painful self-discovery in Provence, in the South of France. Out of this came his greatest paintings.

During the whole of his adult life, with the exception of the two years in Paris when he was living with him, Vincent kept up a virtually continuous correspondence with his brother Theo, and,

[1] See Acknowledgements p. 128 for references.
[2] Irving Stone, *Lust for Life, the Novel of Vincent van Gogh*, London, 1934.
[3] *Le Mercure de France*, January 1890.

to a much lesser extent, with other friends and relations: this forms probably the most revealing documentation of an artist's thought and life known to us. Throughout these letters Vincent discusses not only the intimacies of his everyday life, but also the development of his aesthetic – that is, his artistic philosophy. Central to it is his understanding of the need for a completely faithful and constant reference to Nature, and it is this often almost mystical consciousness of Nature which permeates all his paintings. Once this key to his thinking is grasped it is possible to understand that throughout the profound transformations that took place in his painting style there is a unity of purpose and a constant thread of reference to Nature. Combine this with a recognition of the awareness of spirituality underlying all of Vincent's thinking, and it is possible to see how the same man could have painted *The Potato Eaters* (plate 20) and *The Night Café* (plate 54). Nature and God were almost synonymous for Vincent; both had always to be intimately concerned in the process of observing and making art.

Plate 2
Vincent's Bedroom in Arles F482
Arles, October 1888
oil on canvas
$28\frac{1}{4} \times 35\frac{1}{2}$ in (72 × 90 cm)
Rijksmuseum Vincent van Gogh,
Amsterdam

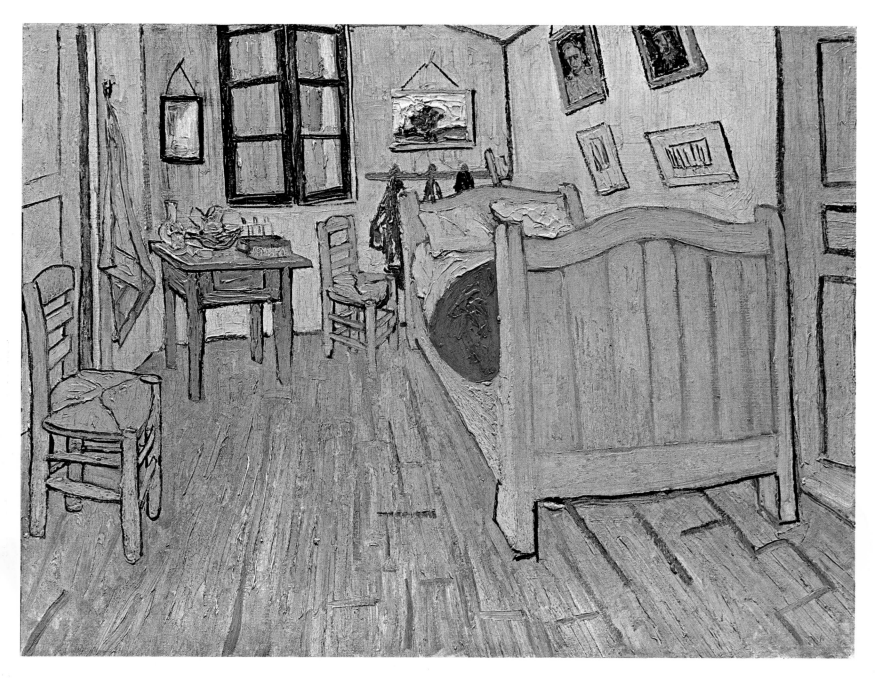

Early Life

Plate 3
Square at Ramsgate Juvenilia XXVII
Ramsgate, May 1876
pen and pencil
$2\frac{1}{4} \times 2\frac{1}{4}$ in (5.5 × 5.5 cm)
Rijksmuseum Vincent van Gogh,
Amsterdam

Vincent van Gogh's father, Theodorus, pastor of Groot Zundert, a village in the Dutch province of North Brabant, followed his father into the Church and so opted out of the prosperity to which he could have succeeded as a member of the long-established and wealthy Van Gogh family. Three of Vincent's uncles were art dealers: this was to be the crucial factor in determining the future of the first surviving child born in the parsonage; although little is known of Vincent's childhood, it is certain that the family, typical of its period and class, took a protective interest in the children of their least materially successful brother. Vincent's birth followed to the day a year after his parents' first child, also called Vincent, was still-born, and, although five more children followed, Vincent never seems to have escaped the psychological burden of being the inheritor of all the hopes his parents placed on their first-born son. Theo was born four years later and the brothers shared the simple education that was the best their parents could afford: a brief period at the village school, next a governess to insulate the children from what their parents considered to be the rough children of the village, then four years until he was sixteen at a boarding school some distance from Zundert. One of his sisters remembered him on holiday at home as a teenager, reserved, passionately interested in natural history, drawing in the country around the village and beginning to acquire a reputation in his family and amongst the villagers for unsociability. His career began in 1869, when, still only sixteen, he joined his childless uncle Vincent's art dealing business, Goupil's, then the largest in Europe, at the Hague branch. There was every likelihood that he would eventually be able to inherit the whole organisation, but his stay with them lasted only until March 1876 when he was dismissed from the Paris branch, where he by then was, for his utter lack of interest in the mechanics of Goupil's commercial life.

Goupil's was his introduction to the complexities of the international art scene and to the various current art styles of Holland, England and France. For several years he showed every sign of being willing to accept his fate. The branch he worked at

first dealt in the local Hague School: artists such as Israels, Bosboom, the brothers Maris and Weissenbruch, whose paintings were in the tradition of their own great 17th-century School and of the French Barbizon painters—landscapes and interior scenes of peasant and town life. They gave Vincent a grounding in both subject matter and painterly style which profoundly influenced his first five years of painting.

He impressed his uncle enough to be sent abroad, and moved in May 1873 to the London branch where he was involved in selling photographic reproductions of modern paintings from the Goupil office near the Strand. This first year in London was carefree and active, busy with the excitement of exploring a strange city to which he soon grew deeply attached, and capped by the elation of his first love. He became infatuated with his landlady's daughter Ursula, but when, after nearly a year of silent adoration, he proposed, he discovered she was already engaged to a previous lodger. A similar disappointment occurred later over his cousin Kee Vos, again because he failed to take the simple precaution of finding out first the feelings of the woman involved. This need to launch himself headlong into every hazardous emotional and working situation he encountered characterised his life—it is as if the first symptoms of his illness had their beginning in a total lack of the normal instincts for self-preservation. This painful introduction to emotional adulthood coloured his life—it helped to give him a poignant nostalgia for England and things English, and it gave him an early demonstration of the ineptness of his attempts at relationships of most kinds.

These two years in London exposed him also to the overpowering culture of Victorian England. There were the Academic, conventional artists, of whom he thought very little; the Social Realist painters like Luke Fildes, of whom he developed an increasingly high opinion; the French-influenced school of artists like Whistler and Legros; the English masters, Constable, Turner and Gainsborough; and, of course, the English novelists. In the following decade his letters were filled with discussion of his latest reading, and admiration for Charles Dickens, George Eliot, John Bunyan, Harriet Beecher Stowe, Thomas Carlyle, Charlotte Bronte and Shakespeare competed for attention with his devotion to the great French literary masters Zola, Michelet, Hugo, Balzac and the Goncourt brothers. His reading was extraordinarily catholic and intelligent. There were occasional anomalies: Mrs Craik's *John Halifax, Gentleman* and Susan Wetherell's *The Wide, Wide World* are so spectacularly badly

written and their stories so piously trite that the modern reader cannot help wondering at the tolerance of Vincent's taste when he set them beside Dickens and found them his equal. His need to commit himself to masters, whether literary or artistic, seems to have stemmed from a need to make an act of faith over every issue in his life – there were never any easy alternatives, only polarised issues, with any compromise seen as a betrayal of his own integrity. From Etten, in 1881, he wrote, 'In reading books, as in looking at pictures, one must admire what is beautiful with assurance – without doubt, without hesitation.' (148).

His preoccupations outside Goupil's business built up during his time in London, and, when he was transferred to the Paris office in May 1875, his increasing religious interests added to the indifference he felt towards the whole sophisticated and mercenary world in which he was supposed to succeed. He was sacked and returned to England in April 1876, finding a wretched job as a master in a little boarding school in Ramsgate, on the Kent coast. His youthful optimism supported him here, allowing him to relax from the strains of the commercial life of Goupil's, and find simple happiness in the community of boys to whom he behaved as an elder brother. He made some attractively skeletal drawings of the town, and took lyrically described walks in the country and along the coast, which reminded him vividly of The Hague and its surroundings. He used these drawings in his letters as descriptive shorthand to his family and as a prop for himself. This continued throughout his life – several years later, from the Borinage in Belgium, he wrote, 'Often I draw far into the night, to keep some souvenir and to strengthen the thoughts raised involuntarily by the aspect of things here.' (131).

His conscience and his increasing awareness of a religious impulse deeply embedded in his life sent him from Ramsgate to another school, on the western outskirts of London, run by a Congregationalist minister who also maintained a small evangelical mission nearby. He preached his first sermon there, in Mr Jones's new little prefabricated 'tin tabernacle', taking the text from Psalm 119, 'I am a stranger on the earth, hide not Thy commandments from me.' In spite of its reiteration of the hope of resurrection, the sermon sounds a sombre and pessimistic note that reminds us of the expressionistic, subjective drawings, done later, like *Sorrow* (plate 7). 'Are we what we dreamt we should be? No, but still the sorrows of life, the multitude of things of daily life and of daily duties, so much more numerous than we expected, the tossing to and fro in the world, they have covered it over, but it is not dead, it sleepeth. The old eternal faith and love of Christ, it may sleep

in us but it is not dead and God can revive it in us.'[1] This search for religious truth during his young manhood parallels his search for purity of visual and intellectual truth in painting later.

At the end of 1876 Vincent returned to a family Christmas and realised that he could not return to the lonely and limited existence in England. A job was found for him in a bookshop in Dordrecht, halfway between his parents, now in a parish at Etten, and The Hague. From his fellow-lodger at the corn-chandler's house we have a vivid description, recollected thirty-eight years later in 1914, of the twenty-four-year-old Vincent: 'He was a singular man with a singular appearance into the bargain. He was well made, and had reddish hair which stood up on end; his face was homely and covered with freckles, but changed and brightened wonderfully when he warmed into enthusiasm, which happened often enough. Van Gogh provoked laughter repeatedly by his attitude and behaviour – for everything he did and thought and felt, and his way of living, was different from that of others of his age. At table he said lengthy prayers and ate like a penitent friar: for instance, he would not take meat, gravy, etc. And then his face had always an abstracted expression – pondering, deeply serious, melancholy. But when he laughed, he did so heartily and with gusto, and his whole face brightened . . . Night after night Van Gogh sat reading the Bible, making extracts from it, and writing sermons; for in those days . . . strict piety was the core of his being. Only when we took a walk together did the superb views and distant prospects in which Dordrecht is so rich occasion him to expatiate upon what seemed beautiful to him. His religious feelings were broad and noble, the reverse of narrow-minded; although in those days he was an orthodox Protestant, he not only went to the Dutch Reformed Church on Sunday, but also on the same day to the Jansenist, the Roman Catholic and the Lutheran churches. And when I once expressed my astonishment and lack of understanding, he answered with a good natured smile, "Do you really think, G., that God cannot be found in the other churches?" He lived like a kind of ascetic, and permitted himself only one luxury – a pipe . . . Gradually he got more melancholy, and his daily work cost him more and more effort; he was not fit for his job, and his job was not fit for him. In the midst of his book-keeping a beautiful text or a pious thought would occur to him, and he would write it down; he could not resist the impulse. . . . And when he had to give . . . customers information about the prints, exhibited by Mr Braat, he paid no attention to his employer's interests, but said explicitly and unreservedly what he thought of their artistic value . . . To be a minister of religion, that

Plate 4
The Daughter of Jacob Meyer (after Holbein) F847
Brussels, October 1880
charcoal, pencil
17 × 12 in (43 × 30.5 cm)
Private collection

[1] *Letters*, vol. I, p. 90.

was his ideal, and it was an obsession with him; but he condemned, or at least did not approve of, the necessity of a knowledge of Latin and Greek for the ministry.'[1]

This deep-seated mistrust of material and physical comfort was to be a constant factor in his life, affecting every move he made and every piece of work he did. He saw his asceticism as vital to combat what he considered to be the disabling and emasculating effects of the average, cosy, bourgeois existence—and perhaps it was, for, while he later yearned for the security and delight of wife and children, he could never have supported them. And above all, if he had been distracted by family responsibilities, he could never have driven himself to the intensity of labour that produced, out of complete physical and mental exhaustion within so short a time, the masterpieces of his last years.

He was meanwhile collecting prints and engravings, which he wrote about frequently, and now entered on his most intensively religious phase, abandoning the book-keeping in Dordrecht and going to Amsterdam for what proved to be an abortive year struggling with the Classics in the hope of entering the University to study theology. Even as early as this, there were poignant signs of the sort of destructive guilt which was to lead him to suicide thirteen years later: 'When I think of the past; when I think of the future of almost invincible difficulties, of much and difficult work which I do not like—which I, or rather my evil self, would like to shirk; when I think of the many watching me who will know where the fault is if I do not succeed, who will not make trivial reproaches, but as they are well tried and trained in everything that is right and virtuous and pure gold, the expression of their faces will seem to say, We have helped you and have been a light unto you, we have done for you what we could—have you honestly tried? What is our reward and the fruit of our labour now? See! when I think of all this and of so many other things like it too numerous to mention, of all the difficulties and cares that do not lessen as we advance in life—of sorrow, of disappointment, of the fear of failure, of disgrace—then I also know the longing, I wish I were far away from everything!' (98, 30 May 1877). In this case, the work he was afraid of shirking was the missionary work he desperately wanted to be allowed to do, and when he admitted defeat in Amsterdam he found a place at the evangelical training school in Brussels for three months, which equipped him well enough in the eyes of the ministers for him to be sent to the economically very depressed coal mining area of the Borinage, in south Belgium. The 1878 *Baedeker's Handbook for Travellers to Belgium and Holland* gives the bald facts: 'Mons is the

[1] *Letters*, vol. I, pp. 112–3.

centre of a great coal-mining district. The yield of the mines of Hainault averages 12 million tons, valued at upwards of 180 million francs per annum, while the whole kingdom of Belgium produces not more than 15 million tons in all. Of the 110,000 miners in Belgium three-fourths belong to Hainault alone.' The reality behind the statistics was that a minute proportion of these profits reached the desperately deprived miners and their families, most of whom had to work crippling hours for wages that barely covered their needs in a kind year and were hopelessly inadequate in bad winters. Vincent threw himself into a total involvement with the people, which meant first visiting, helping and teaching them, then increasingly living, dressing and feeling as they did with a deeply compassionate commitment. And yet, in spite of this profound human sympathy, Vincent repeatedly drew and wrote of the mining environment with the devastatingly objective eye of the artist. To him, 'everything *speaks*' (127). 'Lately, during the dark days before Christmas, the ground was covered with snow; then everything reminded one of the mediaeval pictures by Peasant Brueghel, for instance, and of those by the many who have known how to express so remarkably well that peculiar effect of red and green, black and white . . . There are sunken roads, overgrown with thornbushes, and old, gnarled trees with their fantastic roots, which perfectly resemble that road on the etching by Dürer, *Death and the Knight* . . . every moment there is something which moves one intensely.' (128).

Inevitably, Vincent's behaviour drew the disapproval of the heads of the mission in Brussels, to whom missionary work amongst such people was a benevolently patronising activity not to be conducted in the undignified manner he had adopted. Naive and honest as he was, he cannot fail to have realised that they would condemn what they saw as over-zealousness, and his behaviour here, as at other times in his life, must be seen as a deliberate provocation of and confrontation with authority. A year later he wrote to Theo about the 'often detestable, tyrannical' position of authority: 'This state of affairs has its bad side for him who does not agree, but protests against it with all his soul and all his heart and all the indignation of which he is capable . . . One of the reasons why I am unemployed now, why I have been unemployed for years, is simply that I have different ideas than the gentlemen who give the places to men who think as they do.' (133).

He had been drawing constantly during his time as an evangelist, awkward, stilted and coarse images of the blackened figures of the miners and their lives, but he understood that technically they

Plate 5
Portrait of the Artist's Father F876
Etten, July 1881
pencil and washed chinese ink
13 × 9¾ in (33 × 25 cm)
Collection Mrs A. R. W. Nieuwenhuizen
Seager-Aarse, The Hague

were amateur and clumsy. With his dismissal in July 1879, Vincent found himself liberated from his evangelical responsibilities and threw himself into the struggle of learning the technical processes which would give him a means of expression as an artist. Already in June 1879 he had established firmly his guiding aesthetic: 'I still can find no better definition of the word art than this, *"L'art c'est l'homme ajouté à la nature"*[1] – nature, reality, truth, but with a significance, a conception, a character, which the artist brings out in it, and to which he gives expression, *"qu'il dégage,"* which he disentangles, sets free and interprets.' (130). His solution to his problem was to copy and recopy from Millet's *Les Travaux des Champs,* from the new standard French art schools' drawing exercises (Charles Bargue's *Cours de Dessin* and *Exercices au Fusain,* published 1868–71), together with a careful study of a book on anatomy and one on perspective (Cassagne's *Traité d'Aquarelle,* published in 1875). 'The style is very dry, and at times those books are terribly irritating, but still I think I do well to study them.' (136). This self-constructed course sustained his technical researches for the rest of his life, and he resorted to the Bargue and Cassagne volumes repeatedly; indeed, he constructed a perspective frame on Cassagne's principles, the use of which can be detected in many of his later paintings.

However diligently he struggled on his own, Vincent was aware that he now needed contact with other artists who could help him through his knottier technical problems, and the obvious solution was to move to nearby Brussels, where, as well as the Art Academy, there was a sizeable population of artists. Here he met the rich young art student Anton van Rappard, with whom he developed a close friendship, mostly conducted by letter, over the next five years. Two practical measures helped him greatly in Brussels: he was able to work on anatomy and perspective in Rappard's studio, and Theo began to send him a monthly allowance, Vincent insisting that it was a salary to be repaid with his paintings for Theo to sell. In this state of awakening consciousness of his ability, Vincent reworked in April 1881 a theme from the Borinage, *Miners' Women Carrying Sacks* (plate 6), which he subtitled *The Bearers of the Burden*. Although he complained later that he had not been able to understand and draw correctly the way the women carried their sacks, the drawing shows that he was already grasping some essentials of form and composition that the very primitive little sketches done in the Borinage so clearly lacked. He continued this progress when he returned for a period of rest and support at his parents' in Etten. He saw and drew the peasants of the area working in the fields,

[1] 'Art is man added to nature.'

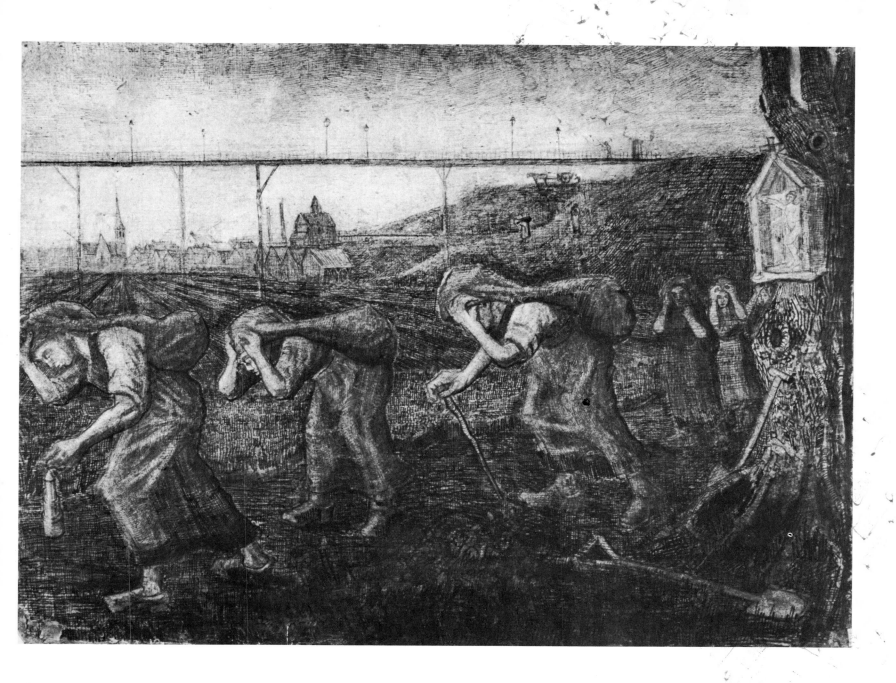

Plate 6
**Miners' Women Carrying Sacks
(The Bearers of Burden)** F832
Brussels, about April 1881
pen, pencil, brush
17 × 23½ in (43 × 60 cm)
Rijksmuseum Kröller-Müller, Otterlo

and the fields themselves, and wrote to Theo, 'More and more
I feel that drawing the figure is a good thing which indirectly has a
good influence on drawing landscape. If one draws a willow as if
it were a living thing – and after all, it really is – then the surroundings
follow in due course if one has concentrated all one's attention
only on that same tree, not giving up until one has put some life
into it.' (152). This animation of his natural surroundings and the
integration of human activity into them, combined with his
continuing religious awareness, suggests an unconscious leaning
towards some kind of simple pantheism – that is, an understanding
of nature and humanity as one expression of divinity.

Uncomprehending and embittered by his family's outrage at
his proposal of marriage to his recently widowed cousin Kee Vos,
Vincent left Etten at the end of the year. She had come to stay
with the family, he had fallen in love with her, and, as before with
Ursula, he had tactlessly and insensitively declared his love, without

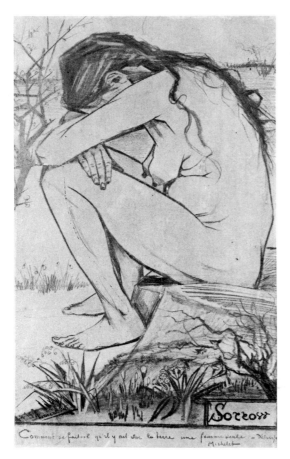

Plate 7
Sorrow F929a
The Hague, April 1882
black chalk
$17\frac{1}{2} \times 10\frac{3}{4}$ in (44.5 × 27 cm)
The Garman-Ryan Collection, Walsall
Museum and Art Gallery

[1] Her name was Clasina Maria Hoornik,
commonly abbreviated to Sien. She was
thirty-two – three years older than Vincent –
when they met.

pausing to realise that his cousin was still immersed in mourning
and could only repulse him. He retreated from the family storm
to The Hague, still declaring his devotion to Kee – 'she and no
other' – and found a studio and the help of his cousin, Anton
Mauve. Mauve was an established and successful painter, a leader
of the Hague School, whom Vincent greatly admired, but after
a few months working closely together Vincent found the pressure
of a rival artistic personality too much, and rebelled against
Mauve's academic instructions to draw from plaster casts. They
quarrelled, Vincent smashed some casts, and the two men were
estranged.

In times of trouble, such as this, Vincent always made great
emotional demands on Theo: he assumed that Theo must be
sympathetic, and, if occasionally Theo condemned him severely,
as he did over the Kee episode, Vincent responded like a hurt
child, then renewed his demands for money, drawing paper,
materials, and, above all, the sustaining encouragement upon which
he was so dependent. Given this rebellious state of mind, it was
perhaps inevitable that Vincent should so consciously have
alienated himself from the respectable painters and dealers of The
Hague, bastion of his old family employers Goupil's, by taking in
a destitute, pregnant prostitute, Sien,[1] and her child. He was
impelled both by the promptings of his Christian conscience,
which suggested the need for a dramatic solution to a dramatic
problem, and by the strictly practical need that he had for Sien
as a woman and as a model. Out of this sad relationship between
two people who were both, in their own way, outcasts, came
many figure studies and a series of tragically expressive drawings
which he called *Sorrow* (plate 7). The quotation written at the foot
of the version illustrated here is from the French historian
Michelet: 'How is it that there could be on earth such a woman,
alone and abandoned'. The expressive qualities of the drawing
and its literary associations show that Vincent was attempting to
create a visual language able to convey the full gamut of his
emotions. With a copy of *Sorrow* he sent to Theo he wrote, 'I did
not hesitate to be rather melancholy.' (186). There are reflections
of Victorian literary images and of the drawing to be found in the
wood engravings of the English illustrated magazines that he was
now collecting, together with the sort of angular and sparse
drawing he had copied in Bargue's manuals, but the
drawing was finally about his identification with his subject:
'Being a labourer, I feel at home in the labouring class, and
more and more I will try to live and take root there.' (194).
As a companion piece to *Sorrow* he had made a drawing of some

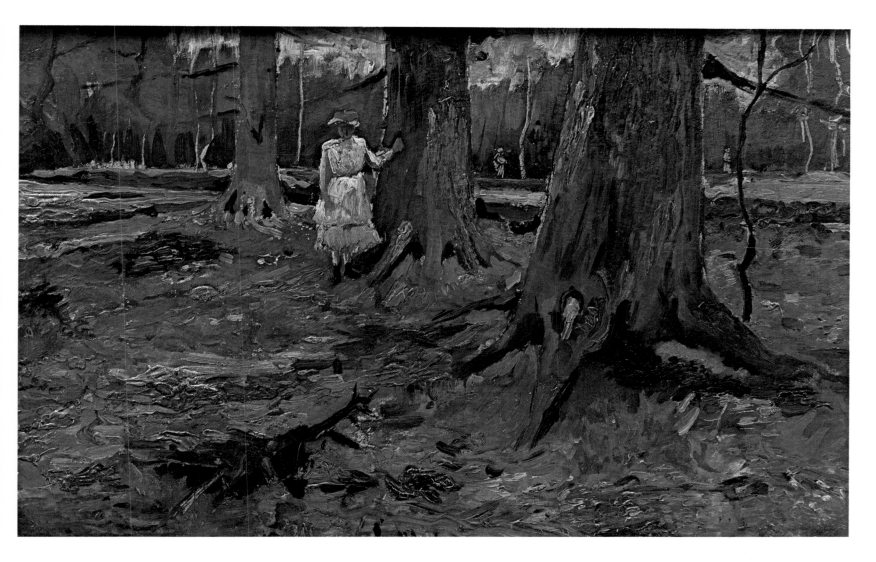

Plate 8
Girl in White in the Woods F8
The Hague, August 1882
oil on canvas
$15\frac{1}{4} \times 23\frac{1}{4}$ in (39×59 cm)
Rijksmuseum Kröller-Müller, Otterlo

tree roots on sandy ground and wrote of them, 'I tried to put the same sentiment into the landscape as I put into the figure: the convulsive, passionate clinging to the earth, and yet being half torn up by the storm. I wanted to express something of the struggle for life in that pale, slender woman's figure, as well as in the black, gnarled and knotty roots. Or rather, because I tried to be faithful to nature as I saw it, without philosophizing about it, involuntarily in both cases something of that great struggle is shown.' (195).

With this deeply felt development in his philosophy of art came his first sustained experiments with paint and colour, and guided by his observation of Mauve's technique he painted works like *Girl in White in the Woods* (plate 8) in August 1882. This is the most successful of the surviving oil paintings from the Hague period and his description of it to Theo gives a vivid insight into his aims: 'The . . . study in the wood is of some large green beech trunks on a stretch of ground covered with dry sticks, and the little figure of a girl in white. There was the great difficulty of keeping it clear, and of getting space between the trunks standing at different distances—and the place and relative bulk of those trunks change with the perspective—to make it so that one can

breathe and walk around in it, and to make you smell the fragrance of the wood.' (227). The paint is generously applied, the uneven ground represented by actual ridges and lumps of earthy paint on the canvas. The composition is adventurous, with a little figure dwarfed by the massive trunks weighing down the foreground space, and his colours are bright and light – he was becoming dissatisfied with the sombre tones of his native School, and was beginning to find the courage to suggest that he could go further with colour – 'The wood is becoming quite autumnal – there are effects of colour which I very rarely find painted in Dutch pictures.' (228).

His technical explorations extended briefly also into lithography: he made a total of nine lithographers, eight in The Hague, and one of *The Potato Eaters* (plate 20) in Nuenen two years later. He discussed the problems of the medium in a letter to Rappard, but

Plate 9
Orphan Man, Standing F1658
The Hague, November 1882
lithograph
$24 \times 15\frac{1}{2}$ in (61×39.5 cm)
Rijksmuseum Vincent van Gogh,
Amsterdam

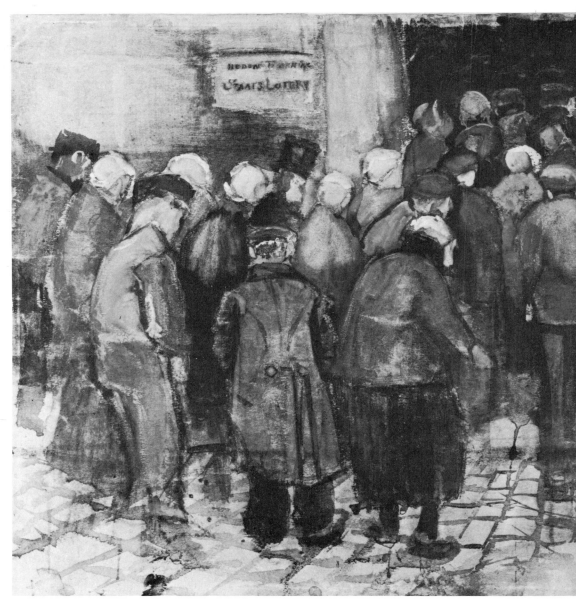

Plate 10
The State Lottery Office F970
The Hague, October 1882
watercolour
$15 \times 22\frac{1}{2}$ in (38×57 cm)
Rijksmuseum Vincent van Gogh,
Amsterdam

Plate 11
Houseless and Hungry
by Luke Fildes (1844–1927)
pub. *The Graphic*, Vol. I, p. 9, 4 December
1869
wood engraving
Victoria and Albert Museum, London

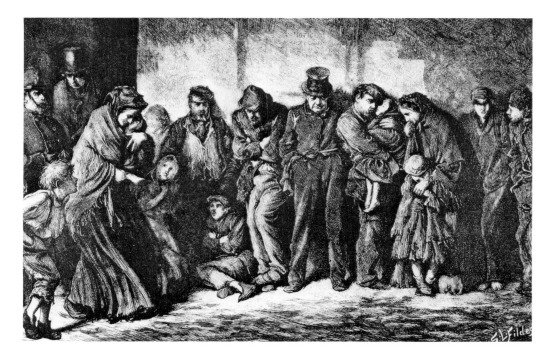

Orphan Man, Standing (plate 9) shows how rapidly he achieved a skilful use of the velvety textures and tonal modulations of lithography. These studies of the old people from the local almshouse ('here they call them very expressively *orphan men* and *orphan women*' [235]) are made with great sympathy but a certain descriptive detachment. He also took a broader look at the social problems of the city in drawings of the public soup kitchen, third class railway waiting rooms, and *The State Lottery Office* (plate 10), influenced graphically by such English wood engravings as Luke Fildes's *Houseless and Hungry* (plate 11). His comments on them show his awareness of the easily exploited hopes of the destitute: 'I passed there on a rainy morning when a crowd of people stood waiting to get their lottery tickets. For the most part they were old women and the kind of people of whom one cannot say what they are doing or how they live, but who evidently have a great deal of drudgery and trouble and care . . . that little group of people–their expression of waiting–struck me, and while I sketched it, it took on a larger, deeper significance for me than at first. For it is more significant when one sees in it *the poor and money*. It is often that way with almost all groups of figures: one must sometimes think it over before one understands what it all means. The curiosity and the illusion about the lottery seem more or less childish to us–but it becomes serious when one thinks of the contrast of misery and that kind of forlorn effort of the poor wretches to try to save themselves by buying a lottery ticket, paid for with their last pennies, which should have gone for food.' (235). Curiously enough, in spite of his emotional commitment to

the underprivileged classes in society, Vincent never seems to have looked for a political solution to their problems. Since the French Revolution at the end of the previous century, Europe had been in a ferment of radical politics. Marx and Engels formulated modern economic and social Communism, William Morris was developing in England his dream of a Socialist Utopia of rustic craftsmen, France and many other countries had had revolutions in 1830 and 1848, and finally the Paris Commune had its few disastrous weeks in 1871 – but at no point does Vincent show any inclination towards even a discussion of these issues, preferring always to express his sympathy with a very individual and personal humanity, of the sort that never admits of organisation and collective action. He felt that his greatest use in social terms was to paint and draw scenes of ordinary life in such a way as to give those more privileged an insight that might perhaps instil some compassion and charity into their view of society.

Meanwhile, Sien's incessant demands on his money and time while he was painting made for an increasingly distracting and unpleasant domestic situation. In spite of this, Vincent's confidence in his abilities was gaining to the extent that he started making plans to earn his living as a draughtsman and illustrator on English and French illustrated magazines. He had been inspired by the wood engraved magazine illustrations that he had been collecting in The Hague and that he remembered seeing in London and Paris. He deliberately worked at amassing a body of studies as 'ammunition' – 'if I fill my portfolios with studies from all the models I can get hold of, I expect to become skilful enough to get a job.' (241, November 1882). Underlying this ambition was a moral conviction of the need for a noble humanity in art that they embodied: 'An artist needn't be a clergyman or a churchwarden, but he certainly must have a warm heart for his fellow men.' (240, 1 November 1882). He was greatly impressed by an article published in the English *Art Journal* that year, written by one of the leading English illustrators, Hubert Herkomer, which discussed the current situation of illustration. Herkomer criticised the increasing slickness and superficiality of magazine illustration and called for a return to the previous standards of excellence in craftsmanship and sentiment.

Vincent's implacable conscience at last relented enough to allow him to understand that if he did not escape the suffocating complications of supporting Sien, the new baby, and her older child, as well as her mother, his painting would succumb, and he virtually fled to Drenthe. This was a bleak, impoverished area of north-east Holland, which had for years attracted a number of

artists precisely because of its deserted nature. Rappard had
already been there and wrote encouragingly to his friend, 'The
country has a very serious character; the figures often reminded
me of studies of yours' (322), and Vincent was at first exhilarated
by his freedom to explore new territory. But he was soon
overcome by loneliness, by feelings of guilt at abandoning Sien
and her baby, whom he had treated as his own, and by the
problems of his work. As ever, he poured this out to Theo: 'I
take it so much to heart that I do not get on better with people in
general; it worries me a great deal, because so much of my success
in carrying out my work depends on it. Besides, the fate of the
woman and the fate of my poor little boy and the other child cut
my heart to shreds. I would like to help them still, and I cannot.
I am at a point where I need some credit, some confidence and
warmth, and, look here, I find no confidence. You are an
exception, but it makes me feel even more how hopeless everything
is just because you have to bear the brunt of it all. And if I look
at my equipment, everything is too miserable, too insufficient, too
dilapidated. We have gloomy rainy days here, and when I come
to the corner of the garret where I have settled down, it is
curiously melancholy there; through one single glass pane the
light falls on an empty colour box, on a bundle of worn-out
brushes, in short it is so curiously melancholy that fortunately it
also has a comical aspect, enough not to make one weep over it,
but to take it gaily. For all that, it is very disproportionate to my
plans, very disproportionate to the seriousness of my work – so
here is an end of the gaiety.' (328).

He worked for three months in the area, taking his subjects
directly from the local people and the land, and, in a letter, made
one of his periodic attempts to persuade Theo to become an artist.
His observation was becoming more acute and he scattered more
and more of his letters with little sketches of work he was already
doing or was planning to do. On the page illustrated from
Letter 339 (plate 12) he discussed two paintings he was then working
on in terms that show how much he saw still in terms of tone, and
light and shade, despite his excursion into brighter colour in the
Girl in the Wood (plate 8). He wrote, 'I will just make a scratch
of the landscapes which I have on the easel. These are the kind of
studies which I should like you to try at once: To learn to look at
the landscape in a big way, and see its simple lines and contrasts of
light and brown. The little sketch at the top is what I saw today.
. . . In reality that earth was superb. I don't think my study ripe
enough yet, but I was struck by the effect, and as to light and
shade, it was indeed as I draw it for you here. The one at the

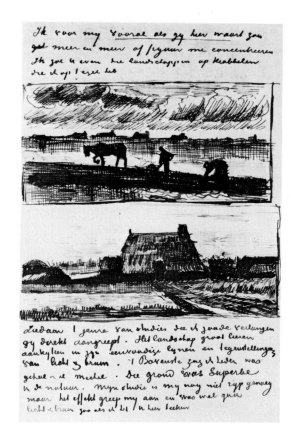

Plate 12
A page from letter no. 339, written from
Drenthe, probably on 14 November 1883.
Reproduced by kind permission of the
New York Graphic Society from
The Complete Letters of Vincent van Gogh
© 1958

bottom is a tender green little cornfield in the foreground, and withering grasses; behind the cottage, two piles of peat, again a glimpse of the heath, and a very light sky.' (339).

Once again, however, Vincent was overcome with feelings of depression and what were probably psychosomatic illnesses and returned to sanctuary with his family. At the age of thirty he settled in for almost two years at home, painting and drawing with increasing authority the peasants and the country around Nuenen, his father's new parish, east of Etten, in south Holland. Almost immediately, Vincent found that his parents, ageing and set in their provincial clerical ways, could hardly take his aggressive, energetic pursuit of his art. He wrote to Theo that they regarded him as a large, muddy-pawed dog who barked and disrupted their lives, while they struggled to guide him into some course where he could become self-supporting; the ghost of the still-born first son loomed more uncomfortably than ever before over Vincent's inadequacies and over his failure to live up to his parents' expectations of their eldest son.

In his first winter at Nuenen he drew a study of *The Vicarage Garden* (plate 13) which can be looked at in the light of some of these conflicting currents. The agitated angularity of the branches hangs over the still garden, which encloses an enigmatic figure, nun-like in its anonymity. Not only does he achieve an extraordinary panoramic distance, giving great depth to the perspective, but the lines can also be read as an abstract pattern on the surface of the drawing with an energy and beauty of their own. However, his ability to model form is not yet sure, as the trunk of the nearest tree demonstrates. Another drawing made within a few weeks, *Pine Trees in the Fen* (plate 14), shows how subtly he could now control the tonal effects in his landscape drawing. Using the pen (always his preferred medium for landscape), he builds up his dark areas with superimposed strokes and fine cross-hatching; the total effect is one of a shadowy, atmospheric marsh that is both a representation of a particular scene and a reflection of French and English precedents. But he was dissatisfied with his drawing and wrote to Rappard about it: 'As for the execution, I should have wished with all my heart that the direction of the pen scratches had followed the forms more expressively, and that the forces which render the tone of the masses expressed their shape more clearly at the same time. I think you will admit that I did not systematically or intentionally neglect the composition of things, their shape, but I had to take a shot at it in a rough sort of way in order to render the effect of light and brown – the atmosphere of the scenery as it was at that moment – the general aspect – as well

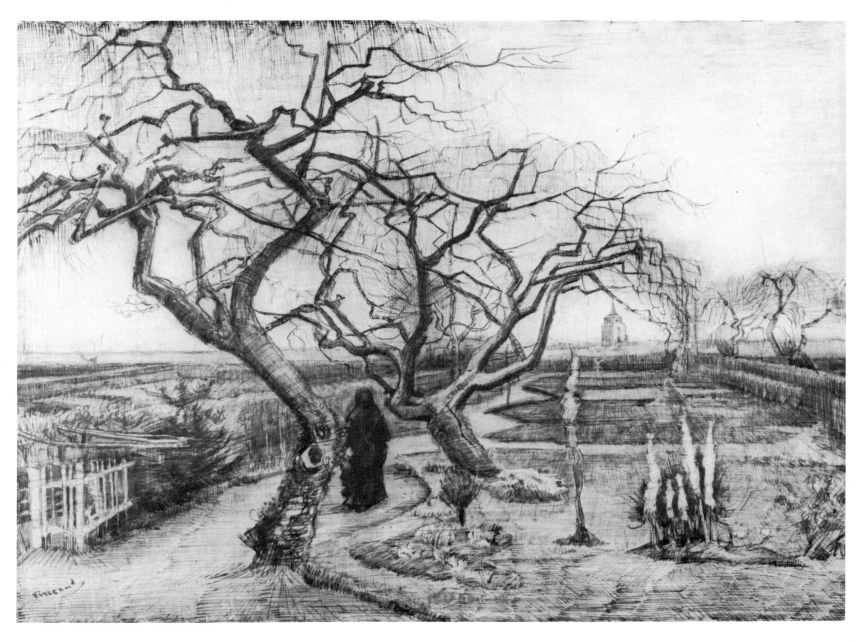

Plate 13
The Vicarage Garden at Nuenen in Winter F1128
Nuenen, March 1884
pencil and pen
$15\frac{1}{4} \times 20\frac{3}{4}$ in (39 × 53 cm)
Rijksmusem Vincent van Gogh,
Amsterdam

Plate 14
Pine Trees in the Fen F1249
Nuenen, April 1884
pen and ink
$13\frac{1}{2} \times 17\frac{1}{4}$ in (34.5 × 44 cm)
Rijksmuseum Vincent van Gogh,
Amsterdam

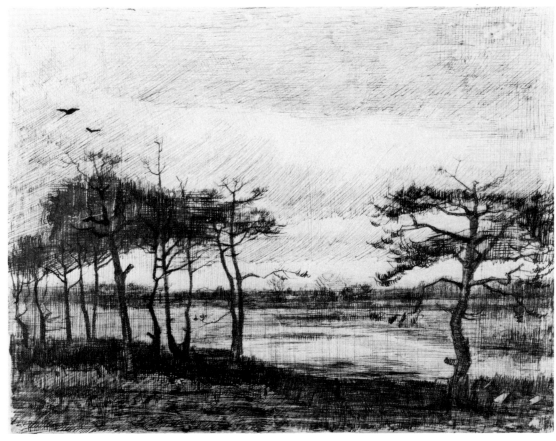

Plate 15
The Old Church Tower at Nuenen F84
Nuenen, May 1885
oil on canvas
$23\frac{3}{4} \times 41$ in (63 × 79 cm)
Rijksmuseum Vincent van Gogh,
Amsterdam

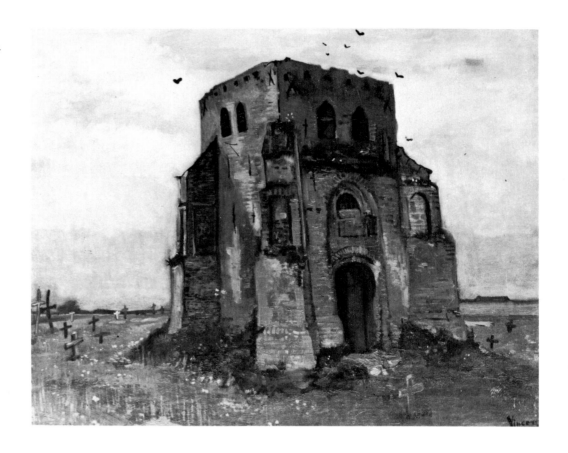

as I could. For at present one can see these three things together only at special moments.' (R45).

Perhaps more so with Van Gogh than with most other artists there are clearly discernible constants in his aims, and in his choice of subject matter. He had a great sense of urgency, and his working life, compressed as it was into little more than a decade, focussed his attention sharply and repeatedly on the same problems: in the letter just quoted he understood the need to use the actual pen strokes to describe form and in his later landscape drawings he can clearly be seen achieving this—the Montmajour drawing (plate 48) is a perfect example of his later refinement of this expressive line. His treatment of similar subjects also has an intriguing consistency: the old church tower at Nuenen fascinated him because of its stocky and forceful shape, dominating the flat countryside for miles around; sadly it was gradually being demolished during his stay in Nuenen in 1884–5. In May 1885 he painted *The Old Church Tower at Nuenen* (plate 15), its spire gone, crows flying bleakly around the blank windows, weeds filling the cemetery. It has much of the vigour of one of his last paintings, *The Church at Auvers* (plate 100). There is the same distorted angle, with the bulk of the building leaning away and up into the space of the composition, the same powerfully articulated outline against the sky: the vital difference is that at Auvers, at

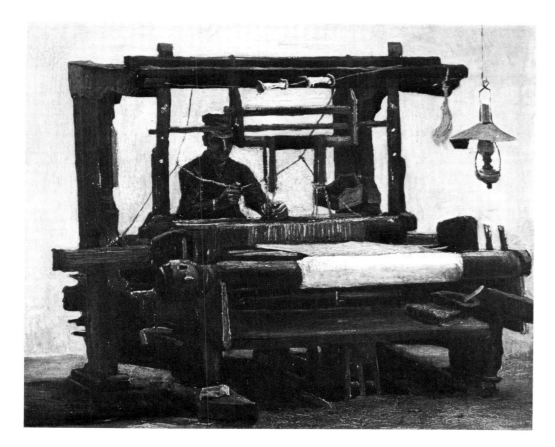

Plate 16
**The Weaver: the Whole Loom, Facing
Front** F30
Nuenen, May 1884
oil on canvas
$27\frac{1}{2} \times 33\frac{1}{2}$ in (70×85 cm)
Rijksmuseum Kröller-Müller, Otterlo

the end of his life, Vincent's overriding concern was with colour,
while at Nuenen he was still exploring the expression of three-
dimensional, bulky form on a two-dimensional canvas.

The second major group of works at Nuenen was the series of
studies of peasants which culminated in his apotheosis of peasant
life, *The Potato Eaters* (plate 20). Almost as soon as he arrived
home, Vincent walked around the fields and nearby villages, as
he had done at Etten, observing the peasants at work. He found
particular satisfaction in the community of weavers who were a
relic of the pre-industrial, cottage loom era, struggling to maintain
a living against competition from modern industrial methods.
The images (see plate 16) he made of the small, dogged figure,
engulfed in the architectural framework of the loom, which was
so large it filled the whole of the main room of the tiny
peasant cottages, expressed vividly the social condition of the
whole class, dependent as it was on a piece of obsolete craft
machinery for a subsistence livelihood. Vincent saw in the weavers
the same qualities he had seen in the miners of the Borinage, from
where he had written: 'The miners and the weavers still constitute
a race apart from other labourers and artisans, and I feel a great
sympathy for them. I should be very happy if someday I could
draw them, so that those unknown or little-known types would be
brought before the eyes of the people. The man from the depth

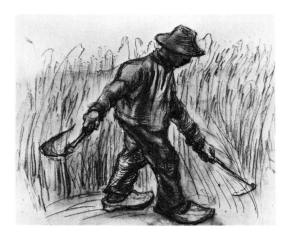

Plate 17
The Reaper with Hat: facing right
F1316
Nuenen, August 1885
black chalk
17 × 21¼ in (43 × 54 cm)
Rijksmuseum Vincent van Gogh,
Amsterdam

Plate 18
**Peasant Woman Stooping:
seen from the back and side** F1269
Nuenen, August 1885
black chalk, washed
20¾ × 17¼ in (52.5 × 43.5 cm)
Rijksmuseum Kröller-Müller, Otterlo

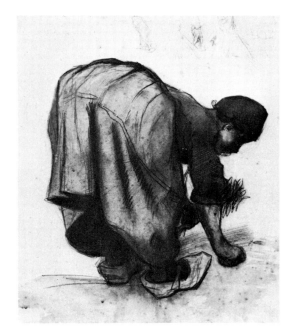

of the abyss, de profundis – that is the miner; the other, with his dreamy air, somewhat absent-minded, almost a somnambulist – that is the weaver.' (136). By the time he encountered the weavers and the reality of their existence at Nuenen his understanding of their situation and his translation of that understanding on to paper had hardened, become less sentimental and more intimately involved in the stuff of their lives. One of the most successful of all the weavers pictures is *The Weaver: the Whole Loom, Facing Front* (plate 16), in which he shows a keen technical appreciation of the mechanics of the process as well as a capacity to identify closely with the subject and social importance of the class. He discussed with Rappard the drawings that his friend was making of industrial machinery at the same time as Vincent was working on his weavers studies. The difference in their intentions is clear, for Vincent found the human involvement unavoidable, while Rappard was interested in the mechanics of the apparatus: Vincent wrote to Rappard, 'As for the weaving loom, the study of that apparatus was indeed made on the spot from start to finish, and it was a hard job – on account of the fact that one must sit so close to it that it is difficult to take measurements; I did include the figure in the drawing after all. But what I wanted to express by it was just this: "When that monstrous black thing of grimed oak with all those sticks is seen in such sharp contrast to the grayish atmosphere in which it stands, then *there* in the centre of it sits a black ape or goblin or spook that clatters with those sticks from early morning till late at night". And I indicated that spot by putting in some sort of apparition of a weaver, by means of a few scratches and blots, where I had seen it sitting. Consequently I hardly gave a thought to the proportions of the arms and legs. When I had finished drawing the apparatus pretty carefully, I thought it was so disgusting that I couldn't hear it rattle that I let the spook appear in it. Very well – and – let us say it is only a mechanical drawing – all right, but just put it beside the technical design for a loom – and *mine will be more spectral all the same, you may be sure of that*. And if you were to put my study beside the drawing of a mechanic who had designed a weaving loom – mine would express more strongly that the thing is made of oak grimed by sweaty hands; and looking at it (*even if I had not included him in the drawing at all*, or even if I did add his figure out of proportion), you could not help thinking occasionally of the *workman*, whereas absolutely nothing like it would occur to your mind when you looked at the model of a loom drawn by a mechanic. A sort of sigh or lament must issue from that contraption of sticks now and then . . . Meanwhile I quite understand your

idea that, if it were to be a *black-and-white drawing*—which I *hope* to make it someday, if I can get hold of the right model—that little black spook in the background must be the centre, the starting point, the heart of it, most deeply felt, most elaborately finished, and all the rest must be kept subordinate to it.' (R44). For Vincent, at this time, the human element took precedence over any purely technical or painterly process, and in a situation like this his representations of working people at this period could be labelled 'humanist realism', his maxim 'man in nature and nature in man'.

He took his observation of people at work out into the fields where he drew on the spot analyses of every aspect he could discover of the representation of the human figure at labour. *The Reaper with Hat* (plate 17) is about movement and how it interacts with light. The body, weighted with its disproportionate limbs and rooted in massive clogs, is caught in a moment of equilibrium before the trunk topples forward with the swing of the sickle. The planes of the form are described with contrasting tonal areas and lines showing the angles of the surfaces—all repeatedly and densely worked over. The way in which the figure crowds out of the page at us gives a sensation of immediacy that is entirely Vincent's. A drawing also done in the August of his second and last summer at Nuenen, when he did dozens of these studies in a blaze of activity went further. *The Peasant Woman Stooping* (plate 18)— 'I think they [the figure studies] are getting rounder and fuller than at first' (412)—is no longer being seen by Vincent as an individual person, bending down for the prosaic task of pulling up weeds—she has become an abstract shape in its purest sense. Vincent has here shown the same concern with pure form that reappears in many of the Arles paintings, such as *La Mousmé* (plate 47), with its tensely arched chair enclosing the figure. As he wrote to Theo, '*I should be desperate if my figures were correct* . . . my great longing is to learn to make those very incorrectnesses, those deviations, remodelling, changes in reality, so that they may become, yes, lies if you like—but truer than the literal truth.' (418).

This maturing concentration brought his attention not only to the generalised 'little black spook' but also to the individual man or woman, and he submitted a few of the peasants, those who would agree to sit for him (some were terrified by the extraordinary apparition roaming around their fields), to a microscopic examination by portrait. These studies of heads were rehearsals for *The Potato Eaters* (plate 20) and began to accumulate from December 1884. Many are clumsy and coarse, heads so grotesque that they become abstract jigsaw puzzle profiles against

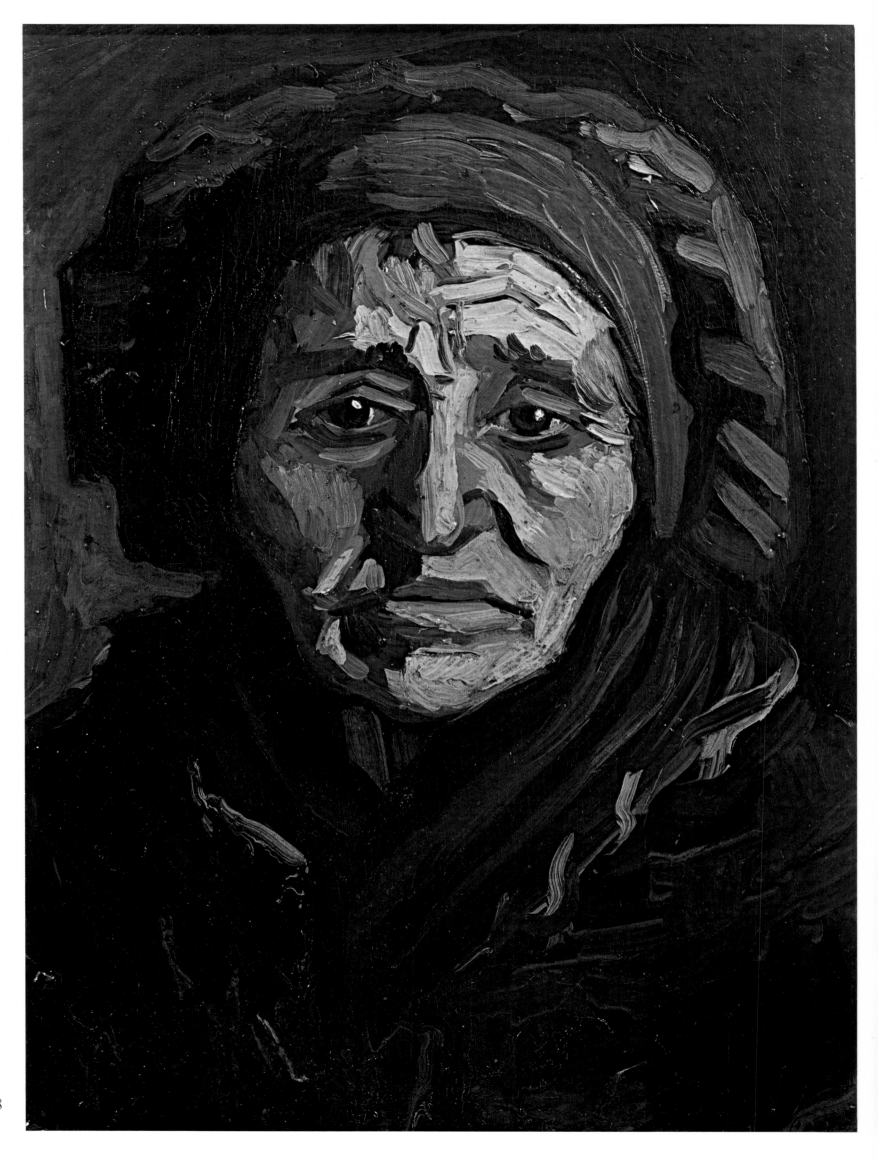

28

Plate 19
**Head of an Old Peasant Woman:
full face, with dark cap** F74
Nuenen, February–March 1885
oil on canvas
$14\frac{3}{4} \times 11$ in (37.5 × 28 cm)
Rijksmuseum Kröller-Müller, Otterlo

a window; some were technical experiments, now blackened and crackled by his use of bitumen in the dark backgrounds; but there are a few that are magnificent penetrations of the individuals' faces, while retaining the tight control of line and colour that was vital to prevent the portraits degenerating into the sentimental. *The Head of an Old Peasant Woman* (plate 19) is a beautiful example of these heads of the people: it is a compassionate representation of the particular woman's appearance and it is an absolute expression of old age. The hieratic stillness of the blunt, frontal view creates an icon to Vincent's belief in the peasants–'a peculiar expression of *simplicity* and *goodness*–both *through and through*'. (395).

Since February of 1885 Vincent had been working on the composition of 'those peasants around a dish of potatoes in the evening' (398), *The Potato Eaters* (plate 20). He began work on the subject with a coarse, primitive study, done in the family's cottage by day and by lamplight, and within a few days attempted another canvas, adding the woman second from the left, and manoeuvring the figures, their poses, and the angle of vision around in an awkward attempt to achieve a coherent composition. The definitive version, reproduced here, is a heavily overpainted, muddy, ugly painting with the kind of impact that insists on its message. As he was finishing the painting, he wrote to Theo, 'I have tried to emphasize that those people, eating their potatoes in the lamplight, have dug the earth with those very hands they put in the dish, and so it speaks of *manual labour*, and how they have honestly earned their food. I have wanted to give the impression of a way of life quite different from that of us civilized people. Therefore I am not at all anxious for everyone to like it or to admire it at once. All winter long I have had the threads of this tissue in my hands, and have searched for the ultimate pattern; and though it has become a tissue of rough, coarse aspect, nevertheless the threads have been chosen carefully and according to certain rules. And it might prove to be a real *peasant picture. I know it is.* But he who prefers to see the peasants in their Sunday-best may do as he likes. I personally am convinced I get better results by painting them in their roughness than by giving them a conventional charm . . . If a peasant picture smells of bacon, smoke, potato steam–all right, that's not unhealthy; if a stable smells of dung–all right, that belongs to a stable; if the field has an odour of ripe corn or potatoes or of guano or manure–that's healthy, especially for city people. Such pictures may *teach* them something. But to be perfumed is not what a peasant picture needs.' (404, 30 April 1885).

Not only was this painting a milestone in Vincent's interpreta-

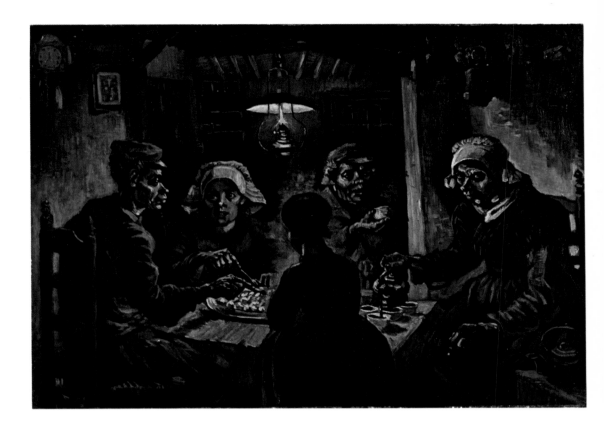

Plate 20
The Potato Eaters F82
Nuenen, April 1885
oil on canvas
32¼ × 45 in (82 × 114 cm)
Rijksmuseum Vincent van Gogh,
Amsterdam

tion of peasant life, but also it gave him the incentive to make what was to be his last lithograph. There followed two significant events. Theo, who had now been with Goupil's in Paris for several years, took a print of the lithograph to Portier, a Paris dealer, who became interested in Vincent's work. Since an isolated commission at The Hague from his uncle Cor for twelve views of the town, intended for publication, Vincent had been eager to sell more. But he braced himself–before making the lithograph, he wrote to Theo, 'As to *general* sympathy, years ago I read something about it in Renan[1], which I have always remembered, and shall continue to believe, namely that he who wants to accomplish something really good or useful must neither count on nor want the approval or appreciation of the general public, but, on the contrary, can expect that only a very few hearts will sympathize with him and take part in it.' (400). And now, although Vincent had called the lithograph 'quite a private affair' (400), Portier's interest encouraged him, in spite of Theo's technical criticisms of it. The second important result of the lithograph involved Rappard. He criticised the lithograph with the most devastating thoroughness, and Vincent was bitterly hurt; the coincidental deaths of their fathers, and recriminations over their mutual failure to write proper letters of condolence, exacerbated the situation. Although the exchanges continued fitfully until September, it was clear that yet another of Vincent's relationships with a brother artist had ground painfully to an end: though there were to be exceptions, the pattern was set.

The last months at Nuenen were fraught with tensions and the

[1] The French religious historian.

major family bereavement of his father's death at the end of March. Vincent's behaviour had increasingly scandalised the local petite bourgeoisie; he had been accused of causing the attempted suicide of a woman who had unhappily become infatuated with him, and they were incensed by his very presence which disrupted the complacency of their existence. The respectable people of Nuenen felt threatened by Vincent's anarchic and total abandonment of all the values which governed their lives. He cared nothing for niceties of dress or speech, the local worthies bored or angered him, and his publicly proclaimed preference for the company of the peasant families he painted outraged their sense of social order. He was a threat to their security simply by existing – the living demonstration of anti-materialism, who rejected the need for any property other than that which allowed him to work, and despised their petty snobberies and social rituals. He was virtually ostracised in his family circle, took his meals apart from the others, and hardly exchanged a word with them. Theo came home for their father's funeral and this sustained him for a while, but Vincent knew that he had to escape the confines of constant disapproval before he suffocated. During this summer there was a feeling of change and new influences: Theo sent him Émile Zola's novel *Germinal*, which reinforced all his commitment to peasant life, particularly that of the miners whom the book celebrates. He was beginning to explore colour and wrote a lot about the colour theories evolved by the great early 19th-century French painter, Eugène Delacroix, which he was studying and to which he was greatly attracted. These were to be very important when he came to Paris and encountered Signac and Seurat whose painting, labelled Neo-Impressionism, used complementaries. Vincent discussed with Theo Delacroix's theory, on which so much of Vincent's later work was based, the foundation of Neo-Impressionism, and central to so much French painting in the three decades after Delacroix's death in 1863. Vincent gave the basics of the theory with great clarity, and it is worth following him through the argument: 'If one combines two of the primary colours, for instance yellow and red, in order to produce a secondary colour – orange – this secondary colour will attain maximum brilliancy when it is put close to the third primary colour not used in the mixture. In the same way, if one combines red and blue in order to produce violet, this secondary colour, violet, will be intensified by the immediate proximity of yellow. And finally, if one combines yellow and blue in order to produce green, this green will be intensified by the immediate proximity of red. Each of the three

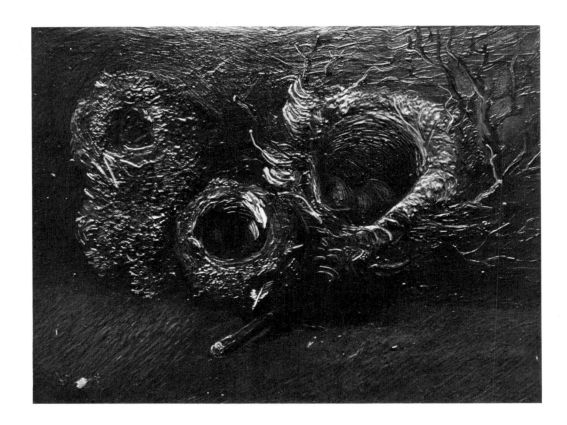

primitive [primary] colours is rightly called complementary with regard to the corresponding secondary colours. Thus blue is the complementary colour of orange; yellow, the complementary colour of violet; and red, the complementary colour of green. Conversely, each of the combined colours is the complementary colour of the primitive one not used in the mixture. This mutual intensification is what is called the law of simultaneous contrast. When the complementary colours are produced in equal strength, that is to say in the same degree of vividness and brightness, their juxtaposition will intensify them each to such a violent intensity that the human eye can hardly bear the sight of it.' The other combinations are listed: combining of complementaries in equal proportions, resulting in a dead, colourless grey, mixing complementaries in unequal proportions resulting in a broken tone in shades of grey which may be contrasted with a pure complementary producing a harmony with one dominant colour. He concluded, 'So it is clear that there are various means, divergent among themselves, but equally infallible, by which to intensify, to maintain, to weaken or to neutralize a colour's effect, and this by its reaction to the contiguous tones—by its touching what is not itself.' (401).

Vincent's technical researches were essential if he was ever to emancipate himself from the traditional Dutch palette. Before he left Nuenen, he went further into symbolism than he had been so far, in several paintings of birds' nests. He was quite specific

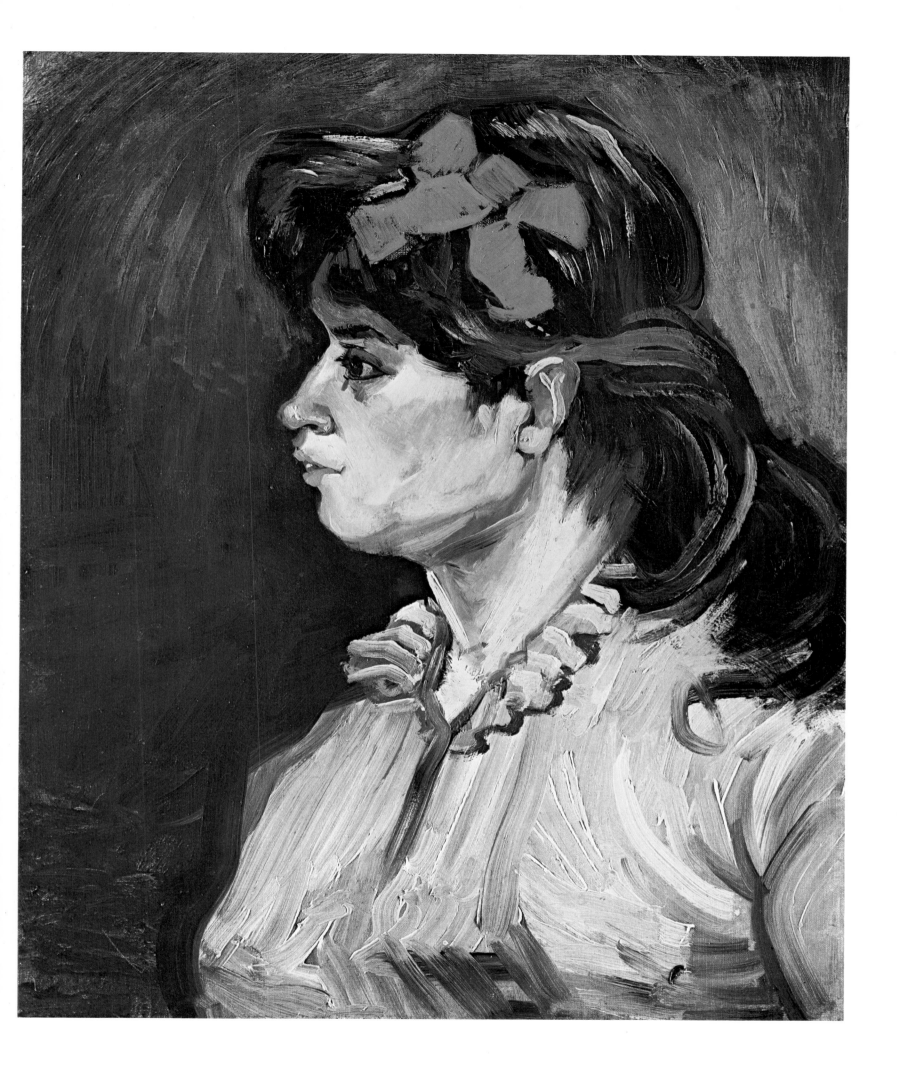

33

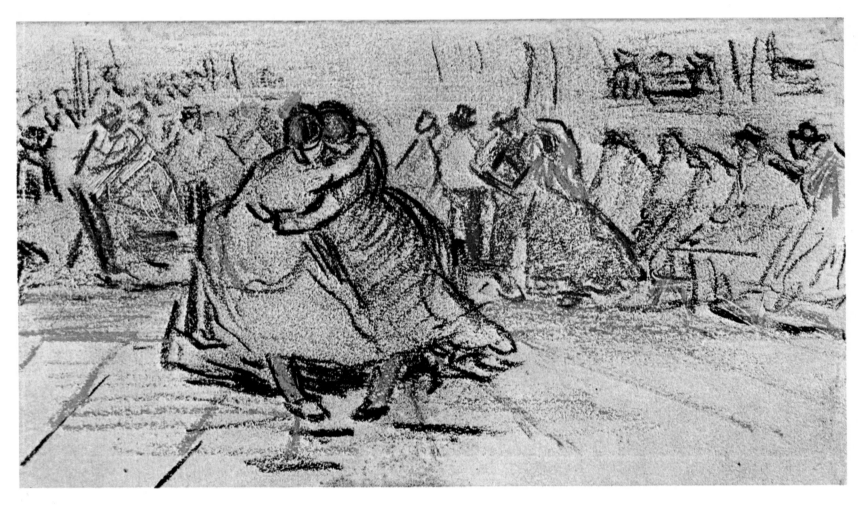

Plate 23
Woman Dancing F1350b
Antwerp, December 1885
black and coloured chalk
3¾ × 6½ in (9.3 × 16.4 cm)
Rijksmuseum Vincent van Gogh,
Amsterdam

about his intentions when painting the nests he had collected –
'. . . they were all nests which the young birds had left, so one
could take them without too many scruples. It was so full of
character . . .' (411, June 1885) – and he quite deliberately wished
to extract them from their natural surroundings and regard them
as separate objects, emphasising this by placing them against a
black background. The effect, in for instance the *Three Birds'
Nests* of September 1885 (plate 21), is to isolate the nests against a
velvety anonymity, the bleakness of their actual vacancy softened
by Vincent's placing of some unseasonal eggs in one nest. Although
it had been a couple of years since Vincent had referred to his
great affection for Longfellow's poetry, the lines from *It is not
always May,* a poem which Vincent must have read in a collected
edition of Longfellow, come to mind:

> For time will teach thee soon the truth,
> There are no birds in last year's nest!

Finally, Vincent was finding it impossible to remain at Nuenen,
even in the separate cottage he had rented in an attempt at
independence. At the end of November, he shook off the
constraints and frustrations of Nuenen for Antwerp with the glad

cry 'it seems to me like a return from exile.' (435).

Antwerp's attraction lay in its great Rubens collection: Vincent detested Rubens's overblown religious and allegorical compositions, but felt: 'What he can do – combinations of colours – what he can do is – paint a queen, a statesman, well analyzed, just as they are.' (435). The impact is self-confessed: 'Rubens is certainly making a strong impression on me; I think his drawing tremendously good – I mean the drawing of heads and hands in themselves. I am quite carried away by his way of drawing the lines in a face with streaks of pure red, or of modelling the fingers of the hands by the same kind of streaks.' (439, December 1885). The marvellously liquid handling of frequent passages of pure colour in the *Portrait of a Woman* (plate 22) shows how quickly he assimilated the lessons; the head of the old peasant woman (plate 19) painted at Nuenen at the beginning of the same year still had the muddier tones, less confidently worked paint and, above all, the intimate psychological involvement with the subject.

With this lightening of his palette came a lightening of his spirits, for, in spite of his never-endingly precarious finances, he found several dealers willing to take one or two of his studies on trial, and he found a new kind of subject around Antwerp. Pages from a sketchbook which survive show charming and lively little scenes, like that of *Woman Dancing* (plate 23), where the little figures cavort with such gaiety and energy that, as he wrote to Theo, 'It does one good to see folks actually enjoy themselves.' (438, December 1885). However, he was also aware of the need to work from the model, so he enrolled at Antwerp Academy in January 1886, only to run into the inevitable arguments with the very conventional professors whose insistence on drawing from plaster casts in the driest possible way exasperated him. One typical incident was recalled by Victor Hageman, a fellow-student in the drawing class, when Vincent was drawing from a cast of the Venus de Milo. He strongly accentuated the hips and 'The beautiful Greek goddess had become a robust Flemish matron. When honest Mr Sieber[1] saw this, he tore Van Gogh's drawing sheet with the furious corrective strokes of his crayon, reminding his disciple of the inviolable canons of his art. Then the young Dutchman . . . whose rudeness had terrified the fair clients of Goupil's at Paris, flew into a violent passion, and roared at his professor, who was scared out of his wits: "So you don't know what a young woman is like, God damn you! A woman must have hips and buttocks and a pelvis in which she can hold a child!" '[2]

[1] Professor Siberdt of the Academy.
[2] *Letters*, vol. I, p. 508.

Paris

Plate 24
Self Portrait F178 verso
Paris, first half of 1886
oil on canvas
$15\frac{1}{2} \times 11\frac{1}{2}$ in (39.5 × 29.5)
Collection Haags Gemeentemuseum,
The Hague

He left Antwerp looking, in his own words, 'as if I had been *in prison* for ten years' (448, February 1886), and a *Self Portrait* (plate 24) from the time of his arrival in Paris, shows all those characteristics of a man suddenly in a strange milieu– the strokes are tentative, the expression uncertain and the whole atmosphere of the painting is one of wary anticipation. The effect Paris had on him can be seen in the *Self Portrait in Front of the Easel* (plate 25), painted just before he finally left Paris for Arles, from where he wrote to his sister Wil, 'Seeing that I am so busily occupied with myself just now, I want to try to paint my self-portrait in writing. In the first place I want to emphasize the fact that one and the same person may furnish motifs for very different portraits. Here I give a conception of mine, which is the result of a portrait I painted in the mirror, and which is now in Theo's possession. A pinkish-grey face with green eyes, ash-coloured hair, wrinkles on the forehead and around the mouth, stiff, wooden, a very red beard, considerably neglected and mournful, but the lips are full, a blue peasant's blouse of coarse linen, and a palette with citron yellow, vermilion, malachite green, cobalt blue, in short all the colours on the palette except the orange beard, but only whole colours. The figure against a greyish-white wall. You will say that this resembles somewhat, for instance, the face of – Death . . . all right, but it is a figure like this– and it isn't an easy job to paint oneself– at any rate if it is to be *different* from a photograph. And you see– this, in my opinion, is the advantage that impressionism possesses over all the other things; it is not banal, and one seeks after a deeper resemblance than the photographer's.' (W4, late June–July 1888).

The two years in Paris saw Vincent undergoing a barrage of new sensations– visual, intellectual and social– that was unprecedented in his life and that very nearly overwhelmed him. He moved into Theo's tiny flat on the rue Laval, where they lived in acute discomfort until they found a large fourth-floor apartment at 54 rue Lepic in June. This was just north of the boulevard de Clichy, the southern border of what was becoming

37

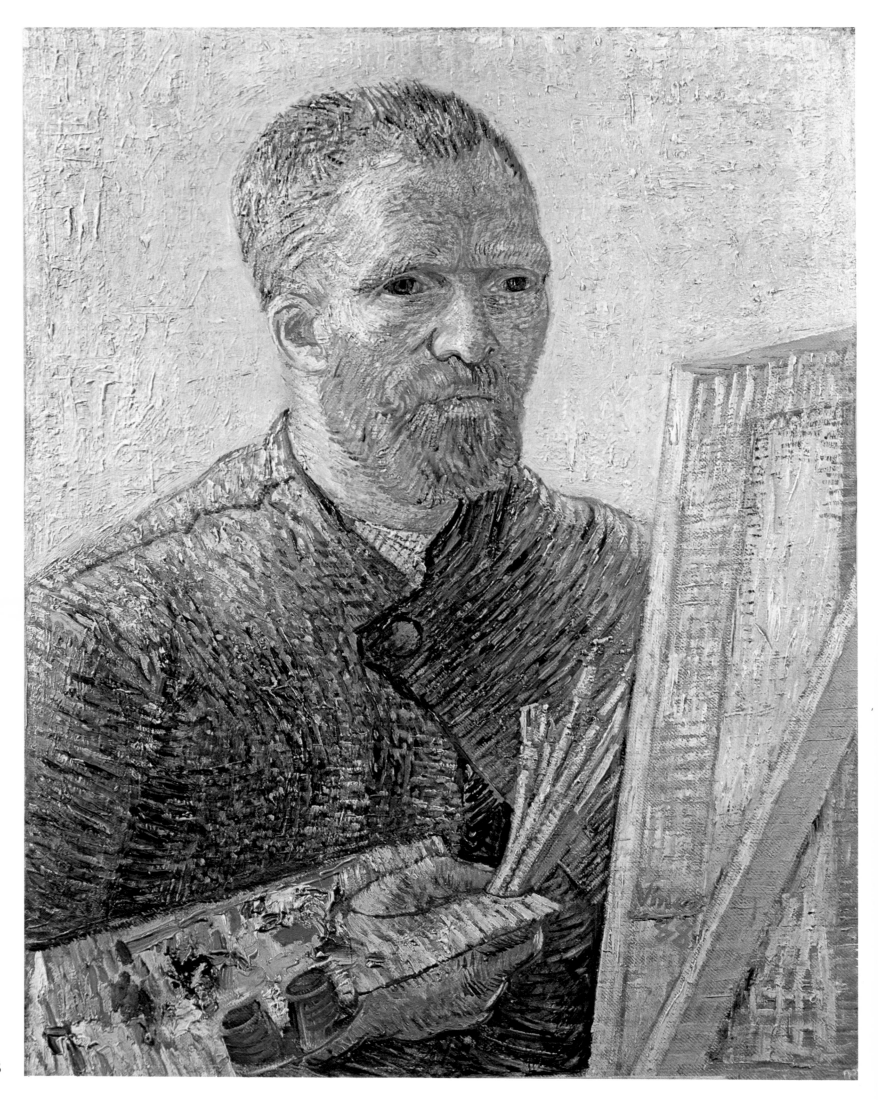

the artists' colony of Montmartre. Not far to the north of them, Montmartre became semi-rural, with allotments and vegetable gardens separating the houses. Here Vincent had a room to himself for a studio and could start to paint, and try to recover from the effects of culture shock. With his usual pleasure in consolidating his security of living and working space, Vincent made several studies of the view from his studio window. The drawing, *View from Vincent's Room in the rue Lepic* (plate 26), gives some idea of his outlook: the typical Parisian buildings nudge his window with a curiously insubstantial airiness.

In the Paris of 1886, apart from the conventional Salon-orientated art world, with its annual dinosaur-like exhibition (known as 'the Salon'), there were three movements jostling for position amongst the avant-garde–the Neo-Impressionists, the Gauguin-Bernard group, and the Symbolists. The eighth, and last, Impressionist exhibition represented the last collective statement of what was left of the group which had so dramatically burst before the astonished gaze of Paris at their first notorious exhibition twelve years before, in 1874. They were now estranged by conflicting developments in their individual work: Renoir and Monet showed separately, abandoning Durand-Ruel their old dealer and champion. Durand-Ruel's exhibition embodied the triple head of the avant-garde: of the old-guard Impressionists, only Degas and Pissarro showed, while the new generation of Neo-Impressionists, Gauguin, and the Symbolists (represented by Odilon Redon) took up the rest of the space. The Neo-

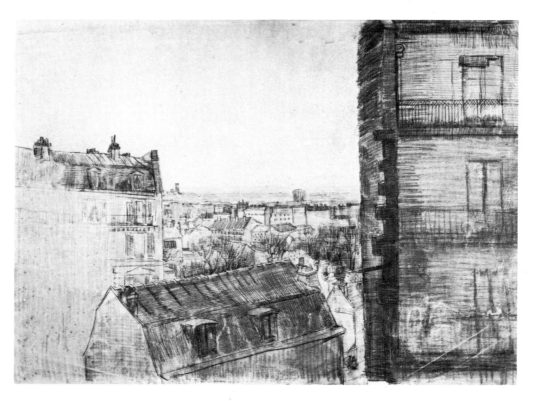

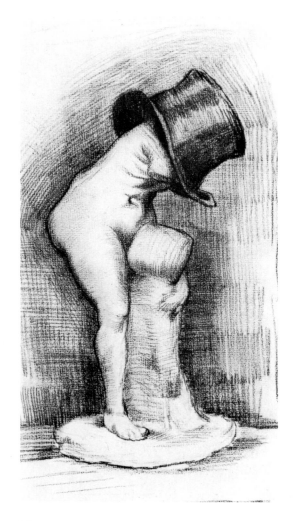

Plate 27
**Study after Plaster Statuette:
female torso with one leg and top hat**
F1363f recto
Paris, 1886
black chalk
$15 \times 7\frac{3}{4}$ in (38×19.5 cm)
Rijksmuseum Vincent van Gogh,
Amsterdam

Impressionists, Seurat and Signac, scathingly labelled by Gauguin 'the dotters', had already converted Pissarro to their brainchild, which they christened 'Divisionism'. This was a method of painting which involved the application, according to the latest scientific principles, of the theories of colour contrast and complementary colours, as first propounded by Delacroix, by means of a very precise pointillist (dotted) technique. Redon represented the rising tide of reaction against pure painting: they were artists who introduced literary and symbolic elements into their painting to try and parallel the symbolic forms used in experimental literature and poetry. That August, the Salon des Indépendants opened – this was the exhibition of those paintings rejected by the Salon, together with many not even submitted to the Salon jury, by those artists too far outside accepted official taste. Here Vincent could see Seurat's first major Divisionist painting, *La Grande Jatte*. The impact of Seurat's painting was backed up by the critic Félix Fénéon's series of articles on *Les Impressionnistes*, which claimed that naturalistic Impressionism was being superseded by the new scientific method of his friend Seurat. Theo brought Vincent into the thick of all this, for he was now running the branch of Goupil's called Boussod and Valadon, at 19 boulevard Montmartre, where he was allowed to show the unsaleable Impressionists on condition that he never impinged on the prestigious trading area of Goupil's. The parent gallery's best sellers were the perfectly academic nude fantasies of artists like Bouguereau.

The Bouguereau market was often reinforced by the products of Cormon's atelier, the studio where Vincent spent about three months on arriving in Paris. Cormon was an academic artist of mediocre quality, but a good teacher, and his was one of the several studios in Paris where students could go for a small fee to draw from the model and receive intermittent instruction from the master. Vincent planned at first to spend three years there, studying diligently what he thought Paris had to teach him, but he soon realised that it was not that far removed from the spirit of the Antwerp Academy. He did, however, make two important friends there, the young Toulouse-Lautrec and Louis Anquetin, who was to work with Gauguin. A friend of Lautrec's there, François Gauzi, recalled Vincent's impact on the studio. His Northern dourness saved him from the usual merciless teasing meted out to new students, but he flared up alarmingly in arguments over art. Gauzi remembered how colour drove him mad and how, when he spoke of Delacroix, his lips trembled; but, until he embarked on his first startling oil of a nude, his drawings

seemed relatively undistinguished. At least one drawing distinguished itself with an irreverent streak of caricature: *Study after Plaster Statuette* (plate 27) perhaps shows that some of Lautrec's cynicism had briefly rubbed off on Vincent. In spite of the gulf between Lautrec's sophisticated cynicism and the Dutchman's ingenuousness, they were friendly, though never close, and Vincent went to his studio to work. Suzanne Valadon, who later became a painter in her own right, remembered a typical visit when she was modelling for Lautrec: 'He would arrive carrying a heavy canvas under his arm, which he would place in a well-lighted corner, and wait for someone to take notice of him. No one was the least concerned. He would sit down opposite his work, surveying the others' glances and sharing little in the conversation. Finally wearying, he would depart carrying this latest example of his work. Nevertheless, the following week he would return and commence the same stratagem yet again.'[1] Vincent's unsophisticated intensity was clearly a mutual embarrassment.

Another Cormon student was the English painter A. S. Hartrick. His recollections of Vincent were more bluntly put: '. . . to my eye Van Gogh was a rather weedy little man, with pinched features, red hair and beard, and a light blue eye. He had an extraordinary way of pouring out sentences, if he got started, in Dutch, English and French, then glancing back at you over his shoulder, and hissing through his teeth. In fact, when thus excited, he looked more than a little mad; at other times he was apt to be morose, as if suspicious.'[2] This hesitancy and ambivalence was clearly apparent in his first reactions to the Impressionists. He wrote to a friend in Antwerp, in the second half of the year: 'In Antwerp I did not even know what the impressionists were, now I have seen them and though *not* being one of the club yet I have much admired certain impressionists' pictures – *Degas* nude figure – *Claude Monet* landscape. And now for what regards what I myself have been doing, I have lacked money for paying models else I had entirely given myself to figure painting. But I have made a series of colour studies in painting, simply flowers, red poppies, blue corn flower and myosotis, white and rose roses, yellow chrysanthemums – seeking oppositions of blue with orange, red and green, yellow and violet seeking *les tons rompus et neutres* to harmonise brutal extremes. Trying to render intense colour and not a grey harmony . . . So as we said at the time: in *colour* seeking *life* the true drawing is modelling with colour.' (459a). Theo had written to him of the Impressionists, and he had seen a few Manets when he had worked in Paris in the 1870s, but his

[1] *Van Gogh in Perspective,* edited by Bogomila Welsh-Ovcharov, Prentice-Hall, New Jersey, 1974, p. 35, transl. from *Vincent Van Gogh,* by Florent Fels, Paris, 1928.
[2] A. S. Hartrick, *A Painter's Pilgrimage through Fifty Years,* Cambridge, 1939, p. 40.

Plate 28
Vase of Flowers
by Adolphe Monticelli (1824–1886)
oil on canvas
20 × 15⅛ in (51 × 39 cm)
Ex Collection Theo van Gogh
Rijksmuseum Vincent van Gogh,
Amsterdam

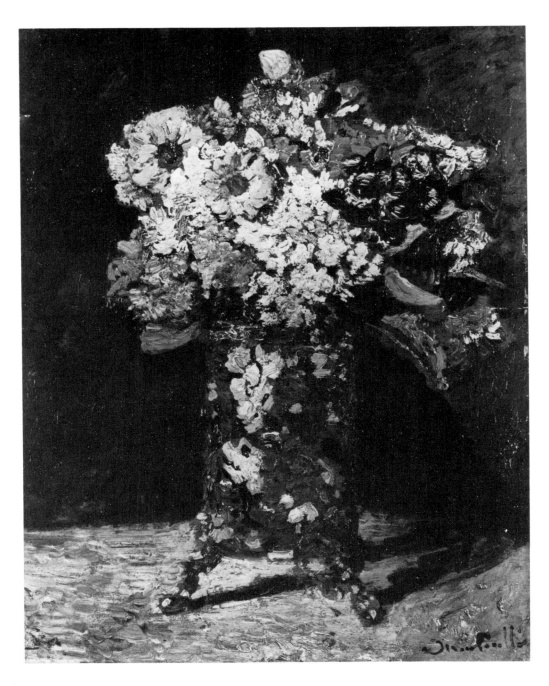

instinct, born perhaps of a sense of technical inferiority, was for painters whose technical brilliance obscured their academic mediocrity. Vincent wrote to his sister Wil from Arles in 1888 recalling his feelings in 1886: 'One has heard talk about the impressionists, one expects a whole lot from them, and . . . and when one sees them for the first time one is bitterly, bitterly disappointed, and thinks them slovenly, ugly, badly painted, badly drawn, bad in colour, everything that's miserable.' (W4).

What sustained him through this period of adjustment to the Impressionists' use of colour was his admiration for the Provençal painter Monticelli. Monticelli came from Marseilles to Paris where he had considerable success before the Franco-Prussian War and the Commune of Paris in 1870–1, but he returned to the South

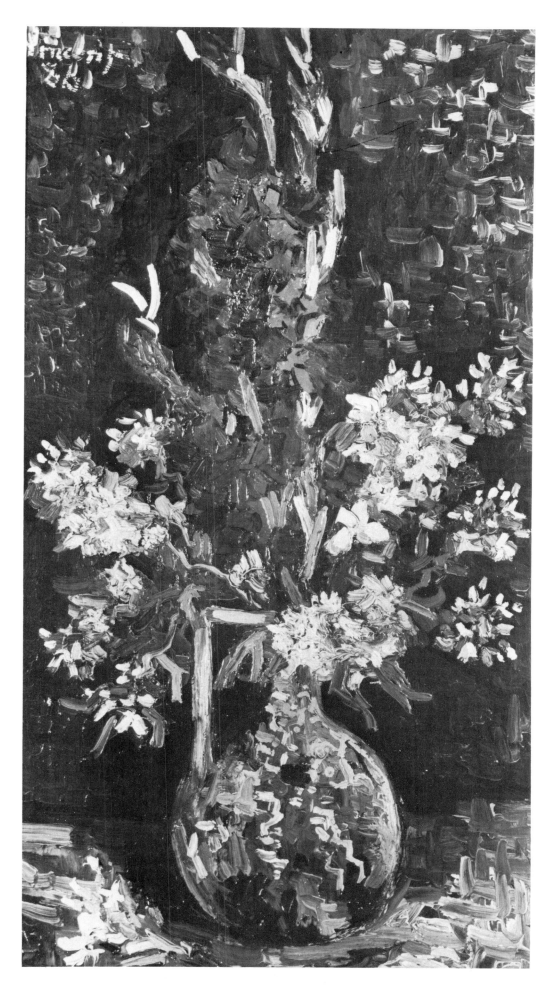

Plate 29
**Still Life: One-eared Vase with
Physostegia, Gladiolus and Lychnis**
F237
Paris, late summer 1886
oil on canvas
$25\frac{3}{4} \times 13\frac{3}{4}$ in (65.5×35 cm)
Museum Boymans-van Beuningen,
Rotterdam

Plate 30
Still Life: Fritillaries in a Copper Vase
F213
Paris, summer 1887
oil on canvas
29 × 23¾ in (73.5 × 60.5 cm)
Musée du Louvre, Paris

and spent the last fifteen years of his life in poverty and neglect. The attraction of being a Southern painter, the romance of his decline and above all the quality of his painting drew Vincent; Monticelli died in 1886, and Theo showed Vincent the paintings that Monticelli's dealer had. These showed him to be a painter of brilliant little *fêtes champêtres* – pastoral idylls – in the tradition of Watteau and the rest of French 18th-century painting, and of flower pieces in which the richness of the impasto gives the surfaces a romantically baroque effect. From his earliest Paris flower paintings right through to the St-Rémy period, Vincent shows in his work what a profound influence Monticelli's almost sculpted paint had on him. Theo owned several Monticellis, and the *Vase of Flowers* (plate 28), from his collection, was the painting to which Vincent referred Albert Aurier when replying to Aurier's 1890 article (quoted on page 6). The *Still Life* (plate 29) illustrated, of the late summer of 1886, shows Vincent manipulating paint with all the bravado to be seen in any late Monticelli, but with his palette still relatively subdued. The succeeding influences, first of Impressionism and then of Signac and Neo-Impressionism, on his treatment of the paint and colours is plain in a flower piece of the next summer. The *Still Life: Fritillaries in a Copper Vase* (plate 30) shows him using paint to express the form of the flowers sculpturally, while describing the blue background, complementary to the orange of the flowers, in the pointillist (dotted) manner that he saw in Signac's work.

There was one artist who supplemented Theo's guidance during this metamorphosis: Pissarro, the benevolent father-figure of the Impressionists, mentor of Cézanne and Gauguin, was now starting to deal with Theo, and there was considerable respect between the two of them. Theo wrote of him to Vincent later, 'There you have old Father Pissarro, who notwithstanding everything has done very fine things recently, and in them you also find those qualities of rusticity which show immediately that man is more at ease in wooden shoes than in patent-leather boots.' (T16, 5 September 1889). And it was old Father Pissarro who observed later that he had felt very soon that Vincent 'would either go mad or leave all of us far behind. But I didn't know that he would do both.'[1]

The *Montmartre Quarry* (plate 31) of his first Paris October shows how his palette was visibly lightening, the space inside the picture frame airily expressed with freely applied strokes, light and bright. The choice of subject is reminiscent of the Dutch period, but Vincent is now moving towards the French method of impartial observation of a segment of a natural or urban

[1] John Rewald, *Post-Impressionism*, the Museum of Modern Art, New York, 1962, p. 77, note 36.

44

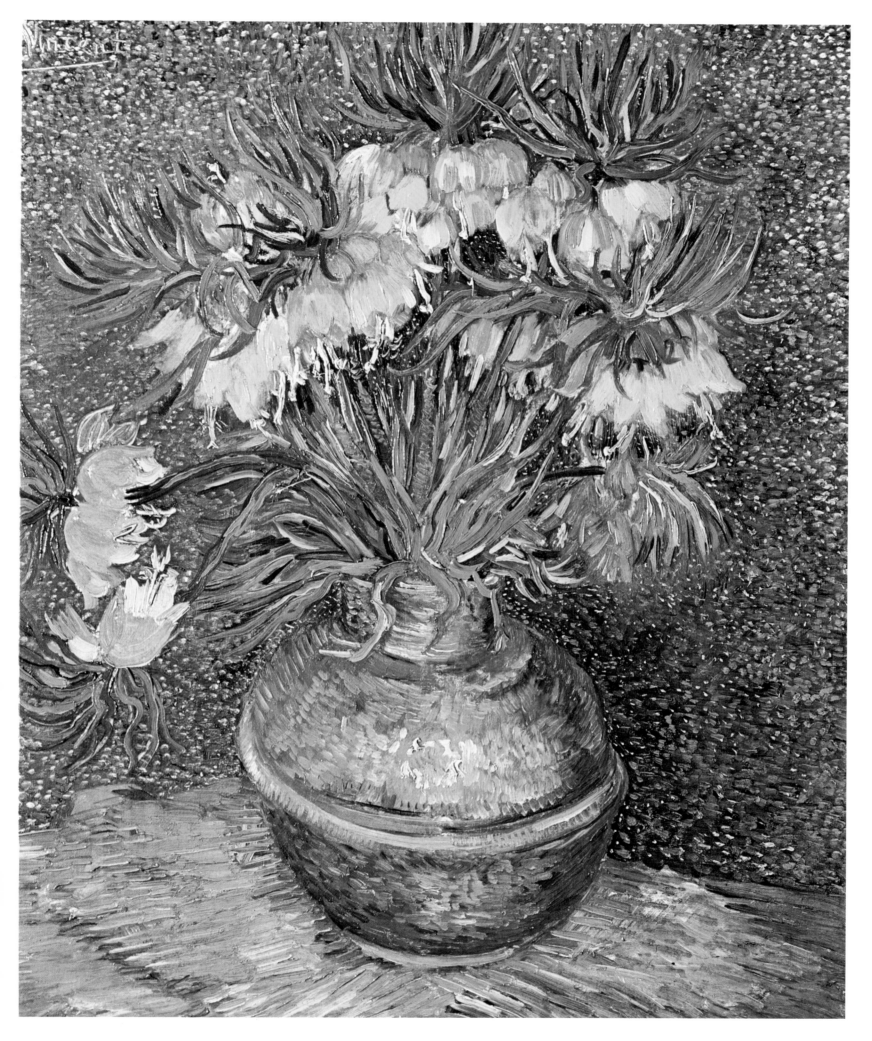

45

Plate 31
Montmartre: Quarry, the Mills F230
Paris, October 1886
oil on canvas
22 × 24½ in (56 × 62 cm)
Rijksmuseum Vincent van Gogh,
Amsterdam

Plate 32
**Two Self Portraits; fragments of a
third** F1378 recto
Paris, summer 1887
pen, pencil, ink
12½ × 9½ in (31.6 × 24.1 cm)
Rijksmuseum Vincent van Gogh,
Amsterdam

environment, and away from the close emotional and social
identification with the subject that proclaims his involvement with
his Dutch subjects overriding all his experiments with abstract
forms. The move from subjectivity to objectivity was
accomplished in Paris within six months: the peasant walking
along the road, spade on shoulder (plate 33) is a whole culture
away from the Nuenen *Reaper* (plate 17). In *Road with Peasant
Shouldering a Spade* the figure is an incidental part of the wider
landscape, a compositional ploy – the focus point defining the
perspective on the diagonal of the road as it pushes into the
picture space from left foreground to right background, the whole
composition expressed in the pointillist technique that revealed his
debt to the 'dotters'.

Undoubtedly, this trend away from overt subjectivity could not
have been so complete if Vincent had not continued the remark-
able group of Paris self-portraits. These were first of all a practical,
free means of making a prolonged series of figure studies when,
as usual, hiring models was far too expensive an addition to the
already high cost of essential materials. They were also an
extraordinary exercise in self-analysis and revealing to a brutal
degree. Without being over-fanciful, or indulging in the wilder
flights of dubious psychoanalytic examination, it is possible to see

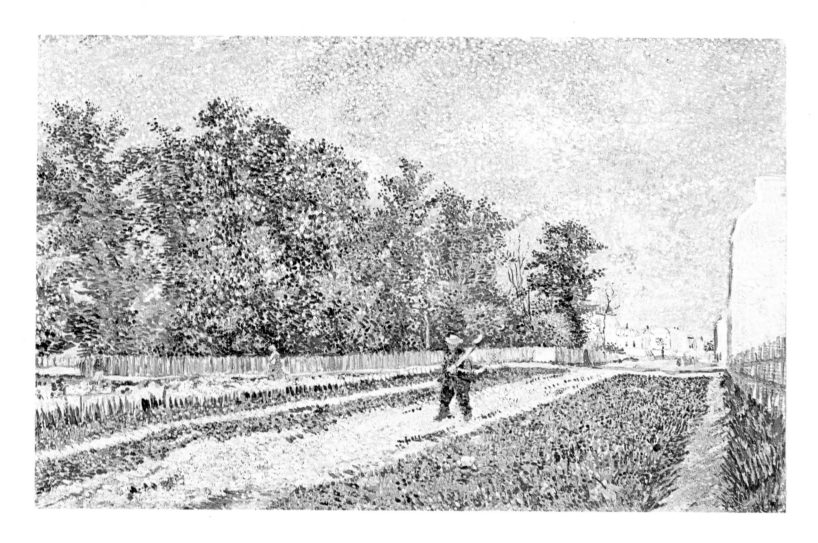

Plate 33
**Outskirts of Paris: Road with
Peasant Shouldering a Spade** F361
Paris, spring 1887
oil on canvas
19 × 28¾ in (48 × 73 cm)
Karen Carter Johnson Collection, Fort
Worth, Texas

in them both the personal and artistic consequences of Paris. The
central head in the sheet of working drawings (plate 32) from the
summer of 1887 is closely observed and the drawing accurate. He
used his pencil to describe the texture of the beard and hair, as well
as describing the form with the same marks. The over-emphasis of
nose and eyes is not clumsiness but repeated attempts to get them
right—as his details of the eye at the top right shows.

The 'dotters' had already enlisted Pissarro in their ranks, and
Vincent's meeting, at Père Tanguy's materials shop, with the
young lieutenant of the movement, Paul Signac, brought him into
personal contact with the theories of Divisionism. He met Seurat,
the chief theorist and most significant painter of Divisionism, and
went to his studio just once, immediately before his departure for
Arles, but Vincent's friendship with Signac was immediate and
close. Signac was ardent with a wild missionary fervour for
Divisionism, which antagonised and appalled the opposition—led
by Émile Bernard and Gauguin, also Vincent's friends. Signac and
Vincent worked together in and around Paris, and Signac recalled
later a typical excursion they made to Asnières: 'Van Gogh,
dressed in a blue workman's shirt, had painted little touches of
colour on his sleeves. Sticking close to me, he shouted, waved his
arms, brandishing his large, freshly-painted, size 30 canvas: and

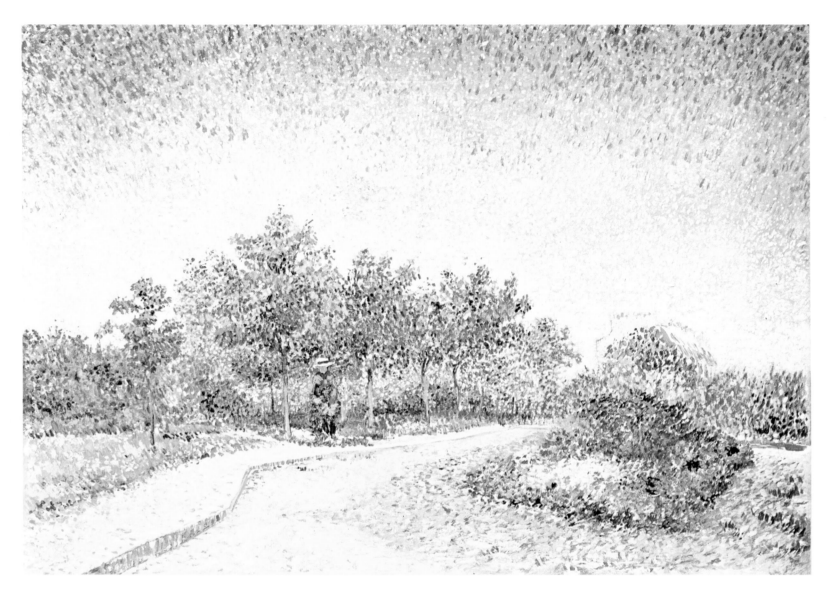

Plate 34
**Corner in Voyer-d'Argenson Park at
Asnières** F276
Paris, May 1887
oil on canvas
23¼ × 32 in (59 × 81 cm)
Yale University Art Gallery, New Haven
Gift of Henry R. Luce

[1] Gustave Coquiot, *Vincent Van Gogh*,
Librairie Ollendorff, Paris, 1923, p. 140

with it he polychromed himself and the passers-by.'[1]

The view of *The Park at Asnières* (plate 29) is one of half a dozen paintings where Vincent came closest to Neo-Impressionism; but he never committed himself to it wholeheartedly. Although he exploited their colour techniques, his compositions were always freer, the colours not strict complementaries: there are dozens of exuberantly coloured paintings of 1887 that proclaim his open-minded freedom – for instance, the watercolour drawing of the gateway (*Garden Entrance on a Sunny Day*, plate 35) in Montmartre, with its clear and intense colours anticipates the Arles watercolours (see *Boats on the Beach at Saintes-Maries*, plate 46). The association with Neo-Impressionism was vital to his growing understanding of colour, and these stylistic experiments which he undertook in Paris underlaid much of his future search for the ideal means of expression. From Arles in the summer of 1888, he wrote, 'As for stippling [Divisionist dots] and making haloes [areas of lighter tones painted around objects or figures and other things], I think they are real discoveries, but we must already see to it that this technique does not become a universal dogma any more than any

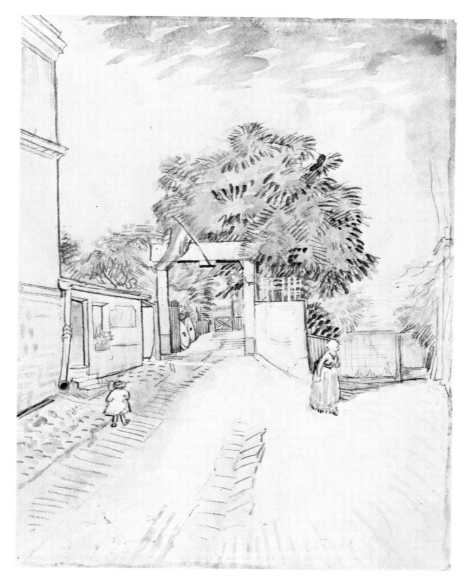

Plate 35
Garden Entrance on a Sunny Day F1406
Paris, summer 1887
black chalk and watercolour
12½ × 9½ in (31.5 × 24 cm)
Rijksmuseum Vincent van Gogh,
Amsterdam

other.' (528).

The second of the two dominant strands in Vincent's Paris experience was that represented by Gauguin, whom he met in November 1886, and his young associate Émile Bernard. The authoritative historian of the period, John Rewald, has described the relationship between Vincent and Gauguin: 'A strange friendship soon united the two, in spite of the cold purposefulness of the one and the boiling enthusiasm of the other. All they had in common was the belligerent character of their convictions. Gauguin began to show the certitude of one who has found his way and who has become used to being listened to; Van Gogh was animated with the ardour and humility of the devotee who, having witnessed wonders, feels growing in himself the fierce pride of new beliefs. Van Gogh readily recognised the superiority of Gauguin who was older than himself and who had known the Impressionists and participated in their struggles, but he could not possibly always agree with the extreme intolerance of Gauguin's views. Gauguin was very critical of Pissarro's recent work and must have taken pleasure in demolishing Van Gogh's respect for Seurat's theories.'[1]

[1] John Rewald, *op. cit.*, p. 41

Others who knew them could see this, and Vincent himself understood the violence of his own commitment: 'I cannot always keep quiet, as my convictions are so much part of myself that it is sometimes as if they took me by my throat.' (R57). Perhaps it was this that attracted Gauguin and Vincent to each other, and made inevitable too the tragedy of the following year in Arles. The young Émile Bernard had worked with Gauguin—a man who relished disciples—at Pont Aven in Brittany, but was spending time in Paris when he got to know Vincent during his first Paris winter at Père Tanguy's early in 1887. Again, there was an immediate attraction, they exchanged paintings and became close friends—Bernard filled the place left empty by Rappard. Perhaps there was something protective in Bernard's affection for the older man—he knew how abrasive Gauguin could be, and fully appreciated how vulnerable Vincent's degree of commitment made him. He also came to have a profound admiration for Vincent's work: three years after Vincent's death he wrote: 'Vincent has seen the sublime.' Bernard saw as the sublime element in art that ability to reveal the truths normally hidden; the sublime draws together sounds, colours and scents to a harmonious unity. 'It is the gift of analogy, of affinities, of penetration; it is—in a word—the gift of vision. Vincent van Gogh had that gift.'[1]

The interest all of them had in common was Japanese art. Since 1858, when Japan signed commercial treaties with England and France, there had been a steady flow to Europe of Japanese prints, porcelain and bric-à-brac. European fascination with the East was centuries old, but Japan, unlike China, had been relatively unknown. The influx of what the French called *japonaiserie* had an immediate impact at the end of the 1850s not only on the transient world of the fashionable, but also on artists, in Paris. Félix Bracquemond, the etcher, is reputed to have discovered the first prints, which had been used for wrapping imported porcelain, and within a few years a fashionable shop, La Porte Chinoise, had opened to sell them. The prints were by artists of the Ukiyo-e, 'floating world' school, and reflected the new Japanese urban culture of the 18th and 19th centuries, as well as rural Japan. The landscapists, Hokusai and Hiroshige, are the most famous of them, but there were many others, making prints of theatrical subjects, courtesans, and country scenes: artists like Sharaku, Utamaro, Kuniyoshi and Kiyonaga. They were essentially illustrators of popular life for the people, and their wood-cut prints, many of them superbly coloured, were sold in great numbers in Japan; it was ironic that many of the European aesthetes, like the Goncourt brothers, who took them up, would

[1] Emile Bernard, *Le Mercure de France*, April 1893, reprinted in *Lettres de Vincent Van Gogh à Emile Bernard*, Ambroise Vollard, Paris 1911, p. 47.

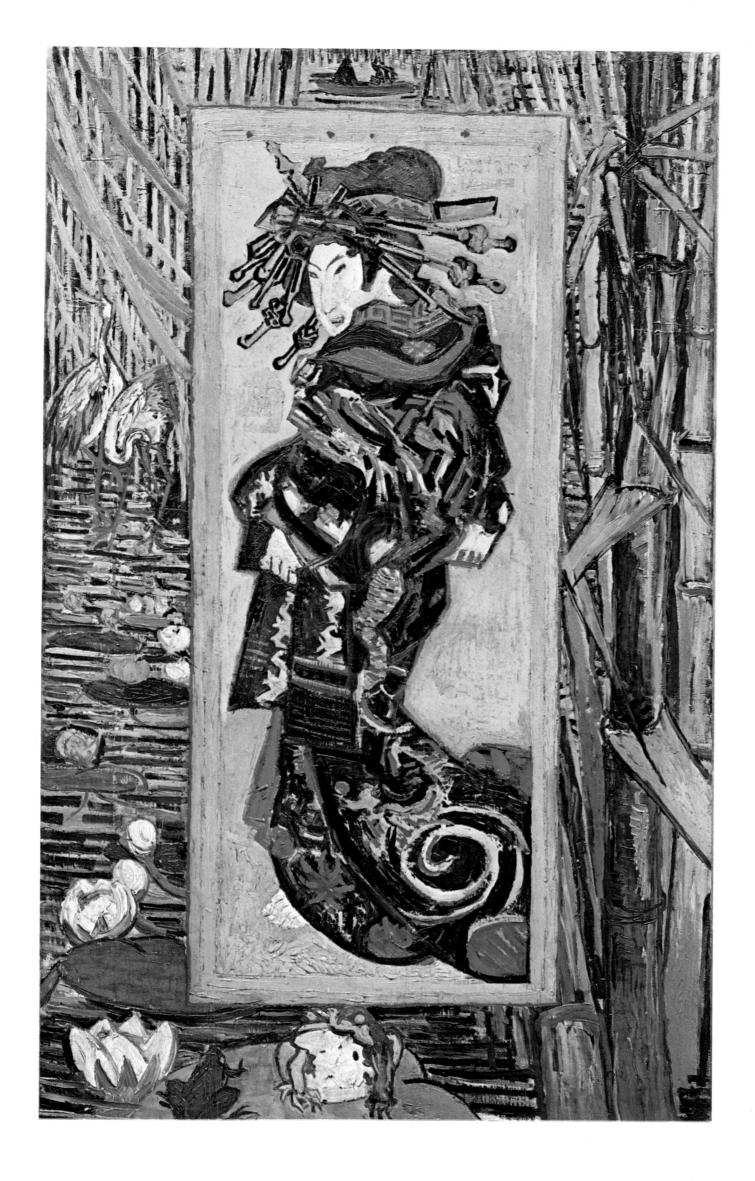

Plate 37
The Actor by Keisai Yeisen (1792–1848)
Paris Illustré, front page, May 1886

probably have been appalled by the discovery of their vulgar origins. During the 1860s and 1870s, Manet, Degas, Whistler and Monet led the avant-garde exploration of the revolutionary Japanese treatment of space and form. The prints showed a daring schematisation of perspective, abruptly interrupted lines cut by the picture edge, forms described by flat areas of subtle colour and defined by flowing calligraphic lines that took on abstract patterns on the paper. These were all immensely exciting to European artists brought up on the post-Renaissance tradition of the three-dimensional descriptive modelling of form, and most enterprising artists at least experimented with the techniques, while many were profoundly and permanently affected by them. Later there were exhibitions of the prints in Paris, and Bing's opened in the rue de Provence, crammed from cellar to attic with *japonaiserie*. These Vincent was allowed to explore, and he bought what he and Theo could afford, urging his friends to do the same: Bernard and Anquetin (his friend from Cormon's) were already enlisted, and their work at Pont Aven with Gauguin in the early stages of what came to be known as Synthetism showed clearly the influence of Japan. But Vincent cannot have failed to see such prints during his first stay in Paris, and had since read novels and illustrated magazine articles about the country. He had decorated his room in Antwerp with Japanese prints and had written to Theo from there, immediately after he arrived, of Antwerp and its docks: 'One of de Goncourt's sayings was: "Japonaiserie forever". Well, those docks are a famous Japonaiserie, fantastic, peculiar, unheard of – at least one can take this view of it. I should like to walk there with you, just to know whether we see alike. One could make everything there, city views – figures of the most varied character – the ships as the principal things, with water and sky a delicate grey – but above all – Japonaiserie. I mean, the figures are always in action, one sees them in the queerest surroundings, everything fantastic, and at all moments interesting contrasts present themselves.' (437, end of November 1885). The intriguing element in Vincent's admiration of the Japanese was the way in which he manipulated his interpretations according to his prevailing interest: in Antwerp the Japanese were associated with 'a delicate grey', but in Paris his translations of Japanese images – for instance the *Japonaiserie Oiran* (plate 36) of the summer of 1887 – are violent in their colour distortion, and by the time he reached Arles, he was ecstatic about what he saw as the Japanese quality of the light and colour in Provence. Discounting the fact that most of Japan is far from tropical, with long and bitter winters, Vincent associated Provence and the tropics with Japan and the strong clear colours of

Plate 38
Portrait of Père Tanguy F363
Paris, autumn 1887
oil on canvas
$36\frac{1}{4} \times 29\frac{1}{2}$ in (92×75 cm)
Musée Rodin, Paris

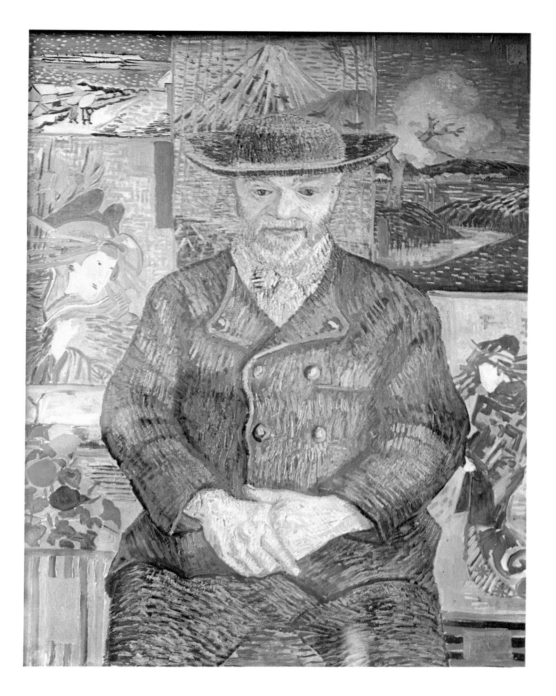

Japanese prints: soon after his arrival in Arles he wrote to his sister Wil: 'You will understand that nature in the South cannot be painted with the palette of Mauve, for instance, who belongs to the North, and who is, and will remain, a master of the grey . . . Only when making a choice one prefers sunny and colourful effects, and there is nothing that prevents me from thinking that in the future many painters will go and work in tropical countries. You will be able to get an idea of the revolution in painting when you think, for instance, of the brightly coloured Japanese pictures that one sees everywhere, landscapes and figures. Theo and I have hundreds of Japanese prints in our possession.' (W3).

The Oiran painting (plate 36) is a patchwork of images from at least four separate Japanese prints, but the central figure is traced (then doubled in size) directly from the front cover of a special Japanese number, published in May 1886, of the magazine *Paris*

Plate 39
Japonaiserie: the Bridge in the Rain
(after Hiroshige) F372
Paris, summer 1887
oil on canvas
$28\frac{3}{4} \times 21\frac{1}{4}$ in (73 × 54 cm)
Rijksmuseum Vincent van Gogh,
Amsterdam

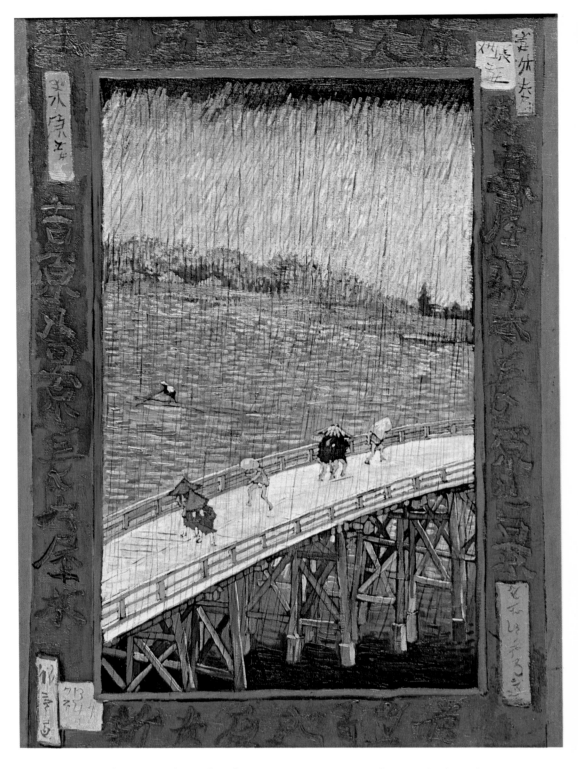

Illustré, which reproduced *The Actor* (an Oiran) by Keisai Yeisen (plate 37). Vincent's colour is applied violently, with a glutinous impasto that completely contradicts the flatness of the prints. The same actor figure reappears in the lower right-hand corner of the *Portrait of Père Tanguy* (plate 38), one of the two portraits Vincent painted of the old picture and paint dealer. Tanguy was a generous-hearted, simple man, an ardent revolutionary of the 1871 Commune – which had cost him two years in prison. He ran his own colour grinding business and sold paintings by his customers as a sideline; all the Impressionists had bought from him (often, when too poor, exchanging their

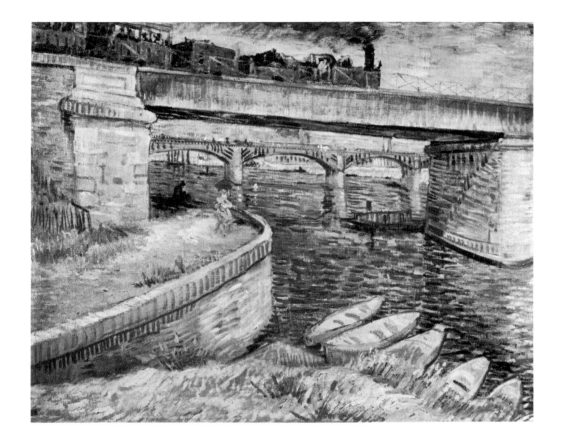

Plate 40
The Bridges at Asnières F301
Paris, summer 1887
oil on canvas
20½ × 25½ in (52 × 65 cm)
E. G. Bührle Collection, Zurich

paintings for more materials), and for much of his time in Paris Vincent bought Tanguy's colours and used his shop constantly. He met there Cézanne, Bernard and Signac; he saw Cézanne's paintings, of which Tanguy proudly owned an immense and unsaleable stock; and Vincent was one of the many young artists to whom Tanguy extended almost unlimited credit – subsidies contested at every step by what Vincent called his 'poisonous' old wife. He and Theo between them, at one time or another, were the principal financial supports of every significant Impressionist and Post-Impressionist painter in Paris during the 1870s and 1880s. In painting his portrait, Vincent has created an ambiguous and slightly uneasy image, imbuing the squat, benevolent Tanguy with echoes of an enigmatic, Buddha-like figure, pinned flatly against a wall papered with Japanese prints.

The most beautiful of Vincent's three direct copies of Japanese prints was *The Bridge in the Rain* (plate 39) after Hiroshige. In this tightly controlled reconstruction of Hiroshige's design, the paint application is much more sparing, the oxblood and forest green border framing a thickly, but never coarsely, painted scene. The rain is suggested by a screen of delicately scratched lines, and the whole treatment embodies what he felt were the greatest virtues of Japanese art. He was also integrating Japanese elements increasingly successfully into his observed landscapes: *The Bridges at Asnières* (plate 40) of that summer is, in fact, a skilful manipulation of perspective – the three arches of the further bridge are brought within view through the single arch of the railway bridge solely

Plate 41
Undergrowth F306
Paris, summer 1887
oil on canvas
12½ × 18 in (32 × 46 cm)
Museum van Baaren Foundation, Utrecht

to create a more satisfying geometric structure of two parallels surmounting a balanced trio of arches. The boats moored in the lower foreground push the eye into the picture space by their angle, which is parallel to the direction of the embankment wall at the left. Vincent was mastering the new visual vocabulary he had learnt from the Japanese.

So deeply committed was he to them that he had organised in the spring an exhibition of Japanese prints in a café called Le Tambourin, owned by an Italian ex-model known to the *habitués* as *La Segatori*. It was rumoured that she and Vincent had a brief affair–their relationship was certainly stormy, but she did provide him with valuable wall-space for his work. The largest exhibition Vincent arranged was in November 1887 at La Fourche, a huge restaurant along the boulevard de Clichy from Le Tambourin. Here Vincent showed with his paintings those of Bernard, Gauguin, Anquetin and Lautrec, whom he called the 'painters of the Petit Boulevard', as opposed to the 'painters of the Grand Boulevard'–the Impressionists.

There were one or two other small opportunities to show his work during this year, which also produced a number of works curiously anticipating images that appeared in the final two years of his life. Several paintings of undergrowth, notably that of *Undergrowth* now at Utrecht (plate 41), all done in the summer of 1887, prepare the eye for the obsessive observation of dense undergrowth in the hospital at St-Remy (see plate 36). *The Garden with Sunflower* (plate 42) is one of the rare occasions when Vincent painted a live, growing sunflower, and the only one in which the whole plant is seen—indeed, here the plant is gigantic and seems to threaten the defenceless little figure at the right, almost exploding out of the small canvas with its dynamic, sun-seeking life. Departing briefly from his increasing commitment to a closely-textured network of small brushstrokes, Vincent here has described the sunflower with generous sweeps of his brush. The most poignant example perhaps is the *Wheatfield with a Lark* (plate 43). It is lyrical and heartening, the whole scene, including the sky, freely painted—a windblown and idyllic forest of ripening wheat, but the foreground area of stubble betrays the presence of the reaper. For Vincent these images of growth, fruition and reaping had long been charged with symbolism—from The Hague in November 1882, he was already writing: 'Young corn has something inexpressibly pure and tender about it, which awakens the same emotion as the expression of a sleeping baby, for instance' (242); but Arles was to draw from him a much more oppressive interpretation of the image in paintings like *The Sower* (plate 61), which had their tragic culmination in the wheatfields of his last days.

This work of Vincent's continued because Theo made it possible by his presence and his support. However, the brothers were totally incompatible personalities when physically close, and every vestige of Theo's enormous generosity and patience was tried by Vincent's hopelessly selfish and singleminded demands. Both men were subject to ill-health—Theo through physical frailty, and Vincent through the privations to which he subjected himself deliberately. In June 1886, Theo's future brother-in-law wrote to his parents: 'Theo is still looking frightfully ill; he literally has no face left at all. The poor fellow has many cares. Moreover his brother is making life rather a burden to him, and reproaches him with all kinds of things of which he is quite innocent.' (426a). During their first winter together, 1886–7, Theo wrote to his youngest sister, 'My home life is almost unbearable. No one wants to come and see me any more because it always ends in quarrels, and besides, he is so untidy that the

Plate 42
The Garden with Sunflower F388 verso
Paris, summer 1887
oil on canvas
$16\frac{3}{4} \times 14$ in (42.5×35.5 cm)
Rijksmuseum Vincent van Gogh,
Amsterdam

Plate 43 (page 58)
A Wheatfield with a Lark F310
Paris, summer 1887
oil on canvas
$21\frac{1}{4} \times 25\frac{1}{2}$ in (54×64.5 cm)
Rijksmuseum Vincent van Gogh,
Amsterdam

room looks far from attractive. I wish he would go and live by himself. He sometimes mentions it, but if I were to tell him to go away, it would just give him a reason to stay; and it seems I do him no good. I ask only one thing of him, to do me no harm; yet by his staying he does so, for I can hardly bear it.' 'It seems as if he were two persons: one, marvellously gifted, tender and refined, the other, egoistic and hard-hearted. They present themselves in turns, so that one hears him talk first in one way, then in the other, and always with arguments on both sides. It is a pity that he is his own enemy, for he makes life hard not only for others but also for himself.' But when she told him to leave Vincent, Theo replied, 'It is such a peculiar case. If only he had another profession, I would long ago have done what you advise me. I have often asked myself if I have not been wrong in helping him continually, and have often been on the point of leaving him to his own devices . . . He is certainly an artist, and if what he makes now is not always beautiful, it will certainly be of use to him later; then his work will perhaps be sublime, and it would be a shame to have kept him from his regular study.'[1] With fluctuations of mood and fortune, this state of controlled tolerance existed for the entire two years in Paris, but during the winter of 1887–8, Vincent grew increasingly depressed by the wintry dullness of the city. While in Holland and the North, he had been content to make more drawings than paintings, but the flood of colour Paris had unleashed on him had completely reversed these proportions: about two hundred paintings and only fifty drawings survive from this period.

Paris had turned him into a colourist, and this bias continued in Arles, where he made twice as many paintings – almost two hundred – as drawings and watercolours – just over one hundred. It was clear that the overwhelming novelty of Paris had taken its toll of exhaustion, and he needed to escape and consolidate his new discoveries in peace in a warmer and brighter place, somewhere where he could paint outside all the year round and where the colours in nature were the ones he wanted to paint. He even considered Africa, but the brothers agreed that Arles, in the South of France, was a more practical solution. Theo wrote to his new fiancée later: 'In Paris he saw so many things which he liked to paint, but again and again it was made impossible for him to do so. Models would not pose for him and he was forbidden to paint in the streets; with his irascible temper this caused many unpleasant scenes which excited him so much that he became completely unapproachable and difficult, and at last he developed a great aversion for Paris.'[1]

[1] *Letters*, Introduction xli–xlii.

Arles

Vincent travelled to Arles on 20 February 1888, taking rooms at the Café de l'Alcazar, on a large open square immediately beside the station. He found the South a spiritual and aesthetic liberation from the increasing claustrophobia of Paris, which he had left 'very miserable, almost an invalid and almost a drunkard.' (544, 29 September 1888). In spite of the heavy snow he was filled with optimism, seeing the mountains around the plain of Arles in terms of the Japanese, nosing out Monticellis in antique shops and dealers', and trying to do business over them with the Scots dealer Alexander Reid. With a sigh of relief, he wrote to Theo: 'I have thought now and then that my blood is actually beginning to think of circulating, which is more than it ever did during that last period in Paris. I could not have stood it much longer.' (464, end of February 1888). In his first week there he had already done a portrait of an old Arles woman, a landscape in the snow and a pork-butcher's shop, explored the two main Arles museums, and settled into his temporary rooms.

He rapidly discovered that the surrounding country was arrestingly beautiful in its state of spring budding, with some striking man-made additions, notably the Langlois bridge (plate 44). In this unfamiliar landscape, he found in the bridge a reassuring echo of the structure of the old Dutch looms and canal draw-bridges. He made five oil versions (four of which survive complete), a watercolour and two pen drawings – a typically thorough working-over, giving him complete mastery of his subject and sureness about the composition. He worked with the perspective frame he had made himself, and combined with it an acute awareness of his place in the history of European art: 'I attach some importance to the use of the frame because it seems not unlikely to me that in the near future many artists will make use of it, just as the old German and Italian painters certainly did, and, as I am inclined to think, the Flemish too. The modern use of it may differ from the ancient practice, but in the same way isn't it true that in the process of painting in oils one gets very different effects

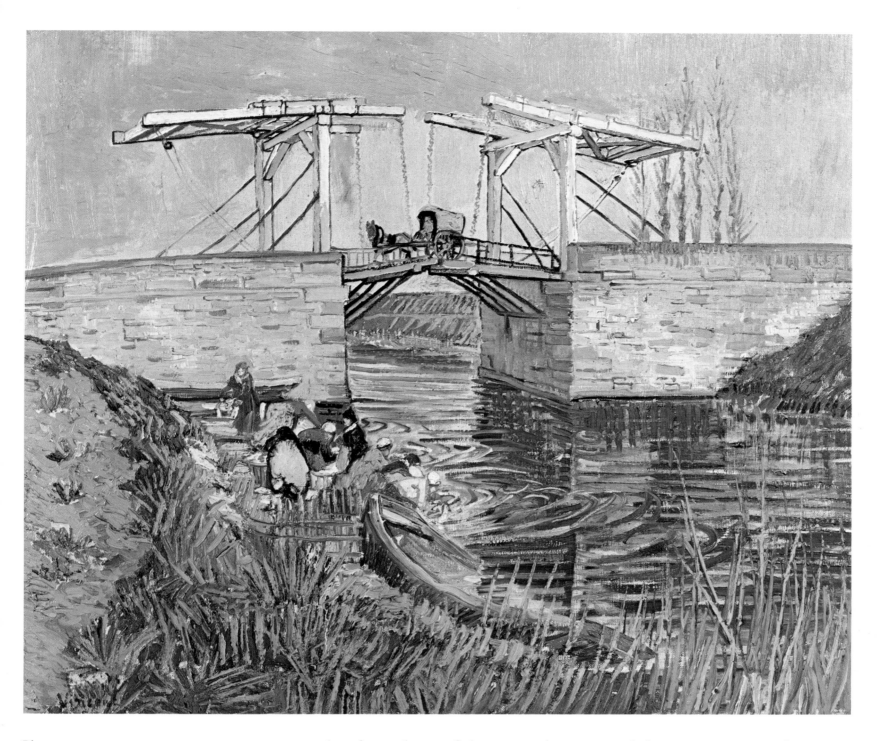

Plate 44
The Langlois Bridge with Women Washing F397
Arles, March 1888
oil on canvas
21¼ × 25½ in (54 × 65 cm)
Rijksmuseum Kröller-Müller, Otterlo

today from those of the men who invented the process, Jan and Hubert van Eyck? And the moral of this is that it's my constant hope that I am not working for myself alone. I believe in the absolute necessity of a new art of colour, of design, and – of the artistic life. And if we work in that faith, it seems to me there is a chance that we do not hope in vain.' (469, about 17 March 1888). The version of *The Langlois Bridge* reproduced here is the most complete expression so far of his new art of colour, with complementaries, particularly blue and orange, offsetting each other with dazzling, though not strictly Divisionist, effect. The outlining of some forms with thick, sure strokes, often of Prussian blue, was used not only to suggest shadow in a formal way, but also as a device to emphasise the abstract nature of some of the

Plate 45
**Pink Peach Tree in Blossom
(Souvenir de Mauve)** F394
Arles, March 1888
oil on canvas
28¾ × 23½ in (73 × 59.5 cm)
Rijksmuseum Kröller-Müller, Otterlo

forms and lines he was creating. This was derived again from the Japanese, and became one of his regular technical devices.

The spring threw him into a frenzy of activity – 'I'm up to my ears in work, for the trees are in blossom and I want to paint a Provençal orchard of astounding gaiety' (473, about 1 April 1888) – but it was saddened by news of the death of his cousin and old teacher, Anton Mauve. He painted a *Souvenir de Mauve* (plate 45) for Mauve's widow Jet with a depth of feeling that is surprising in view of the history of their relationship in The Hague. But, once Vincent had recovered from the immediate effects of the quarrel, he always spoke of Mauve with great respect; writing to Theo in April, he said, 'Mauve's death was a terrible blow to me. You will see that the pink peach trees were painted with a sort of passion.' (474). Vincent was forming the rapidly gathering numbers of orchard paintings – of pear, plum, apricot, and almond blossom as well as peach – into series of three, and the religious implications of the triptych show that he was quite deliberately treating what had been a frequent Impressionist subject (Monet's especially) with an emotional symbolism that took him far beyond and outside their terms of reference. The intricate patterning of branches against the sky in many of them is a direct homage to Japan, and he wrote to Theo, Émile Bernard and his sister of his excitement at the discovery of the Japanese qualities of light and form that he discerned in the South. His description to Bernard of his methods while working in the orchards in March and April reveals his determination to paint what he saw with as direct an observation as possible, ignoring forced academic formalisation: 'Working directly on the spot all the time, I try to grasp what is essential in the drawing – later I fill in the spaces which are bounded by contours – either expressed or not, but in any case *felt* – with tones which are also simplified, by which I mean that all that is going to be soil will share the same violet-like tone, that the whole sky will have a blue tint, that the green vegetation will be either green-blue or green-yellow, purposely exaggerating the yellows and blues in this case.' (B3). The filling-in of contours with simplified tones directly relates to his feelings for the Japanese, and this dominated his work during the rest of the year. A temporary crisis when he ran out of paint forced him to draw while he waited for Theo to shop for his large order in Paris. He felt guilty for deserting old Tanguy, and wrote to Theo rather despondently, 'he's such a funny old soul, and I still think of him many a time. . . . Oh! it seems to me more and more that *people* are the root of everything, and though it will always be a melancholy thought that you yourself are not in real life, I mean, that it's more worth-

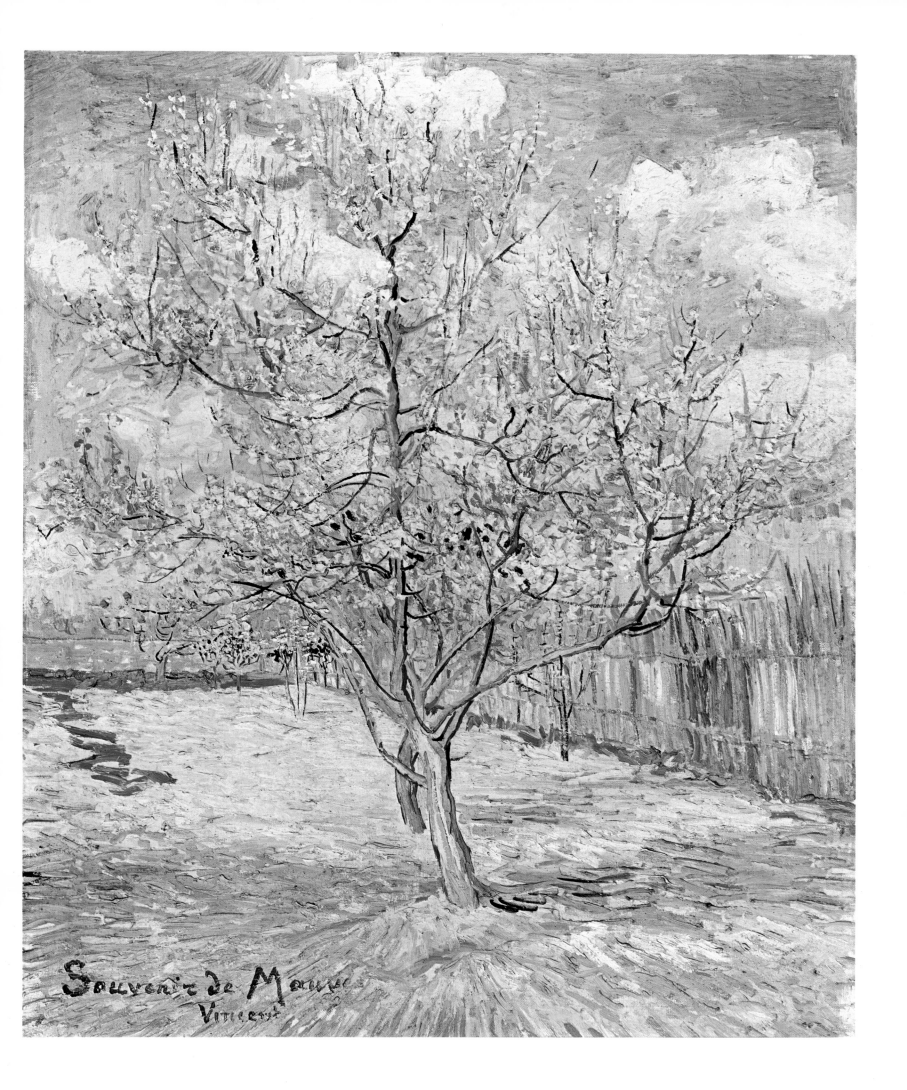

Souvenir de Mauve
Vincent

63

while to make children than pictures or carry on business, all the same you feel that you're alive when you remember that you have friends who are outside real life as much as you.' (476, 10–14 April 1888). This despondency was probably affected by his constant ill-health, the lifelong punishment he had inflicted on his body – eating badly if at all, drinking too much in Paris – was bringing him frequently near to collapse. This state of affairs, cliché though it has now become, was only too common amongst artists and he wrote rebelliously to Theo, soon after his arrival in Arles, 'My God! Shall we ever see a generation of artists with healthy bodies! Sometimes I am perfectly furious with myself, for it isn't good enough to be either more or less ill than the rest; the ideal would be a constitution tough enough to live till eighty, and besides that, blood in one's veins that would be right good blood.' (467, during 4–9 March). His letters to Bernard are dotted with bulletins on the state of his stomach (he must surely have had a severe ulcer as he often could keep no food down) – 'If I have any advice to give you it is to fortify yourself, to eat healthy things, yes, a full year in advance.' (B4, about 20 April 1888). These exhortations were all part of his campaign to persuade Bernard, Gauguin and other sympathetic artists to come to Arles and fulfil his cherished project of a 'Studio of the South'. He rationalised his personal need for support and companionship in ambitious terms in June: 'More and more it seems to me that the pictures which must be made so that painting should be wholly itself, and should raise itself to a height equivalent to the serene summits which the Greek sculptors, the German musicians, the writers of French novels reached, are beyond the power of an isolated individual; so they will probably be created by groups of men combining to execute an idea held in common. One may have a superb orchestration of colours and lack ideas. Another one is cram-full of new concepts, tragically sad or charming, but does not know how to express them in a sufficiently sonorous manner because of the timidity of a limited palette. All the more reason to regret the lack of corporative spirit among the artists, who criticize and persecute each other, fortunately without succeeding in annihilating each other. You will say that this whole line of reasoning is banal – so be it! However, the thing itself – the existence of a renaissance – this fact is certainly no banality.' (B6, second half of June 1888). Throughout his adult life he had admired the collective action of artists, while remaining totally incapable of it himself. In Holland he had expressed his respect and envy for the artists of the English illustrated magazine *The Graphic*, who co-operated with each other over models and

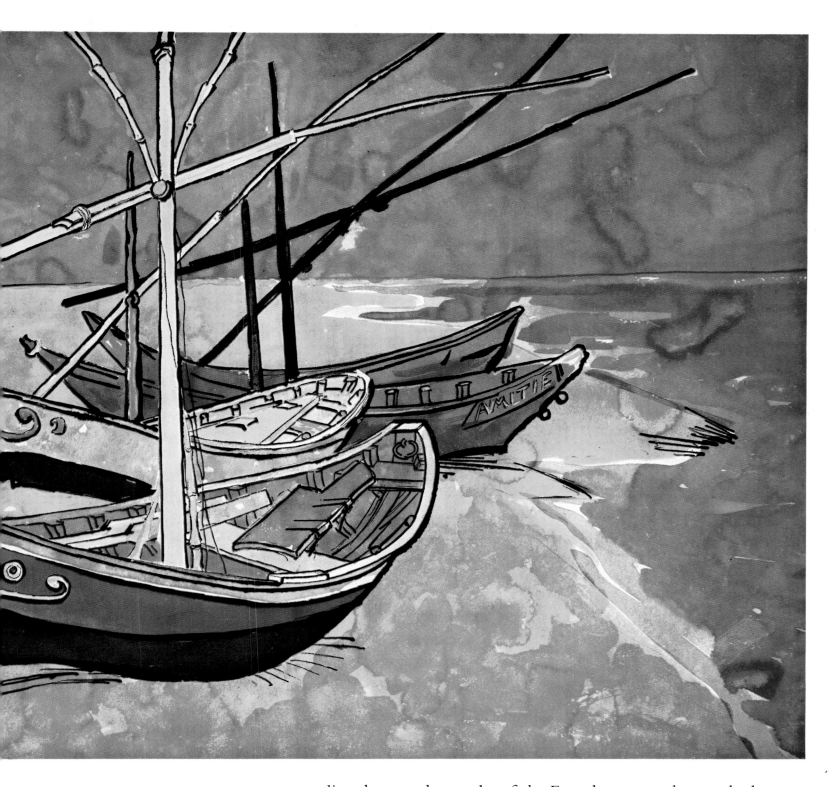

Plate 46
Boats on the Beach at Saintes-Maries
F1429
Arles, June 1888
watercolour
$15\frac{1}{4} \times 21\frac{1}{4}$ in (39×54 cm)
Bernhard Köhler, Berlin

studios; he saw the results of the French group who worked at Barbizon, in the Forest of Fontainebleau outside Paris, whose most revered member was Vincent's god, Millet; he knew the members of the closely linked Hague School personally; and in Paris he saw the Impressionists and their young successors. And he envied them all. However, it was the group that formed around Gauguin at Pont Aven in Brittany that probably gave him the greatest incentive to form his own community. This need was reinforced by the reception he got from the local Arles people. Vincent revelled in the, to him, novel and foreign curiosities of the town, but the people tended to be reserved with him, and he suspected

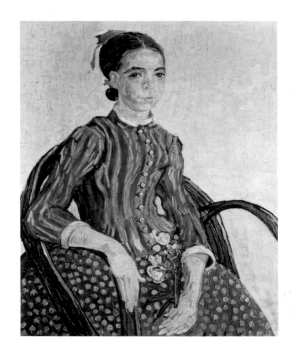

Plate 47
La Mousmé F431
Arles, July 1888
oil on canvas
29¼ × 23½ in (74 × 60 cm)
National Gallery of Art, Washington,
Chester Dale Collection

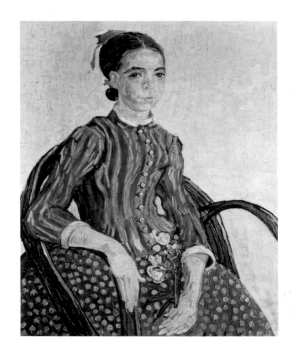

[1] Soldiers of the French light infantry
regiment known as the Zouaves, originally
recruited in Algeria.

them of overcharging for everything and of being deliberately
unhelpful. The problem was, quite simply, that he was lonely –
'Must I tell the truth and add that the Zouaves[1], the brothels, the
adorable little Arlésiennes going to their first Communion, the
priest in his surplice, who looks like a dangerous rhinoceros, the
people drinking absinthe, all seem to me creatures from another
world? That doesn't mean that I'd feel at home in an artistic
world, but that I would rather fool myself than feel alone. And I
think I should feel depressed if I did not fool myself about
everything.' (470, March 1888). These first impressions changed
little during the summer.

April and May were occupied with the orchard series and studies
of the country around Arles. There were visits from a young
Danish and an American painter, and he moved into rented rooms
in the Place Lamartine, just round the corner from the station,
facing the north end of the public park. His letters to Theo were
now filled with practical problems of furnishing the rooms,
brotherly advice about Theo's fragile health, and determination
for the future.

Six days in June spent at Saintes-Maries-de-la-Mer, on the coast
of the Camargue, the marshy area directly to the south of Arles,
produced an intensification of his Japanese style. He had already
written to Theo of Arles, 'A little town surrounded by fields all
covered with yellow and purple flowers; exactly – can't you see
it? – like a Japanese dream' (487, about 12 May 1888), but
Saintes-Maries proved more fruitful still. He went with the
intention of working on his drawings – 'Things here have so much
line. And I want to get my drawing more spontaneous, more
exaggerated.' (495, 9 June 1888). Even in April he was writing of
his need 'to make some drawings in the manner of Japanese prints'
(474), but even he could not have anticipated the explosion of
line and colour that was triggered in his work by the
Mediterranean. The watercolour drawing, painted back in Arles,
from a drawing made on his last morning at the sea, of *Boats on
the Beach at Saintes-Maries* (plate 46) ripples with the explosive
energy of the violent blue-orange colour contrast, while the
geometry of masts and bamboo poles holds the barbaric-looking
boats pinned down to the paper. He must have astonished
himself by his power with the newly acquired watercolours, as
the oil painting (also done on his return to Arles) of the same
subject, is a much paler, almost muddily painted reflection of his
vision of the boats, visually closer to a Paris work like *The Bridges
at Asnières* (plate 40). From Saintes-Maries he wrote to Theo:
'Now that I have seen the sea here, I am absolutely convinced

of the importance of staying in the Midi, and of positively piling it on, exaggerating the colour – Africa not so far away' (500, about 23 June 1888), so the oil version of the *Boats* can be seen as a brief loss of resolve which immediately afterwards firmed again.

This conviction shows vividly in the tense, arched forms in *La Mousmé* (plate 47), of the following month, July. As was his common practice, he made several drawings of the model and of the exact composition – in this case two compositional studies, and at least one study of the girl – but it is the extraordinary back and arms of the chair that dominate the image. From the contemporary portrait of the Postman Roulin seated in what is obviously the same chair, one can see that Vincent has greatly exaggerated the lines in *La Mousmé*, so emphasising the youth and relative fragility of the girl. A *mousmé* is an attendant in a Japanese teahouse, something which he had read about in Pierre Loti's *Madame Chrysanthème*, and this unusual near-illustration of a literary theme allowed him the intellectual freedom to manipulate the observed forms into partially abstracted forms. He later wrote to Bernard that 'abstraction seemed to me a charming path. But it is enchanted ground, old man, and one soon finds oneself up against a stone wall.' (B21, beginning of December 1889). He blamed Gauguin, who joined him three months later, for his dangerous involvement with abstraction (and the attendant threat of loss of contact with nature), thus absolving himself, but it is

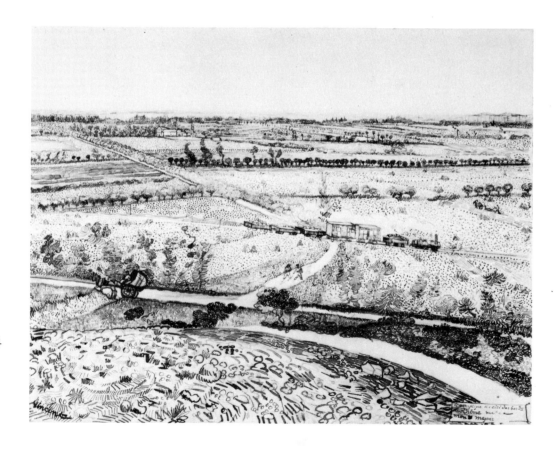

Plate 48
**Landscape near Montmajour, with the
Little Train from Arles to Orgon** F1424
Arles, July 1888
reed pen and black chalk
19¼ × 24 in (49 × 61 cm)
The Trustees of the British Museum,
London

clear from many paintings of the summer of 1888, before Gauguin's arrival, that Vincent was already experimenting with abstraction, influenced by his contacts in Paris with Bernard and Signac, but above all by his love for the Japanese.

A pen drawing of the same month as *La Mousmé*, one of a series taken from the hill of the ruined abbey of Montmajour (plate 48), bears detailed analysis of his debt to the Japanese. There are the faintest pencil marks of an underdrawing, probably done on the spot, and these are covered in a dense curtain of pen marks. He described how he used very thick reed pens for the foreground, and a finer quill pen for the background, and this simple technical device gives an atmospheric distance that achieved exactly the effect of infinity from a bird's-eye view that he was after. Vincent wrote to Bernard, 'It does not have a Japanese look, and yet it is really the most Japanese thing I have done; a microscopic figure of a labourer, a little train running across the wheat field – this is all the animation there is in it.' (B10). By structuring the drawing with four independent directions of movement (the cart, two walkers, train and ploughman), he has contrived a very specific moment in time that is impossible (or at least unlikely) but gives an *impression* of a particular moment. There is a complex counter-point between the precisely balanced axes of movement, as there is between the densely marked land and the totally blank sky.

The tiny little figure at the right of the Montmajour drawing is ploughing: Vincent found the pull of the seasonal cycle irresistible when he was in the country, surrounded by the evidence of haystacks, ploughing and sowing. He recorded it all here with an emotional involvement that transcended the earthiness of his Nuenen work, and created a devotional hymn to the Seasons comparable with any of the great Renaissance allegorical paintings. Although in the painting of *Haystacks in Provence* (plate 49) he modified the writhing pen strokes of the preparatory drawing, there is still enormous vitality in the mounds of hay, and the precipitously sloping foreground threatens to slide them out of the painting at us. Farmyard haystacks were an attractive theme, but Vincent himself knew what vital forms he had created – 'The last canvas absolutely kills all the others.' (497, 12 June 1888). He intended it as a pair to a landscape with cornfields, and remarked to Theo that the pair was similar to two of his Montmartre landscapes that had been shown at the Salon des Indépendants earlier in the year, after Vincent's arrival in Arles. Clearly, Vincent was aware of his growing tendency to play with the foreground perspective in his paintings, creating this kind of slipway that promises to slide down and out of the frame.

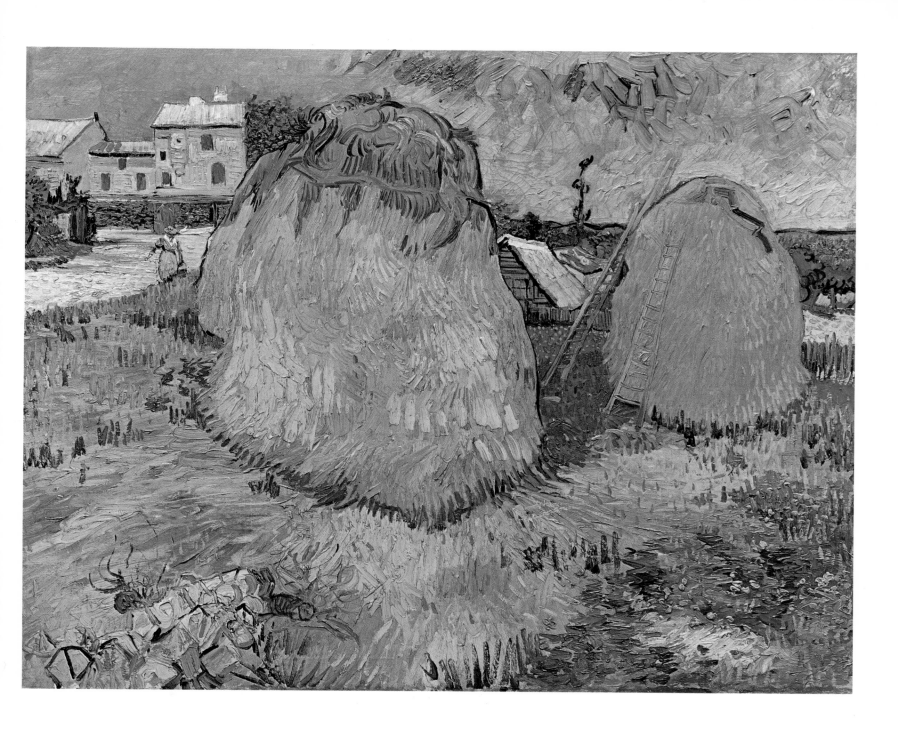

Plate 49
Haystacks in Provence F425
Arles, June 1888
oil on canvas
$28\frac{3}{4} \times 36\frac{1}{2}$ in (73 × 92.5 cm)
Rijksmuseum Kröller-Müller, Otterlo

[1] The plain of Arles.

His study of old *Patience Escalier* (plate 50), 'a sort of "Man with a hoe", formerly cowherd of the Camargue, now gardener at a house in the Crau'[1] (520, 11 August 1888), was part of his continuing involvement with the land. He was very much aware of the links with his Nuenen work; he wanted to set the Escalier portrait beside a Toulouse-Lautrec painting of Parisian night-life because 'it really is a pity that there are not more pictures *en sabots* [in clogs] in Paris . . . and . . . my picture would gain by the odd juxtaposition, because that sun-steeped, sunburned quality, tanned and air-swept, would show up still more effectively beside all that face powder and elegance.' However, he was also aware of his progress, led by Delacroix's colour theories rather than by those of the Impressionists, towards a symbolic use of colour— 'instead of trying to reproduce exactly what I have before my

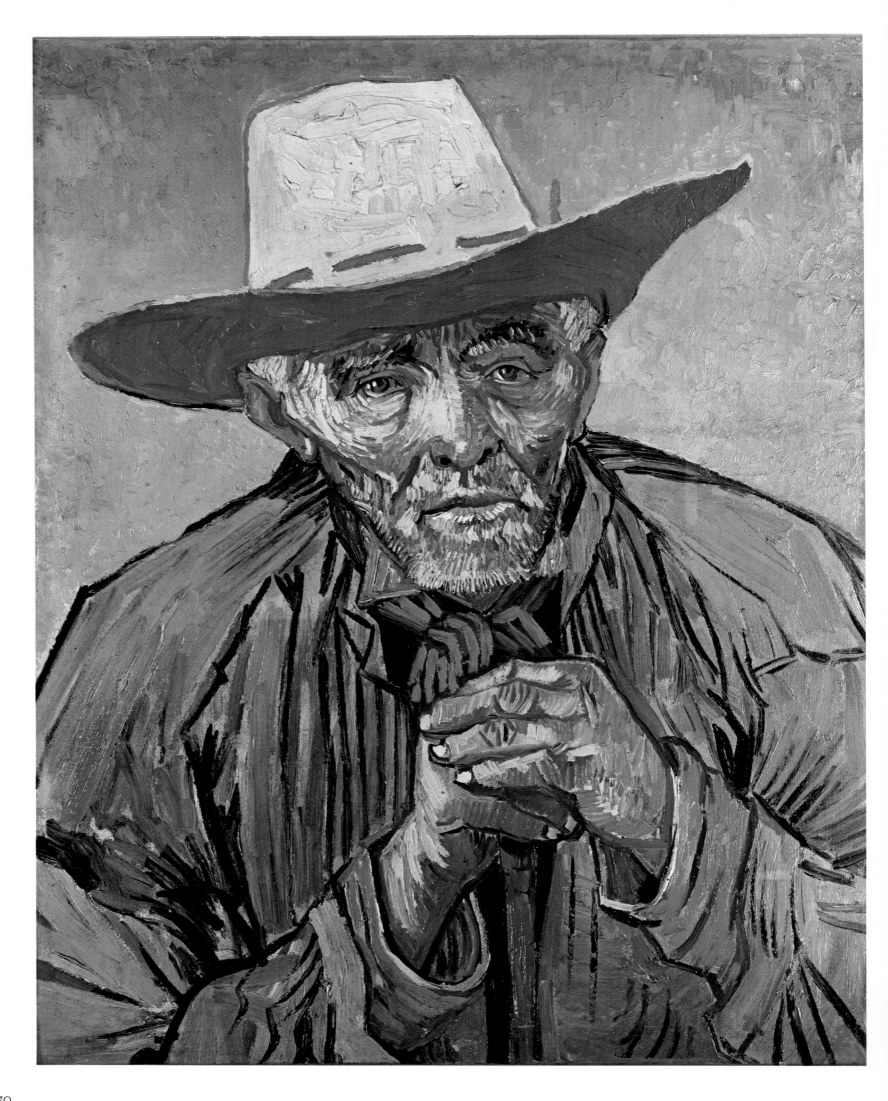

Plate 50
Portrait of Patience Escalier, Shepherd in Provence F444
Arles, August 1888
oil on canvas
$27\frac{1}{4} \times 22$ in (69×56 cm)
Private collection

Plate 51
Portrait of Eugène Boch, a Belgian Painter
(The Poet) F462
Arles, September 1888
oil on canvas
$23\frac{1}{2} \times 17\frac{3}{4}$ in (60×45 cm)
Musée du Louvre, Paris

[1] Portrait of Eugène Boch, a Belgian painter (plate 51).

eyes, I use colour more arbitrarily, in order to express myself forcibly.' This meant that he had to move on to paint a less prosaic subject than a rustic shepherd and gardener, and he went on, 'I should like to paint the portrait of an artist friend, a man who dreams great dreams, who works as the nightingale sings, because it is his nature.[1] He'll be a blond man. I want to put my appreciation, the love I have for him, into the picture. So I paint him as he is, as faithfully as I can, to begin with. But the picture is not yet finished. To finish it I am now going to be the arbitrary colourist. I exaggerate the fairness of the hair, I even get to orange tones, chromes and pale citron-yellow. Behind the head, instead of painting the ordinary wall of the mean room, I paint infinity, a plain background of the richest, intensest blue that I can contrive,

71

Plate 52
Still Life: a Pair of Shoes F461
Arles, August 1888
oil on canvas
$17\frac{1}{4} \times 20\frac{3}{4}$ in (44 × 53 cm)
S. Kramarsky Trust Fund, New York

Plate 53
Self Portrait (dedicated to Paul Gauguin)
F476
Arles, September 1888
oil on canvas
$24\frac{1}{2} \times 20\frac{1}{2}$ in (62 × 52 cm)
Courtesy of the Fogg Art Museum, Harvard
University, Cambridge, Massachusetts
Bequest: Collection of Maurice Wertheim,
Class of 1906

and by this simple combination of the bright head against the rich blue background, I get a mysterious effect, like a star in the depths of an azure sky. Again, in the portrait of the peasant I worked this way, but in this case without wishing to produce the mysterious brightness of a pale star in the infinite. Instead, I imagine the man I have to paint, terrible in the furnace of the height of harvest-time, as surrounded by the whole Midi. Hence the orange colours flashing like lightning, vivid as red-hot iron, and hence the luminous tones of old gold in the shadows. Oh, my dear boy . . . and the nice people will only see the exaggeration as a caricature.' (520). The portrait of the poet was realised at the beginning of September, using as model a young Belgian Impressionist painter, Eugène Boch. It was perhaps their long talks together about the 'great advantage it would be to us if we could *move* now North, now South' (531, 3 September 1888) added to the effects of his painting of the old shepherd that brought him back to an old still-life theme. *The Pair of Shoes* (plate 52) looks back to the series of battered old boots painted in Paris, and the whole image is one inescapably associated with travel – weary travel at that. The decrepit old shoes are the epitome of ordinariness and as such were one of the hardest tasks Vincent could have set himself to paint: everyday objects, including one's own face, are the hardest of all to observe afresh.

From the middle of August he also began his series of paintings of sunflowers (plate 1) – 'I am hard at it, painting with the enthusiasm of a Marseillais eating bouillabaisse.' (526, about 23 August 1888). Vincent's interest in the image was obsessional, and he intended to decorate the studio he planned to share with Gauguin entirely with at least six paintings of sunflowers in a vase, some with twelve and some with fourteen heads. He remembered the sunflowers he had seen and painted in Paris (see plate 42), but these Provençal sunflowers took on a monstrous life that was entirely Southern, twisting in their bowl, some dead and some aggressively alive. In a way, they reflected his own schizophrenic attitude to the South and its sun – he loved the 'blessed warmth' of the 'good god sun', but 'the devil mistral' (the penetrating and exhausting prevailing wind of Provence) wore down his nervous energy. The *Sunflowers'* high-pitched colour is common to all the paintings of the late summer, but the *Self Portrait* (plate 53) which Vincent exchanged with Gauguin's has an intensity that sets it apart. Gauguin and Bernard had sent Vincent their self-portraits; he responded with this portrait of himself as an ochre-toned ascetic, his head encircled with a light-filled halo of acid green curved strokes. The implication in his letter to Gauguin describing

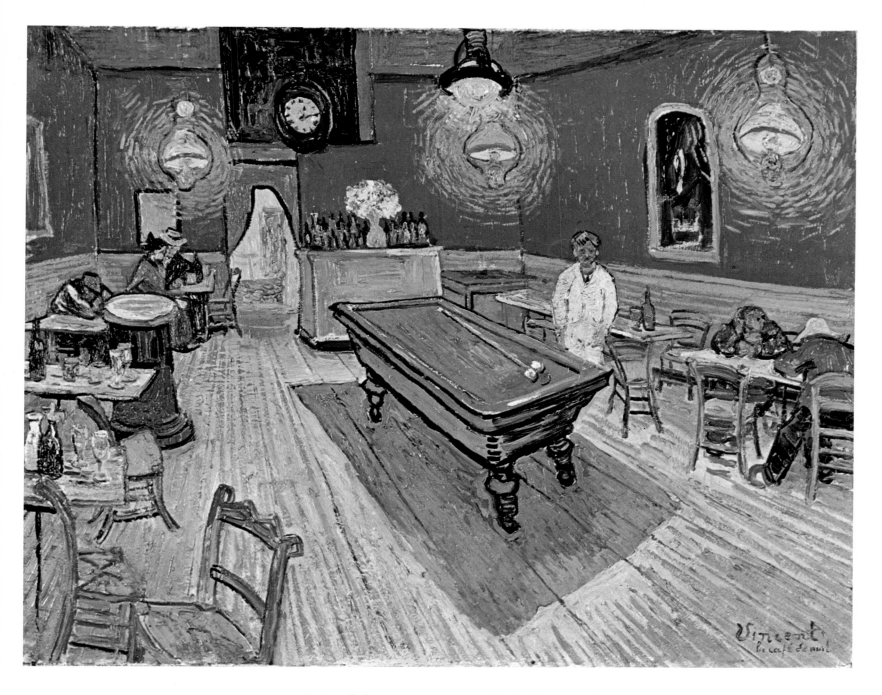

Plate 54
The Night Café on the Place Lamartine, Arles
(now Café de l'Alcazar) F463
Arles, September 1888
oil on canvas
27½ × 35 in (70 × 89 cm)
Yale University Art Gallery, New Haven, Bequest of Stephen Carlton Clark

it is of the penitent in sackcloth and ashes, awaiting the absolution of the Master: 'I have a portrait of myself, all ash-coloured. The ashen-grey colour that is the result of mixing malachite green with an orange hue, on pale malachite ground, all in harmony with the reddish-brown clothes. But as I also exaggerate my personality, I have in the first place aimed at the character of a simple bonze worshipping the Eternal Buddha. It has cost me a lot of trouble, yet I shall have to do it all over again if I want to succeed in expressing what I mean. It will even be necessary for me to recover somewhat more from the stultifying influence of our so-called state of civilisation in order to have a better model for a better picture.' (544a, about 29 September 1888).

The 'bonze' (actually a Buddhist monk) had just completed a painting of the all-night café where he ate (plate 54) and he wrote to Theo, 'the picture is one of the ugliest I have done. It is the

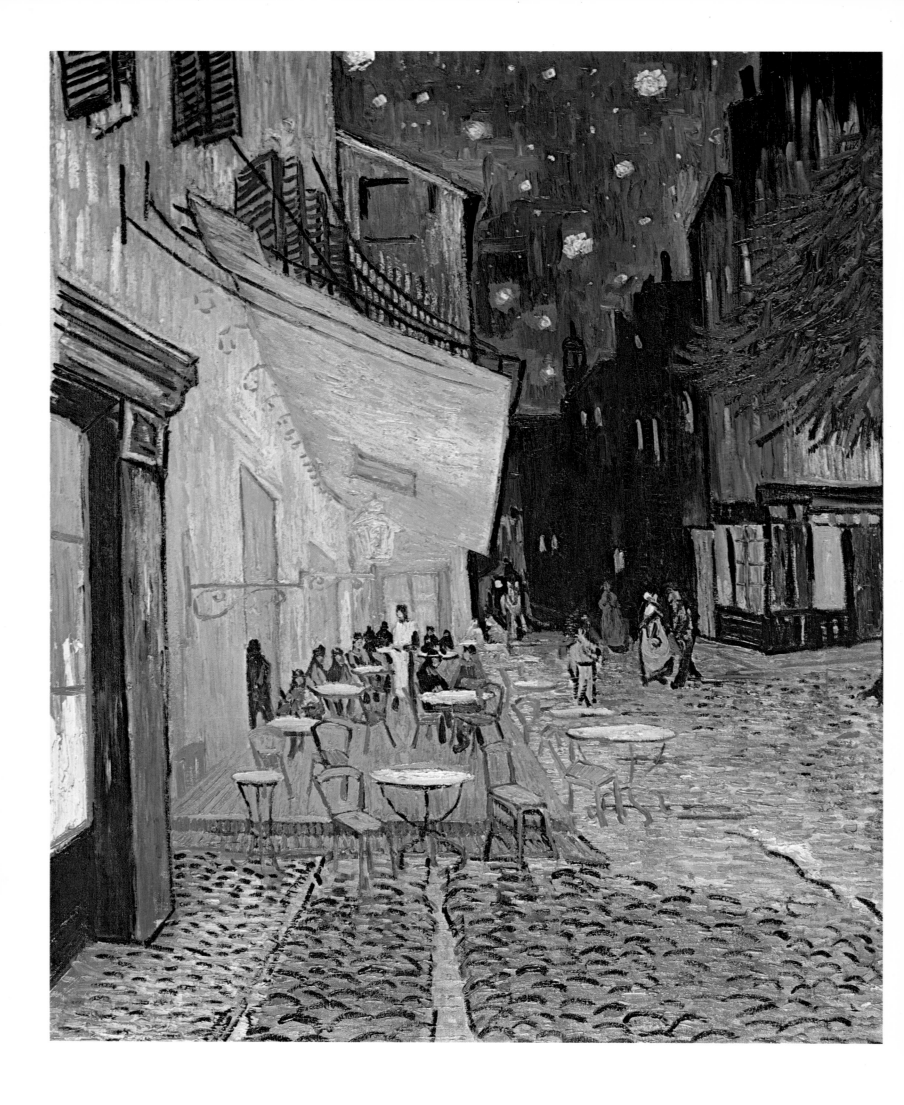

Plate 55
The Café Terrace on the Place du Forum, Arles, at Night F467
Arles, September 1888
oil on canvas
32 × 25¾ in (81 × 64.5 cm)
Rijksmuseum Kröller-Müller, Otterlo

[1] Vincent's old manager at Goupil's.
[2] Transl. from *Verzamelde Brieven van Vincent Van Gogh*, Wereldbibliotheek, Amsterdam, 1953.

equivalent, though different, of *The Potato Eaters* [plate 20]. I have tried to express the terrible passions of humanity by means of red and green.' (533, 8 September 1888). The colour was a deliberate distortion of reality, because, as his next letter said, 'I have tried to express the idea that the café is a place where one can ruin oneself, go mad or commit a crime. So I have tried to express, as it were, the powers of darkness in a low public house, by soft Louis XV green and malachite, contrasting with yellow-green and harsh blue-greens, and all this in an atmosphere like a devil's furnace, of pale sulphur. And all with an appearance of Japanese gaiety . . . But what would Monsieur Tersteeg[1] say about this picture when he said before a Sisley—Sisley, the most discreet and gentle of the impressionists—"I can't help thinking that the artist who painted that was a little tipsy." If he saw my picture, he would say that it was delirium tremens in full swing.' (534, 9 September 1888). The 'appearance of Japanese gaiety' would be more appropriate applied to the charming painting of *The Café Terrace on the Place du Forum at Night* (plate 55), a complete contrast with the sulphurous *Night Café* interior. Although Vincent wrote of 'the powers of darkness in a low public house', he was emphatic that the café was nothing to do with a brothel. He had described for Bernard one of his visits to a brothel, made in April, and wrote of the bright colours of the women's clothes as 'everything that's most complete and most garish'[2] (B4, about 20 April 1888), it would be legitimate to apply his views on the purity of the prostitutes' gaudy colours symbolically to the night café and its 'poor wanderers' (W7). The rootless, shiftless, despairing nature of the café and those who sat and slept there, the atmosphere of insecurity, filled him with horror and sadness, for he was desperate to settle into a home of his own. Consequently his letters of late August and early September were crowded with news of his renting of the rest of the Yellow House (plate 56), where he already had a studio.

He moved in on 17 September, and painted a celebration of the embodiment of his new-found security which was also to be the future established base of the long-cherished group studio. His optimism overflows in the letters, and the chores of buying two beds, twelve chairs and all the basic equipment of simple domesticity gave him intense pleasure—indeed, the house was his bride. 'My dear Theo,' he wrote after his first night there, 'here we are on the right road at last. Certainly it does not matter being without hearth or home and living in cafés like a traveller so long as one is young, but it was becoming unbearable to me, and more than that, it did not fit in with thoughtful work.' (538, 18

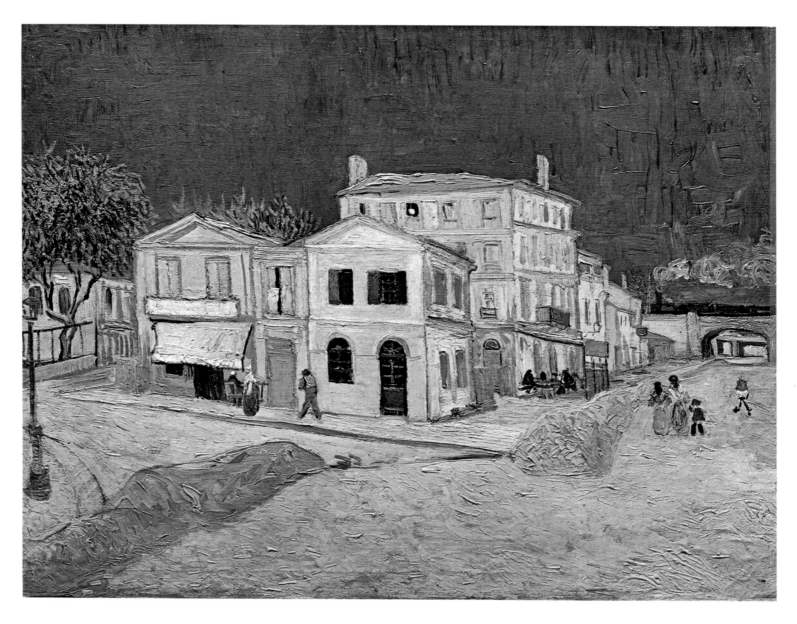

Plate 56
Vincent's House on the Place Lamartine, Arles (The Yellow House) F464
Arles, September, 1888
oil on canvas
30 × 37 in (76 × 94 cm)
Rijksmuseum Vincent van Gogh, Amsterdam

September 1888). Essential to his delight in the house was the idea of sharing it with Theo, as well as with studio members–'I am so happy in the house and in my work that I even dare to think that this happiness will not always be limited to one, but that you will have a share in it and good luck to go with it.' (539, 18 September 1888). The house coincided with a growing awareness of changes of emphasis in his work–'I myself–I tell you frankly–am returning more to what I was looking for before I came to Paris. I do not know if anyone before me has talked about suggestive colour, but Delacroix and Monticelli, without talking about it, did it. But I have got back to where I was in Nuenen, when I made a vain attempt to learn music, so much did I already feel the relation between our colour and Wagner's music. It is true that in impressionism I see the resurrection of Eugène Delacroix. but the interpretations of it are so divergent and in a way so irreconcilable that it will not be impressionism which will give us the final doctrine. That is why I myself remain among the impressionists, because it professes nothing, and binds you to

nothing, and as one of the comrades I need not declare my formula.' (539). His interest in music and the analogies between it and what he was trying to achieve in painting occur in his letters from the summer of 1888 onwards: he saw Wagner's achievement as a pinnacle of original excellence which set a standard for all artists. But he dared not allow himself to think too often that he could succeed alone. Hence the need for a mutually supportive community of painters, an aim tempered always by the self-denigrating 'if I can be of any use in getting them together, I would willingly look upon them all as better artists than I.' (493, early June 1888). His choice of Wagner in particular as a representative of absolute genius is part of an extremely complex personal philosophy that he was now evolving in support of his art. 'I have read another article on Wagner—*Love in Music* . . . How one needs the same thing in painting. It seems that in the book *My Religion* Tolstoy implies that whatever happens in the way of violent revolution, there will also be a private and secret revolution in men, from which a new religion will be born, or rather something altogether new, which will have no name, but which will have the same effect of comforting, of making life possible, which the Christian religion used to have . . . In the end we shall have had enough of cynicism and scepticism and humbug, and we shall want to live more musically.' He found the same quality of optimism in Japanese art—'isn't it almost a true religion which these simple Japanese teach us, who live in nature as though they themselves were flowers?' (542, mid-September 1888). That this was a selective attitude towards the great complexities of Japanese culture detracts not at all from its importance to his work. The Japanese, musical analogies, technical borrowings from other artists—all of these devices in his artistic vocabulary were being synthesised in these months in Arles. The intensity of colour in these great paintings symbolise the intensity of his experience and of his expression of that experience, and the Yellow House represented his attainment of sanctuary. He was exhilarated when he wrote to Theo after his first week as a proud householder with a sketch of his Yellow House painting 'representing the house and its surroundings in sulphur-coloured sunshine, under a sky of pure cobalt. The subject is frightfully difficult; but that is just why I want to conquer it. It's terrific, these houses, yellow in the sun, and the incomparable freshness of the blue. And everywhere the ground is yellow too.' (543, about 28 September 1888).

The time was now rapidly approaching for Gauguin's arrival; negotiations had been made via Theo, who was effectively supporting Gauguin by buying his paintings for Boussod and

Plate 57
The Painter on the Road to Tarascon
F448
Arles, August 1888
oil on canvas
19 × 17¼ in (48 × 44 cm)
Formerly Kaiser Friedrich Museum,
Magdeburg

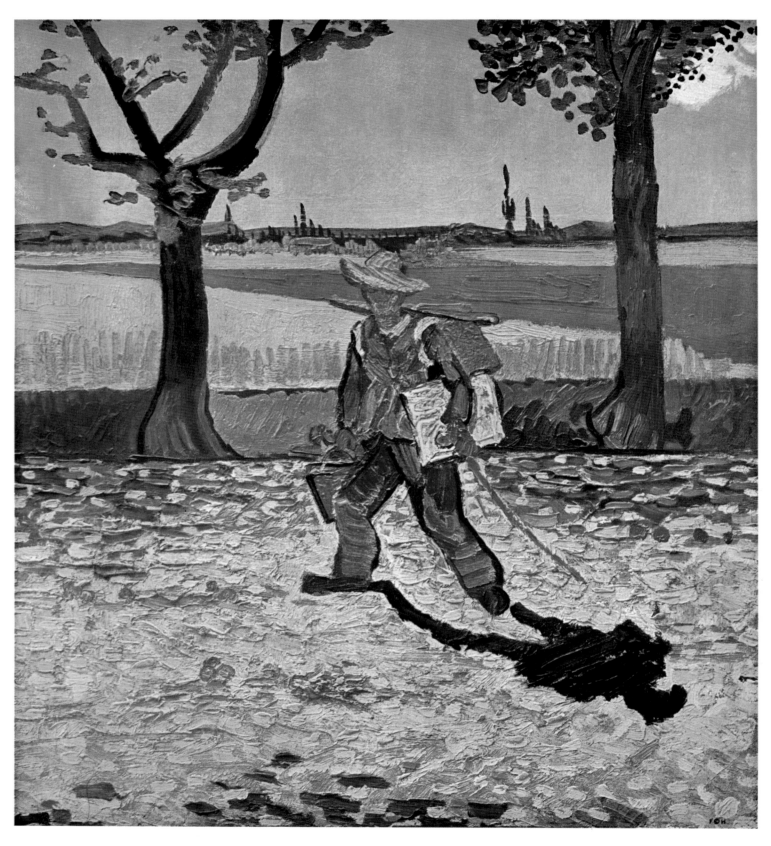

Valadon's largely unsaleable stock. With the exception of *The Night Café*, Vincent's paintings of the previous two months had a basic serenity and optimism that not even the 'devil mistral' could upset. *The Painter on the Road to Tarascon* (plate 57) records an August excursion with a lightness of heart that leaps from the canvas. A study of *The Old Mill in the rue Mireille, Arles* (plate 58), painted in September in the most Monticellian manner of any of his Arles work, is again a spirited, energetic celebration of the landscape – and a testimony to Monticelli's part in Vincent's studio project. Towards the end of September Vincent wrote to Theo of a friend who had said to him, '"But Monticelli, Monticelli, why he was a man who ought to have been at the head of a great studio in the South." I wrote to our sister and to you the other day, you remember, that sometimes I thought that I was continuing Monticelli's work here. Well, don't you see, the studio in question, we are founding it. What Gauguin does, what I do, will be in line with that fine work of Monticelli's, and we will try to prove to the good people that Monticelli did not die sprawled over the café tables of Cannebière, but that the good old boy is still alive. And the thing won't end even with us, we shall set it going on a pretty solid basis.' (542).

Vincent added rather more rarefied southern connotations – this time early Renaissance – to his work, with the series of paintings of the public gardens across the square from his house. He called

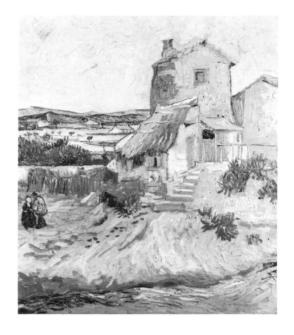

Plate 58
The Old Mill in the rue Mireille, Arles
F550
Arles, September 1888
oil on canvas
$25\frac{1}{2} \times 21\frac{1}{4}$ in (64.5×54 cm)
Albright-Knox Art Gallery, Buffalo, New York, Bequest of A. Conger Goodyear

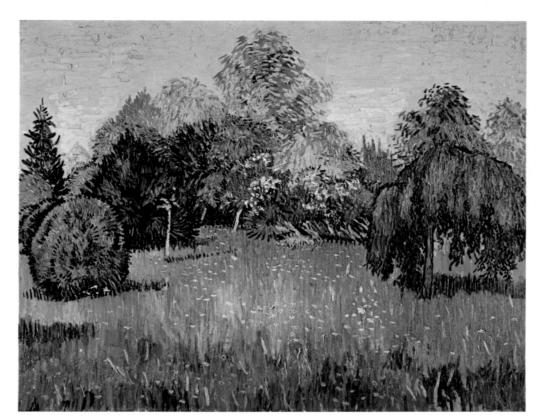

Plate 59
Sunshine in the Park: the Poet's Garden F468
Arles, September, 1888
oil on canvas
$28\frac{3}{4} \times 36\frac{1}{4}$ in (73×92 cm)
Courtesy of the Art Institute of Chicago, Chicago

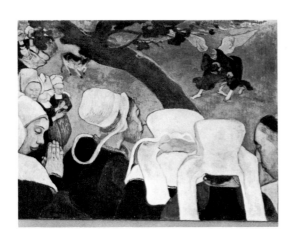

Plate 60
The Vision after the Sermon
by Paul Gauguin (1848–1903)
1888
oil on canvas
28¾ × 36¼ in (73 × 92 cm)
The National Gallery of Scotland,
Edinburgh

each of them *The Poet's Garden* (plate 59). He intended possibly all of them as further decorations for the Yellow House, in honour of Gauguin, this time for Gauguin's own room, and wrote to Gauguin in terms which must have astonished his worldly cynicism: 'The ordinary public garden contains plants and shrubs that make one dream of landscapes in which one likes to imagine the presence of Botticelli, Giotto, Petrarch, Dante and Boccaccio. In the decoration [for your room] I have tried to disentangle the essential from what constitutes the immutable character of the country. And what I wanted was to paint the garden in such a way that one would think of the old poet from here (or rather from Avignon), Petrarch, and at the same time of the new poet living here–Paul Gauguin . . . However clumsy this attempt may be, yet it is possible you will see in it that I was thinking of you with a very strong emotion while preparing your studio.' (544a, about 29 September 1888).

Vincent felt himself to be in a state of spiritual tranquillity and out of this came the painting of his *Bedroom* (plate 2), 'just simply my bedroom, only here colour is to do everything, and giving by its simplification a grander style to things, is to be suggestive here of *rest* or of sleep in general. In a word, looking at the picture ought to rest the brain, or rather the imagination.' He described the sharply pitched colours; then: 'That is all–there is nothing in this room with its closed shutters. The broad lines of the furniture again must express inviolable rest . . . you see how simple the conception is. The shadows and the cast shadows suppressed; it is painted in free flat tints like the Japanese prints. It is going to be a contrast to the night café' (554, about 17 October 1888), and its rugged qualities concealed what was a total contradiction of everything symbolised by *The Bedroom*. With the approach of Gauguin's visit he seems to have fallen into a state of suppressed hysteria: he wrote to Theo of his nearness to what he called 'madness', kept from insanity only by his 'double nature, that of a monk and that of a painter' (556, 22 October 1888). Within a few days Gauguin arrived and settled into the rooms Vincent had so devotedly prepared for him–it was the realisation of the bonze's dream, the visitation of the master, so long awaited and now at last under Vincent's own roof. Gauguin arrived ready to exploit the situation to its full: he had written to a friend in October, 'Mark this well, a wind is blowing at this moment *among artists* which is all in my favour; . . . rest assured, however Van Gogh may be in love with me, he would not bring himself to feed me in the South for my beautiful eyes. He has surveyed the terrain like a cautious Dutchman and intends to push the

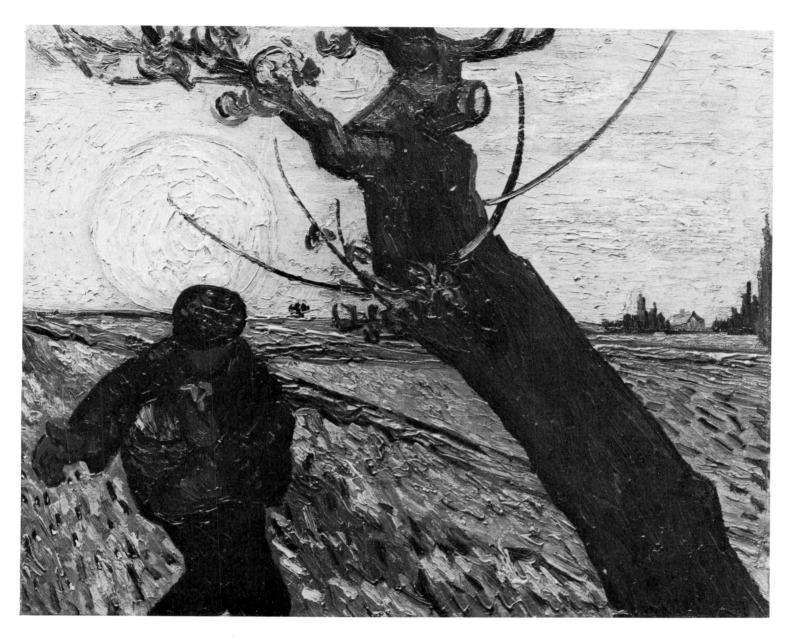

Plate 61
The Sower F451
Arles, 1888
oil on canvas
12½ × 15¾ in (32 × 40 cm)
Rijksmuseum Vincent van Gogh,
Amsterdam

1 Paul Gauguin, *Letters to his Wife and Friends*, ed. Maurice Malingue, transl. Henry J. Stebbing, The Saturn Press, London, 1946, Letter 73, p. 110.

matter to the utmost of his powers, and to the exclusion of everything else. I asked him to lower prices to tempt buyers, but he replied that he intended on the contrary to raise them. Optimist as I am, this time I really have my foot on the solid earth.'[1] The Van Gogh Gauguin refers to here of course is poor Theo, whose letters to Arles now had to include twice the amount of francs to cover Gauguin's costs as well as Vincent's.

The impact of Gauguin's personality and art was immediate – he brought his painting *The Vision after the Sermon* (plate 60) which for Vincent was a revelation. Vincent rooted this synthesised image of Gauguin's in his own observation of reality in *The Sower* (plate 61) – 'yesterday evening an extraordinarily beautiful sunset of a mysterious, sickly citron colour – Prussian blue cypresses against trees with dead leaves' (558a, end of October 1888) – and transposed this directly on to his canvas, but there can be no

mistaking the aggressive, Japanese-inspired angle of the tree trunk from Gauguin's *Vision* slicing across the composition. Added to this structural borrowing was the subject matter: Gauguin's painting, with simple Breton countrywomen experiencing together a mystical vision of Jacob and the Angel wrestling, bears directly on Vincent's interpretation of the figure of the Sower. In a letter of about 6 July he had spoken of using the kinds of colours he had used for the Sower painting he was then working on–'you tumble into a regular metaphysical philosophy of colour à la Monticelli' (503)–and this association of the kinds of colour used for paintings of the Sower with metaphysical or symbolic implications must be applied to this autumn version also. Many of Millet's paintings, too, had clear allusions to the way in which the lives of the peasants he painted and drew symbolised the essence of Life and Death, and there is no doubt that Vincent

Plate 62
The Sower by Jean-François Millet
(1814–1875)
etching by Paul le Rat (1849–1892)
Bibliothèque Nationale, Paris

Plate 63
The Green Vineyard F475
Arles, September 1888
oil on canvas
28¼ × 36¼ in (72 × 92 cm)
Rijksmuseum Kröller-Müller, Otterlo

Plate 64
The Red Vineyard, Montmajour F496
Arles, November 1888
oil on canvas
29½ × 36½ in (75 × 93 cm)
Pushkin Museum of Fine Arts, Moscow

responded to this vision with unqualified sympathy. Just a month before he had asked Theo to send the set of Millet's *Les Travaux des Champs* again, and particularly requested Le Rat's etching of Millet's *Sower* (plate 62). The associations of the Sower image were potent for Vincent: 'The idea of the "Sower" continues to haunt me all the time. Exaggerated studies like the "Sower" and like this "Night Café" usually seem to me atrociously ugly and bad, but when I am moved by something . . . then these are the only ones which appear to have any deep meaning.' Bound up with it all was his obsession for stability and permanence: 'Will my work really be worse because, by staying in the same place, I shall see the seasons pass and repass over the same subjects, seeing again the same orchards in the spring, the same fields of wheat in summer? Involuntarily I shall see my work cut out for me beforehand, and I shall be better able to make plans. Then if I keep some studies here to make a coherent whole, it will mean work of a deeper calm at the end of a certain time.' (535, 10 September 1888).

Meanwhile that deeper calm induced by the almost hypnotic rhythm of the seasons hoped for by Vincent can be seen to have succeeded with great beauty in the pair of paintings of vineyards – *The Green Vineyard* (plate 63) of September and *The Red Vineyard* (plate 64) of November 1888. The turning of the vivid green vines into their intense autumnal red is an integral part of the rhythm of the French countryside; Vincent's representation of the transformation, the quality of the paint applied with such evocative freshness and control – never so thick as to become overweighted, but lush enough to convey perfectly the mellow, fruitful, vined

Plate 65
Memory of the Garden at Etten F496
Arles, November 1888
oil on canvas
29 × 36½ in (73.5 × 92.5 cm)
Hermitage Museum, Leningrad

acres of Provence – puts these two paintings with his greatest. *The Red Vineyard* was, as Vincent said, 'like red wine' (559).

Perhaps it was this very mellowness that prompted the nostalgia of his *Memory of the Garden at Etten* (plate 65). In the first flush of his arrival in Arles, Vincent had declared that he wanted to 'leave Holland alone forever and ever' (473, about 1 April 1888), but within a few months he was drawing analogies between the Camargue and some Dutch landscape painting – not surprisingly, since the Camargue was as flat as most of Holland. Of course, he kept in touch with his family in Holland, writing mainly to his sister Wil, to whom he was closest, but he rarely talked of nostalgia for the North once he was securely installed at Arles. It was only after his first major breakdown, resulting from the quarrel with Gauguin, that he confessed to his memories: 'During my illness I saw again every room in the house at Zundert, every path, every plant in the garden, the views of the fields outside, the neighbours,

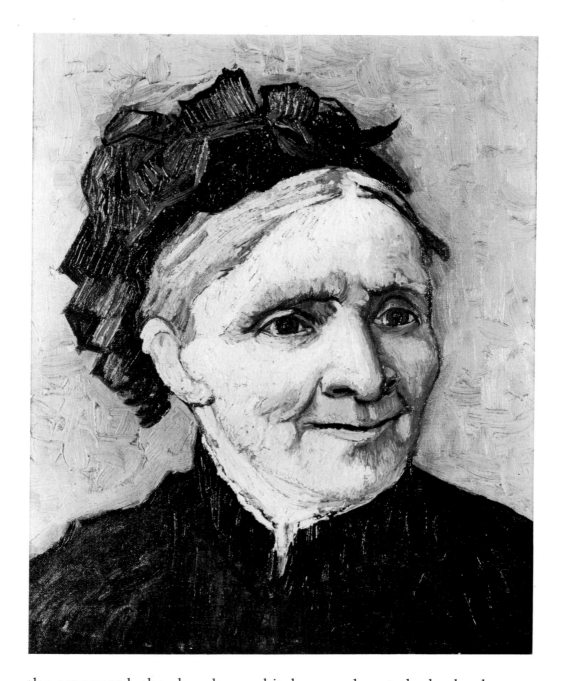

the graveyard, the church, our kitchen garden at the back – down
to a magpie's nest in a tall acacia in the graveyard . . . There's
no-one left who remembers all this but Mother and me.' (573, 23
January 1889). The painting of his memory of the family garden
was a refuge from Gauguin's already overwhelming presence and
in hospital his mind returned to the familiar past with the automatic
mechanism of psychological self-defence. He had already painted a
portrait of his mother (plate 66) from a photograph of her that
annoyed him with the greyness of its black-and-white, but the
garden memory took him far into a complex programme of
symbolism. To his sister Wil, whom he identified as the younger
woman at the left of the painting (it has been suggested that it
may, in fact, have been Kee Vos), he wrote: 'I don't know whether
you can understand that one may make a poem only by arranging
colours, in the same way that one can say comforting things in
music. In a similar manner the bizarre lines, purposely selected and

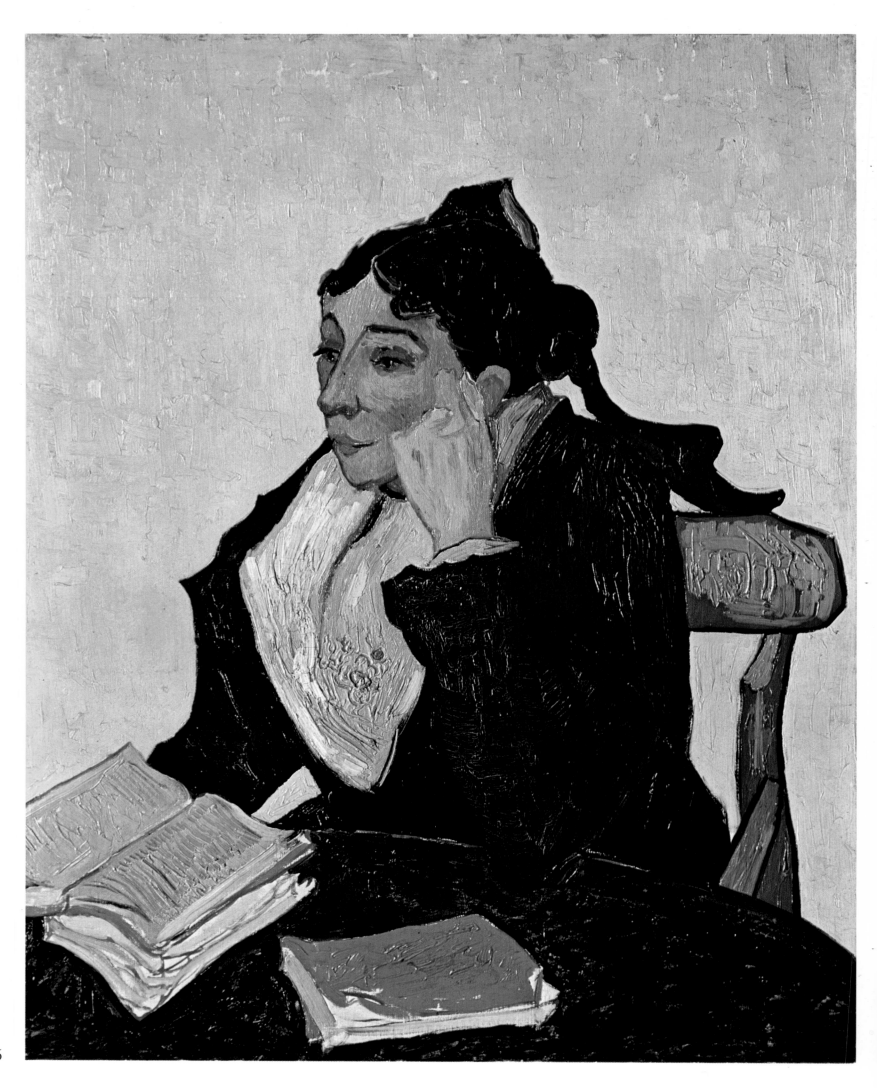

86

multiplied, meandering all through the picture, may fail to give the garden a vulgar resemblance, but may present it to our minds as seen in a dream, depicting its character, and at the same time stranger than it is in reality . . . my friend Paul Gauguin . . . strongly encourages me to work often from pure imagination.' (W9, November–December 1888). Gauguin was also working on a painting, *Arlésiennes in the Park*, with a similar basic composition: the flattened, schematised background, the atmosphere of brooding melancholy and the symbolic colours. The encouragement given to Vincent to work from memory–part of what he meant in the letter to Wil by 'pure imagination'–was a profoundly important part of Gauguin's work. Vincent found it an exciting concept at first–'Gauguin gives me the courage to imagine things, and certainly things from the imagination take on a more mysterious character' (562, November–December 1888), but the excursion into the unknown territory of invented scenes, and the abandonment of the security of observation of nature finally breached his aesthetic defences at this most vulnerable point. The two men were working side by side, but the precise extent of their mutual influence is difficult to determine. Both painted portraits of Madame Ginoux, an *Arlésienne* (plate 67), the wife of the owner of the night café. Vincent's version showed her seated at a table against a 'pale citron' background; Gauguin placed her at a table in the night café, the familiar red walls behind her and the sad, rootless café patrons slumped at their tables. Vincent, habitually a rapid worker, was unusually fast with the painting of *L'Arlésienne*: the outlines, which he 'slashed on in an hour', flicker across the canvas, filled in with large areas of 'perfectly raw Prussian blue' (559, November 1888). Both artists were using their experience of Japanese prints but retained their separate identities: Gauguin's outlines were more rounded, his paint flatter and more carefully modulated. Vincent's copy (plate 68), made at St-Rémy just over a year later, of Gauguin's drawing for his *Arlésienne* shows Vincent's understanding of the distinction between their two approaches to the subject.

While Vincent accepted Gauguin's technical advice–'Gauguin has told me how to get rid of the grease in the things painted in impasto by washing from time to time' (563, December 1888)– their personal relationship was becoming progressively more uneasy. Gauguin described to Bernard their frequent states of armed truce and endless disagreements: 'He likes my paintings very much, but while I am doing them he always finds that I am doing this or that wrong. He is romantic while I am rather inclined towards a primitive state. When it comes to colour he is interested

Plate 67
L'Arlésienne: Madame Ginoux with Books F488
Arles, November 1888
oil on canvas
$35\frac{1}{2} \times 28\frac{1}{4}$ in (90×72 cm)
The Metropolitan Museum of Art, New York, Bequest of Samuel A. Lewisohn, 1951

Plate 68
L'Arlésienne: Madame Ginoux against a Cherry-coloured Background
(after a drawing by Paul Gauguin) F540
Saint-Rémy, January–February 1890
oil on canvas
$23\frac{1}{2} \times 19\frac{3}{4}$ in (60×50 cm)
Galleria Nazionale d'Arte Moderna, Rome

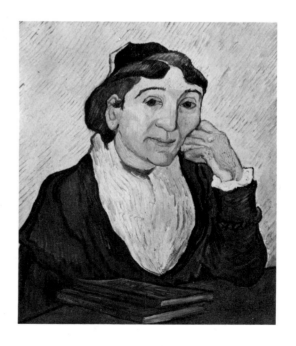

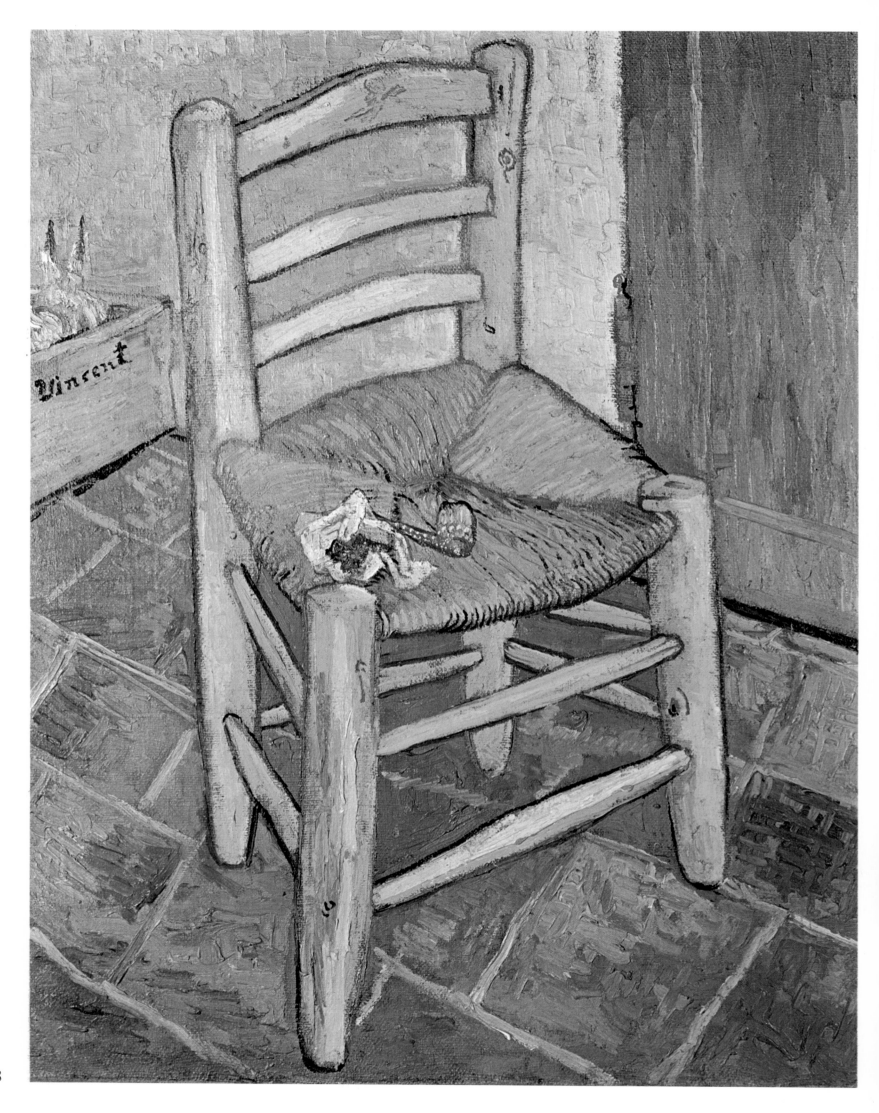

Plate 69
Vincent's Chair with his Pipe F498
Arles, December 1888–January 1889
oil on canvas
$36\frac{1}{2} \times 29$ in (93 × 73.5 cm)
The Tate Gallery, London

in the accidents of the pigment, as with Monticelli, whereas I detest this messing about in the medium, etc.'[1] Vincent found the other's company stimulating – 'It does me a tremendous amount of good to have such intelligent company . . .' (563). But the intelligent company was too demanding – 'Gauguin and I talked a lot about Delacroix, Rembrandt, etc. Our arguments are terribly *electric*, sometimes we come out of them with our heads as exhausted as a used electric battery.' (564). These arguments arose frequently, after visiting a museum together or reading, and more than one major quarrel threatened the embryo studio during December. Gauguin wrote to Theo, 'I must go back to Paris. Vincent and I simply cannot live together in peace because of incompatibility of temper, and we both need quiet for our work. He is a man of remarkable intelligence; I respect him highly, and regret leaving; but I repeat, it is necessary.'[2] This episode was patched up, but Vincent knew on 23 December that a crisis approached; he wrote to Theo, 'Gauguin is very powerful, strongly creative, but just because of that he must have peace.' (565). It seems that Vincent was already working on the two empty chair studies that were to symbolise the collapse of their relationship and Gauguin's departure. He called them 'odd enough' (563), but the intention was clear: *Vincent's Chair* (plate 69) is a homely, ordinary little rush-seated chair, seen clearly by daylight, a pipe and tobacco pouch on it. Its companion, *Gauguin's Armchair* (plate 70), somehow emptier in its deserted grandeur beside the insignificant vacancy of Vincent's chair, is a mysteriously lit monument, book and candle left on the seat as a memorial to Gauguin's lost presence. It is a 'red and and green night effect' – the associations of colour symbolism with *The Night Café* are oppressive. The theme of the empty chair was one with a long history; it was a device used in Roman art to commemorate a dead emperor, and there were many more recent examples from which Vincent could draw, notably an English wood engraving from *The Graphic* by Luke Fildes, drawn on the death of Charles Dickens, which he had greatly admired. It is clear that Vincent felt that Gauguin's departure – which he knew had to be soon in order to restore both of them to peace of mind – also implied a sort of departure for himself. Vincent's chair, as well as Gauguin's, is empty: the connotations of departure and death are intended for both.

Vincent's precarious mental stability gave way under the strain; Gauguin was the catalyst in a situation primed with all the necessary components for the almost inevitable chemical reaction of the breakdown – Gauguin only precipitated the moment. Theo was

[1] Gauguin, *Letters*, 1946, Letter 78, p. 116.
[2] *Letters*, Introduction, p. xlv.

Plate 70
**Gauguin's Armchair, Candle and Books
(His Empty Chair)** F499
Arles, December 1888
oil on canvas
35¾ × 28¼ in (90.5 × 72 cm)
Rijksmuseum Vincent van Gogh,
Amsterdam

brought to Arles by a telegram from Gauguin, and arrived on Christmas Day to discover that Vincent had cut off a piece of his own ear and taken it to a woman in a local brothel. The reasons for Vincent's actions are not clear, but he had at first chased Gauguin along the street with the wrapped earlobe in his hand, and when he failed to catch him, apparently decided on the spur of the moment to go to the brothel, perhaps because it was one of the few places in Arles where he had been able to make any normal human contact. After a violent scene the old postman, Roulin, one of his few friends in Arles, got him home, but the police were told and had him removed to hospital. Theo had just become engaged and wrote to his fiancée, Johanna, 'There were moments while I was with him when he was well; but very soon after he fell back into his worries about philosophy and theology. It was painfully sad to witness, for at times all his suffering overwhelmed him and he tried to weep but he could not; poor fighter and poor, poor sufferer; for the moment nobody can do anything to relieve his sorrow, and yet he feels deeply and strongly. If he might have found somebody to whom he could have disclosed his heart, it would perhaps never have gone thus far . . .'[1] and again, 'There is little hope, but during his life he has done more than many others, and he has suffered and struggled more than most people could have done. If it must be that he dies, so be it, but my heart breaks when I think of it.'[1] Vincent was in hospital until 7 January, when he was allowed to return to the Yellow House, helped by the Roulin family who, after Theo's return to Paris with Gauguin, sustained him through his recovery with their simple, generous friendship. But the attacks – whether of latent epilepsy brought out by the stormy period with Gauguin or of manic depression is impossible to diagnose at this distance – continued throughout January and February. The local people became hostile at what they regarded as a dangerous madman in their midst and petitioned for his confinement in the hospital again. A Protestant clergyman friend of Vincent's visited him and wrote to Theo, 'The petition grieves him very much. "If the police," he says, "had protected my liberty by preventing the children and even the grownups from crowding around my house and climbing the windows as they have done (as if I were a curious animal), I should have more easily retained my self-possession; in any event I have done no harm to anyone."'[2]

Vincent's deep commitment to his work gave him the strength to continue working between his traumatic attacks, and he completed a series of portraits of the Roulin family. The postman and his wife had been the first friends Vincent had made in Arles,

[1] *Letters*, Introduction, p. xlvii.
[2] *Letters*, Introduction, p. xlvi.

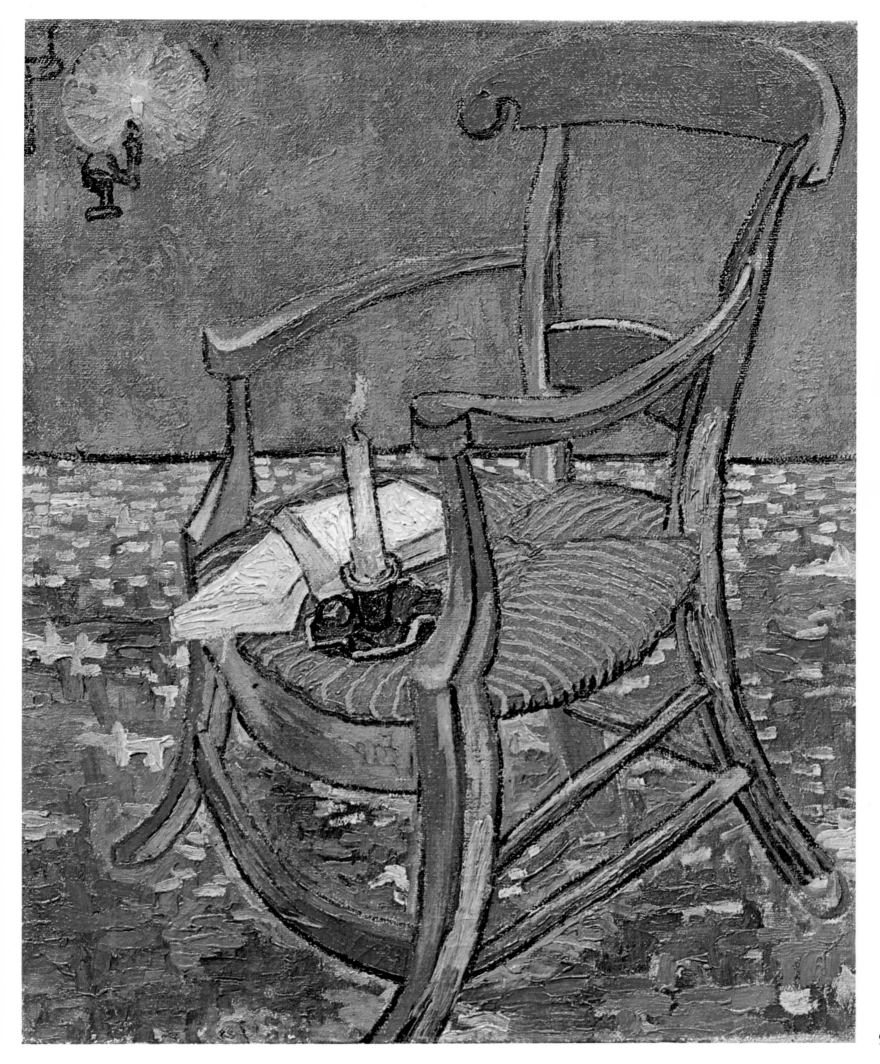

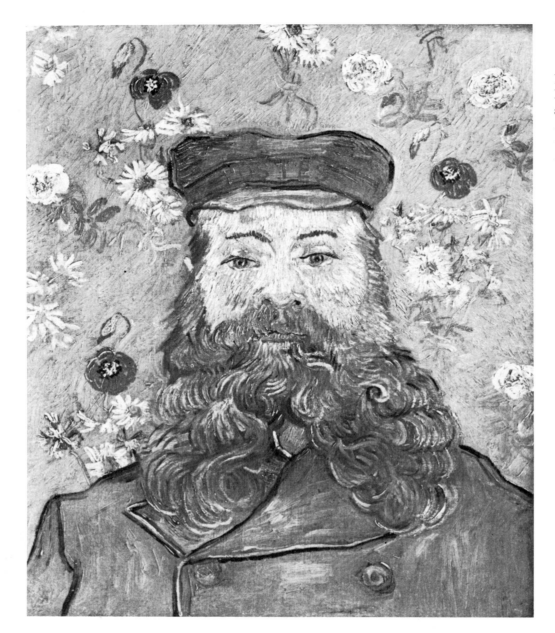

Plate 71
Head of the Postman Joseph Roulin against a Flowery Background F439
Arles, January–February 1889
oil on canvas
$25\frac{1}{2} \times 21\frac{1}{4}$ in (65×54 cm)
Rijksmuseum Kröller-Müller, Otterlo

and their friendship was gratefully received by him. They seem to have felt protective towards this strange, eccentric man, and he appreciated their concern for him. Vincent had already painted Roulin three times during the summer, one a companion piece to *La Mousmé*, and two head studies. In the last month of Gauguin's stay he had begun a series of the whole family, working under Gauguin's influence partly from memory. *The Head of Roulin* (plate 71), of the beginning of the year, shows how abstracted from reality the man's head had become. It is silhouetted against a flowered wallpaper, and stares rigidly out at us as Père Tanguy had done from his backcloth of Japanese prints. The companion to the postman's head was *La Berceuse* (plate 72), a portrait of Madame Roulin as a woman rocking a cradle. It was intended as the centrepiece of a triptych, to be flanked by two of the sunflower paintings (see plate 1), and has a complicated series of literary and symbolic associations woven into it. To a friend Vincent wrote of its connection with a book by the Dutch author Van Eeden, which

Plate 72
La Berceuse: Madame Augustine Roulin F505
Arles, January 1889
oil on canvas
$36\frac{1}{2} \times 29\frac{1}{4}$ in (93×74 cm)
Walter H. Annenberg, Former Ambassador of the United States of America to the Court of St James's, London

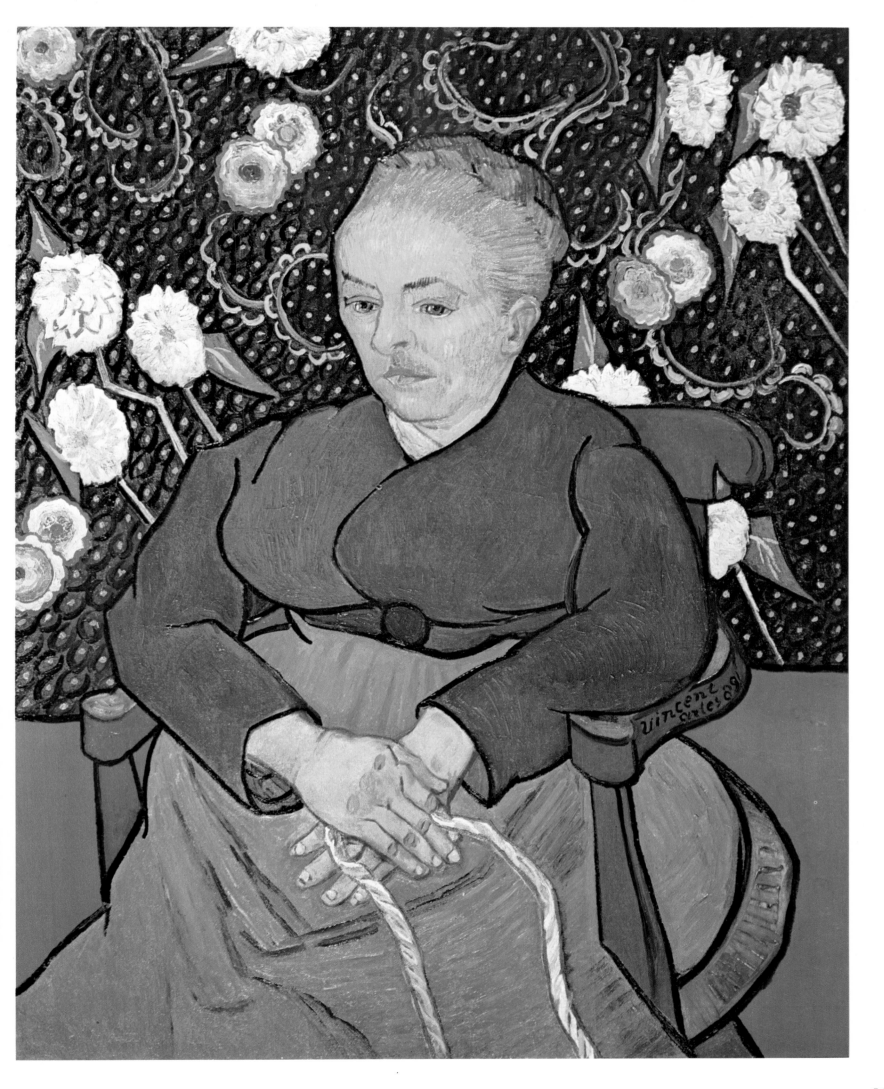

93

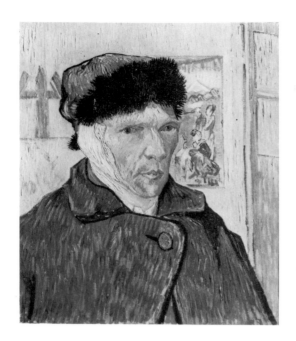

Plate 73
Self Portrait with Bandaged Ear F527
Arles, January 1889
oil on canvas
23½ × 19¼ in (60 × 49 cm)
Courtauld Institute Galleries, London

made it 'a lullaby in colours' (571a), but it was even more closely associated in Vincent's mind with Pierre Loti's *Les Pêcheurs d'Islande* ('The Fishermen of Iceland'). He had talked with Gauguin of the fishermen's 'mournful isolation, exposed to all dangers, alone on the sad sea', and 'the idea came to me to paint a picture in such a way that sailors, who are at once children and martyrs, seeing it in the cabin of their Icelandic fishing boat, would feel the old sense of being rocked come over them and remember their own lullabies.' (574, 28 January 1889). He saw in Gauguin the qualities of Loti's fishermen, but the identification he was also making of his own situation with that of the sailors is obvious and painful to witness. The version illustrated here was the one that Madame Roulin chose for herself out of the three Vincent had by then painted, and he commented, 'She had a good eye and took the best.' (578, 22 February 1889). Compositionally it was more sophisticated than the straightforward Roulin head: the maternal fullness of the woman's body is circled and held by the armchair, her hands are strong and capable as they hold the cord leading to the cradle she will rock, but the whole painting is already seeming to rock by the simple device of making the floorline slightly higher when it reappears at the right. He used this also in the version of *The Sunflowers* illustrated (plate 1), making the link between them and *La Berceuse* still closer.

Vincent recorded his image in the aftermath of the breakdown

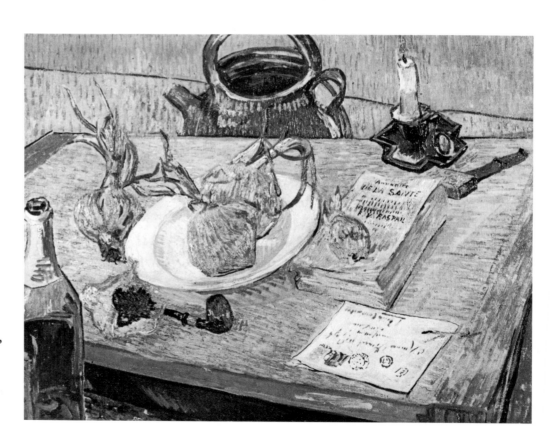

Plate 74
Still Life: Drawing Board with Onions, etc. F604
Arles, January 1889
oil on canvas
19¾ × 25¼ in (50 × 64 cm)
Rijksmuseum Kröller-Müller, Otterlo

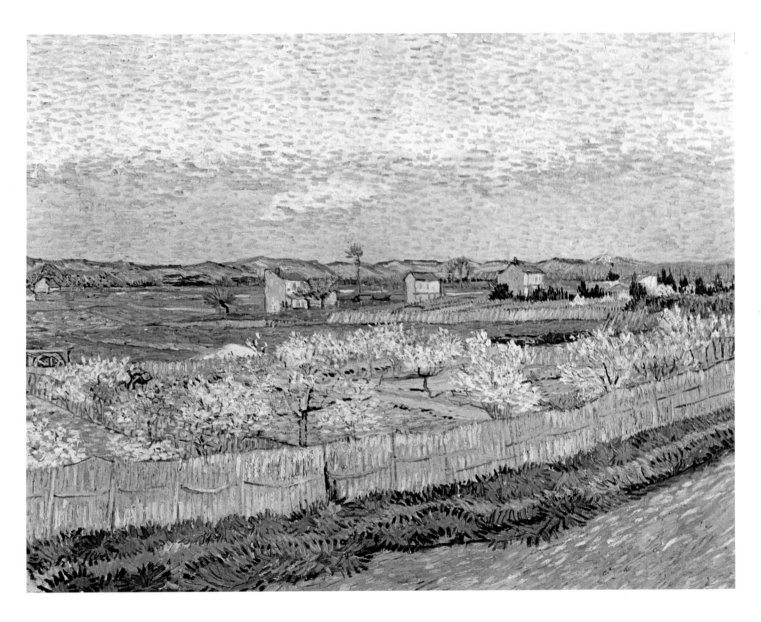

Plate 75
**The Plain of La Crau, with
Orchard of Peach Trees** F514
Arles, April 1889
oil on canvas
25¾ × 32 in (65.6 × 81.5 cm)
Courtauld Institute Galleries,
London

with the *Self Portrait with Bandaged Ear* (plate 73) of January 1889.
Behind his head is a renewed reminder of his Japanese print
collection, the fur hat and bandage framing his beardless and set
face. He had been treating himself for some time after coming out
of hospital with prescriptions for insomnia from a popular medical
book. He painted this book in a *Still Life* (plate 74) which was the
first painting he had made since then – once again, it reassured him
to represent in his work familiar and significant domestic objects.

But with his continuing attacks, his reactions increasingly
paranoid, it became clear that his time alone in Arles must be
limited. He hated his period of enforced detention in the hospital
resulting from the petition got up by those 'poisonous idlers, the
townspeople', but struggled to control his feelings, knowing that
outbursts could only harm his health and his reputation in the
town. Signac came down from Paris and took Vincent back to see
his pictures locked up in the deserted Yellow House. Vincent tried

to restore his peace of mind by re-reading some old favourites–
Dickens's Christmas books, *Uncle Tom's Cabin*, and the Goncourts,
and wrote long letters to Theo musing on Theo's forthcoming
marriage and on his own situation.

During April he managed to get himself together enough to
paint some magnificent canvases of Arles and its surroundings,
struggling to prove his sanity to himself through his paintings.
The Plain of La Crau (plate 75) with its speckled paint drifting
across the canvas in airy patterns suggests perfectly the light and
space of the plain, filled as it was with drifts of blossom. Another,
A View of Arles (plate 76), is again of orchards, seen through a
dramatic screen of leafless poplars that suggest the bars of a cell
window. But the tones of blue used for their trunks and the
creamy-pink masses of blossoming trees beyond them belie such
severity, and we are left with an image of Arles filled with the
promise of the new spring and the beginning of a new seasonal
cycle.

But, as he wrote to Theo, 'It was a fight against the inevitable'
(588, 30 April 1889), and the consensus of opinion was that he
needed a period, away from Arles, in a proper mental home, with
doctors better equipped to diagnose his illness and help him to a
cure. He went with the conviction that it was only for a short
time, talked of joining the Foreign Legion when he was cured,
and yet thoughts of suicide ran in his head: 'If I were without
your friendship, they would remorselessly drive me to suicide,
and however cowardly I am, I should end by doing it.' (586).

Plate 76
A View of Arles F516
Arles, April 1889
oil on canvas
28¼ × 36¼ in (72 × 92 cm)
Neue Pinakothek, Munich

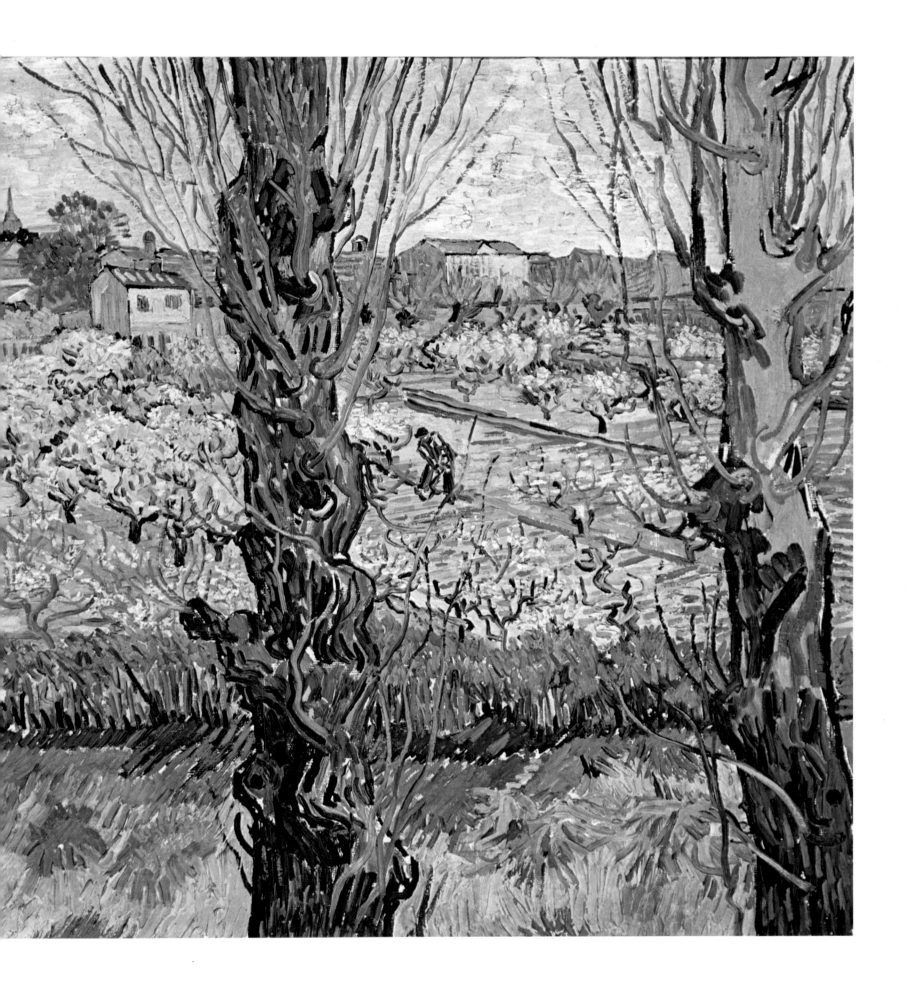

Saint-Rémy

His Protestant pastor friend, Salles, took Vincent to the asylum of St-Paul in St-Rémy, a small town not far from Arles, and he was admitted on 8 May. His letters spoke of his desire to start painting again – the terms of the hospital's acceptance of him had been that he could not paint outside the hospital grounds – and his perennial worry, money. He was always aware of what a drain he was on Theo's resources, and worried constantly about Theo's apartment filling to the doors with his canvases. His favourite theme was of how he would soon be able to have a major exhibition, sell many paintings and start paying Theo back; this dream helped fuel his continued drive to work.

He made studies of particular plants in the hospital garden soon after his arrival which show how vivid his analysis of organic life became: it was a total concentration and distillation of his observations. In the *Death's-Head Moth* (plate 77) Vincent stood over the subject, eliminating the horizon, so that all that is seen is luxuriant growth and a seemingly giant butterfly, alive with intense colour: sharp-focus naturalism revealing his deep involvement with the actual existence of individual, non-human forms of life. Raising his viewpoint a little, he painted *Undergrowth* (plate 78), which, he wrote to Theo, was 'once again as commonplace as a chromo[1] in the little shops, which represents the eternal nests of greenery for lovers.' (592, 22 May 1889). He had compared *La Berceuse* (plate 72) to the cheap chromo-lithographs that could be bought in Paris by anyone with small change to spare, and this analogy was again part of his lifelong interest in 'art for the people'. The dense carpet of ivy seethes over the ground and up the tree trunks, light flickering on the shiny leaves, and again there is the intense sense of immediacy and sensory accuracy so typical of his work, and apparent even in Paris (see plate 41).

Inside the hospital he drew his surroundings, in the same spirit of territorial delineation that had prompted his rue Lepic views (plate 26) and his Yellow House paintings. Using gouache (a quick-drying, water-based paint), he did a view of the vestibule (plate 79) of the hospital. The hospital occupied part of a medieval

[1] A type of lithographic reproduction.

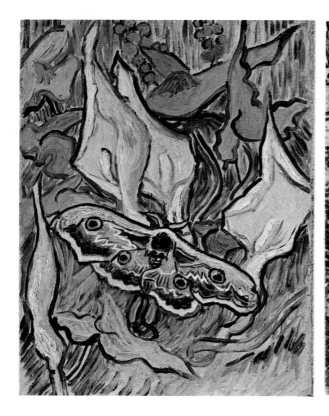

monastery with lovely cloisters, shady, vaulted and cool corridors, and Vincent's ochre-toned paint reflected its sense of sun-baked age. But he found the grounds irresistible, and whenever he could, escaped outside; working again with his reed pen, he drew *The Fountain* (plate 80) with strong, descriptive strokes defining the stones and the trees. The lack of distortion in the perspective reveals his attempt to regain a hold of reality: 'the *fear* of madness is leaving me to a great extent, as I see at close quarters those who are affected by it in the same way as I may very easily be in the future.' (592). But it must have become obvious to Theo as he received more and more canvases from St-Rémy that Vincent's capacity to deal with life outside the controlled environment of the hospital was not returning. If it is possible to see evidence of mental illness in the physical application of paint to canvas, *Starry Night* (plate 81) gives us the most extreme evidence. His *Poet* (plate 51) in Arles had this expanse of starry night behind him, but here the thought of the infinity of darkness he was attempting to pin on to his canvas swept away his control. Writing to Theo about this and some other paintings in September, he called them 'exaggerations from the point of view of arrangement, their lines are warped as in old wood.' (607). This kind of frenziedly exaggerated whirling line is commonly seen in paintings by schizophrenics, but an application of this diagnosis here can only be speculative, for Vincent had employed various kinds of highly exaggerated line for clearly successful

Plate 77
Death's-Head Moth F610
Saint-Rémy, May–June 1889
oil on canvas
13 × 9½ in (33 × 24 cm)
Rijksmuseum Vincent van Gogh,
Amsterdam

Plate 78
Undergrowth F746
Saint-Rémy, July 1889
oil on canvas
21¼ × 36¼ in (74 × 92 cm)
Rijksmuseum Vincent van Gogh,
Amsterdam

technical reasons in many paintings and drawings before. His awareness of the distortions he was employing prevent a conventional attribution of schizophrenic characteristics to the paintings, for it is generally observed that schizophrenics regard their paintings as normal representations of their observation. Nevertheless, there is something immensely disquieting in the frenzied swirling of his line that was only partially accounted for by his conscious schematisation of form. He wrote to Theo of Gauguin and Bernard, as if to justify his boldness: 'they do not ask the correct shape of a tree at all, but they do insist that one can say if the shape is round or square–and honestly, they are right, exasperated as they are by certain people's photographic and empty perfection. They will not ask the correct tone of the mountains, but they will say: By God, the mountains were blue, were they? Then chuck on some blue and don't go telling me that it was a blue rather like this or that, it was blue, wasn't it? Good–make them blue and it's enough!' (607)

Certain dramatic elements in the country around the hospital caught and held his attention: the cypresses were a particularly insistent light-absorbing note in the dry glare of St-Rémy– 'The cypresses are always occupying my thoughts, I should like to make something of them like the canvases of the sunflowers, because it astonishes me that they have not yet been done as I

Plate 79 (opposite)
The Vestibule of St Paul's Hospital
F1530
Saint-Rémy, May–early June 1889
black chalk, gouache
$24\frac{1}{4} \times 18\frac{1}{2}$ in (61.5 × 47 cm)
Rijksmuseum Vincent van Gogh,
Amsterdam

Plate 80
The Fountain in the Garden of St Paul's Hospital F1531
Saint-Rémy, May–early June 1889
black chalk, pen, reed pen and brown ink
$19\frac{1}{2} \times 18$ in (49.5 × 46 cm)
Rijksmuseum Vincent van Gogh,
Amsterdam

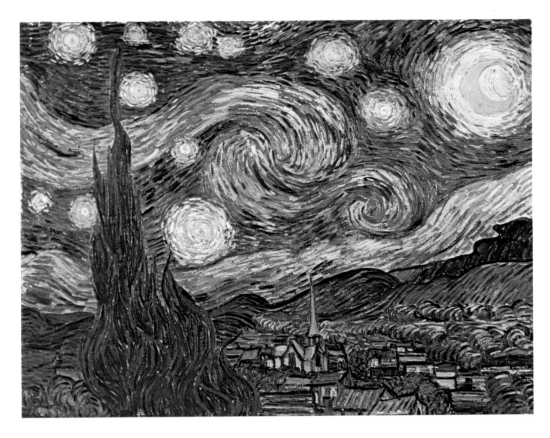

Plate 81
The Starry Night F612
Saint-Rémy, June 1889
oil on canvas
$28\frac{3}{4} \times 36\frac{1}{4}$ in (73 × 92 cm)
Museum of Modern Art, New York

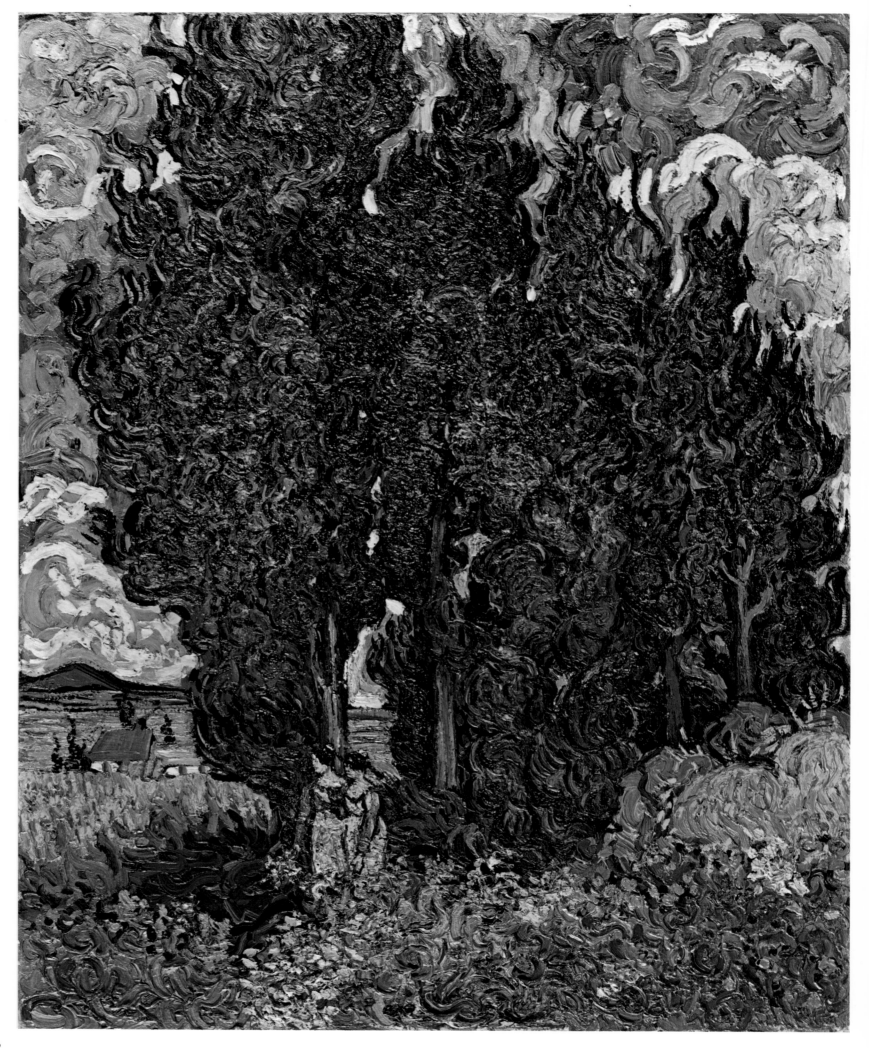

102

Plate 82
The Cypresses F620
Saint-Rémy, June 1889, finished February
1890
oil on canvas
$36\frac{1}{4} \times 28\frac{3}{4}$ in (92 × 73 cm)
Rijksmuseum Kröller-Müller, Otterlo

Plate 83
Wild Vegetation in the Hills F1542
Saint-Rémy, July 1889
reed pen and brown ink
$18\frac{1}{2} \times 24\frac{1}{2}$ in (47 × 62 cm)
Rijksmuseum Vincent van Gogh,
Amsterdam

see them. It is as beautiful of line and proportion as an Egyptian obelisk. And the green has a quality of such distinction. It is a splash of *black* in a sunny landscape, but it is one of the most interesting black notes, and the most difficult to hit off exactly that I can imagine.' (596, 25 June 1889). The painting of cypresses illustrated here (plate 82) was one of a series of paintings that he was working on during the summer and early autumn to send to his mother and his sister Wil, and at this stage had no figures. It was probably not until the following February, when he was working on a small version to send to Albert Aurier, in thanks for Aurier's article, that he added the two women's figures to both versions. Although the paint is thick, the brushstrokes apparently in turmoil, Vincent has, in fact, controlled the texture and lush colours so that, as Theo wrote when he saw it, 'it has the richness of a peacock's tail.' (T33, 3 May 1890).

The beginning of July saw him able to venture out further from the hospital – he painted the wheatfields below the nearby hills and made some drawings of the scrub and bushes on the lower slopes; the reed pen drawing of *Wild Vegetation in the Hills* (plate 83) shows him experimenting with a dramatic degree of abstraction. The small range of rocky hills near the hospital attracted him strongly: they are weirdly eroded heaps of limestone rock which heave suddenly up from the plain to form a tortuous and disturbing barrier. Vincent's study of them, *The Alpilles with*

Plate 84
The Alpilles with Dark Hut F622
Saint-Rémy, July 1889
oil on canvas
28¾ × 19¼ in (73 × 93 cm) .
Justin K. Thannhauser Collection.
Courtesy of the Thannhauser Foundation
and the Solomon R. Guggenheim Museum,
New York

Dark Hut (plate 84), was painted directly under their oppressive shadow, and he wrote defiantly two months later, 'there is something sad in it which is healthy . . . and that is why it does not bore me . . . They will tell me that mountains are not like that and that there are black outlines of a finger's width [in the painting]. But after all it seemed to me it expressed the passage in Rod's book[1] . . . about a desolate country of sombre mountains, among which are some dark goatherds' huts where sunflowers are blooming.' (607, 19 September 1889).

It is possible that the depressed and distorted nature of this painting had to do with the news he received at the beginning of July that Theo and Johanna were expecting their first child. His letters, ever since Theo had first mentioned Johanna, had been full of solicitude for their happiness, and generously worded envy of their new domestic security, but the news of a child, in such contrast to his solitary, imprisoned state, may have upset the fragile equilibrium of his mind. His position in Theo's affections, already rivalled by Johanna, was further threatened by the advent of a child. At any rate, he was determined to get to Arles to collect some paintings he had had to leave behind, but the strenuous day's trip exhausted him. Within a couple of days he had a fifth and extremely serious attack while out painting in the fields on a windy day, so severe that he was unable to work again until the end of August. He was terribly distressed by the repetition of his illness. The doctor's note to Theo at the beginning of September gives an idea of what Vincent had been through: 'He has quite

Plate 85
Self Portrait F626
Saint-Rémy, September 1889
oil on canvas
22½ × 17¼ in (57 × 43.5 cm)
John Hay Whitney Collection, New York

[1] Edouard Rod, *Le Sens de la vie.*

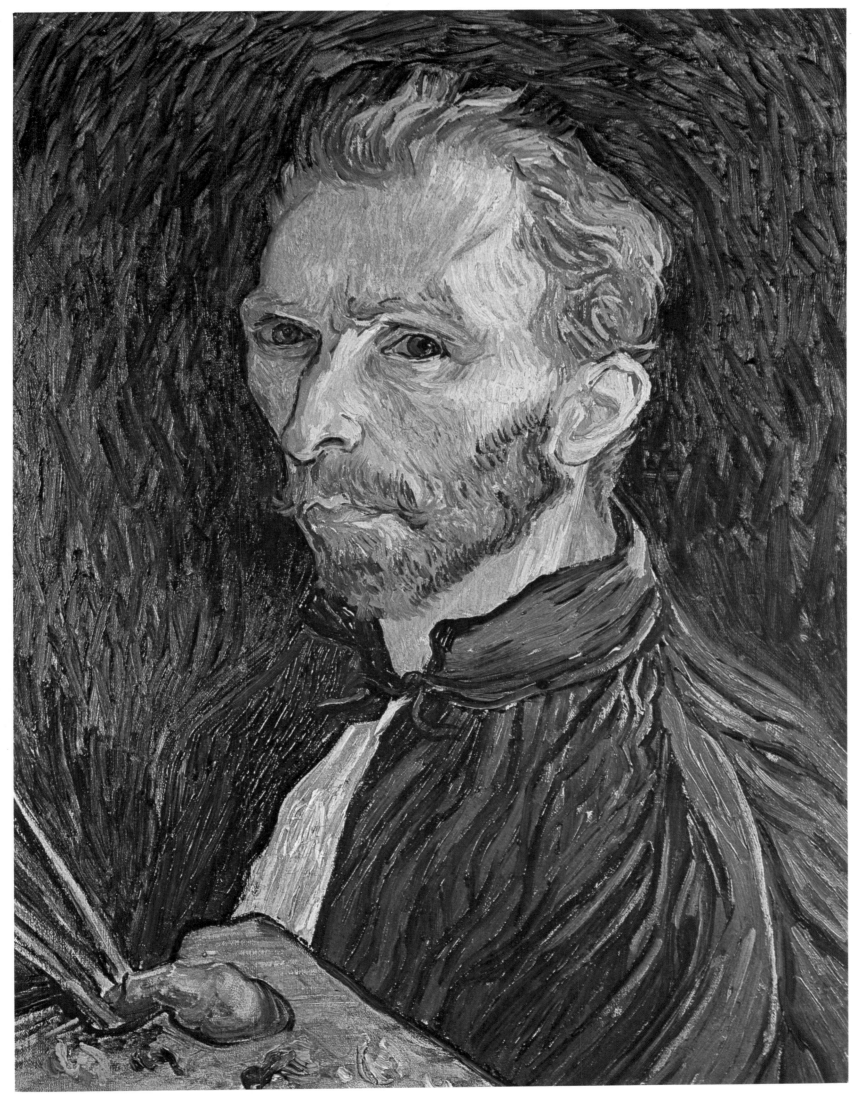

105

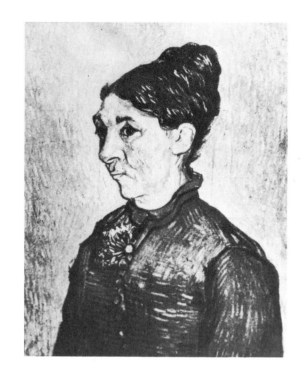

recovered from his crisis, he has completely regained his lucidity of mind, and he has resumed painting just as he used to do. His thoughts of suicide have disappeared, only disturbing dreams remain, but they tend to disappear too, and their intensity is less great. His appetite has returned, and he has resumed his usual mode of life.' (602a).

The *Self Portrait* (plate 85), begun on his first day up, shows how haggard he had become: the thin face is sallow, painted in bilious yellows and pale greens, the outlines of his emaciated cheek silhouetted against the deep Prussian blue ground. He wanted to start on more figure work and, as in Paris, the nearest available subject was himself. He did persuade the hospital attendant to sit for him, and then the man's wife – *Portrait of the Wife of the Attendant Trabu* (plate 86) – of whom he wrote to Theo: 'She is a faded woman, an unhappy resigned creature of small account, so insignificant that I have a great longing to paint that dusty blade

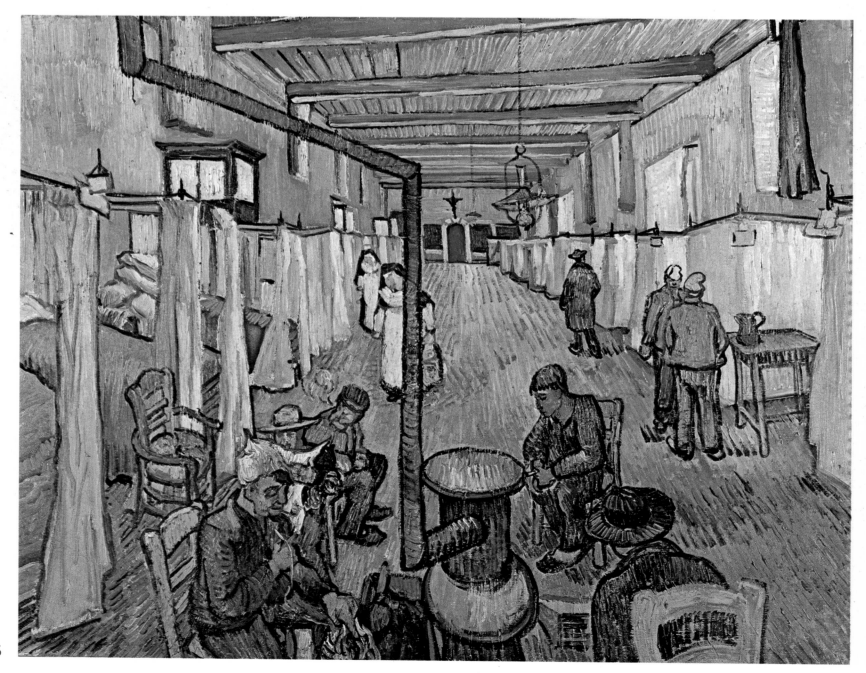

Plate 86
Portrait of the Wife of the Attendant Trabu F631
Saint-Rémy, September 1889
oil on canvas, on panel
25¼ × 19¼ in (64 × 49 cm)
Formerly Otto Krebs Collection, Holzdorf.

Plate 87
The Hospital in Arles F646
Saint-Rémy, October 1889, begun in Arles, April 1889
oil on canvas, 29¼ × 36¼ in (74 × 92 cm)
Oskar Reinhart Collection 'Am Römerholz', Winterthur

Plate 88
The Wheatfield behind St. Paul's Hospital at the Fall of the Day with a Reaper F618
Saint-Rémy, early July 1889
oil on canvas, 29¼ × 36¼ in (74 × 92 cm)
Rijksmuseum Vincent van Gogh

of grass.' (605, during 6–10 September 1889). There is a hint there of the feelings behind his *Sorrow* drawing (plate 7) – and there is the same resignation again in the slumped figures of the patients in his painting of *The Hospital in Arles* (plate 87). He had begun this in Arles in April, but took it up again in St-Rémy in October, calling it both the 'fever' and the 'mad' ward of Arles Hospital. Soon after his arrival at St-Rémy he had told Theo: 'The room where we stay on wet days is like a third-class waiting room in some stagnant village, the more so as there are some distinguished lunatics who always wear a hat, spectacles, and a cane, and travelling cloak, almost like at a watering place, and they represent the passengers.' (592, 22 May 1889). This sad place is reminiscent of some of the run-down waiting rooms he had drawn at The Hague, and the painting seems as much identified with his feelings about St-Rémy as about the Arles hospital. The feelings of claustrophobia induced by the hospital's

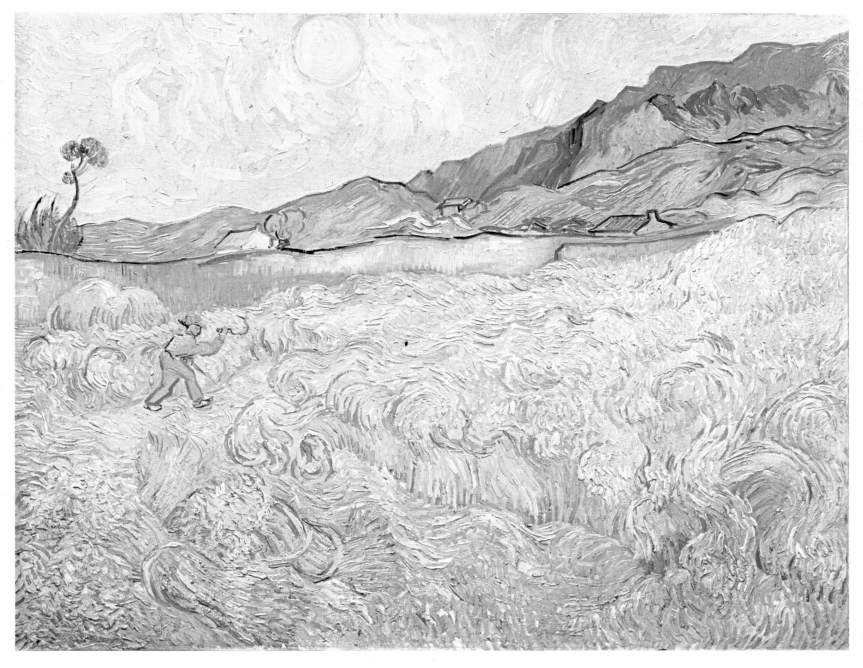

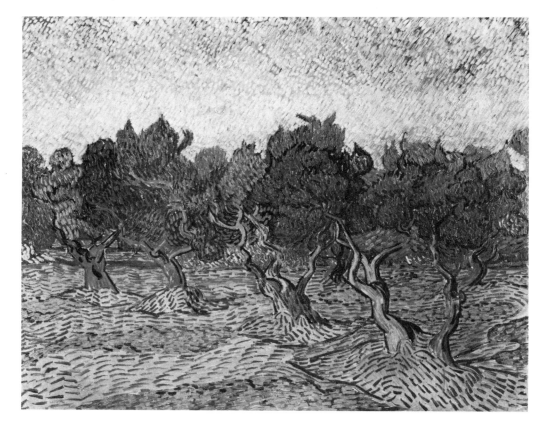

Plate 89
Olive Trees: Pink Sky F707
Saint-Rémy, September–December 1889
oil on canvas
28¾ × 36½ in (73 × 92.5 cm)
Rijksmuseum Vincent van Gogh,
Amsterdam

Plate 90
The Evening Walk F704
Saint-Rémy, October 1889
oil on canvas
19½ × 18 in (49.5 × 45.5 cm)
Museu de Arte, São Paulo

inevitable restrictions and his fear of the religious obsessions that dominated his mind during his latest breakdown prompted a brief outbreak of rebellious irreligiousness – 'what annoys me is continuing to see these good women [the nursing nuns] who believe in the Virgin of Lourdes, and make up things like that, and thinking that I am a prisoner under an administration of that sort, which very willingly fosters these sickly religious aberrations, whereas the right thing would be to cure them.' (605, 10 September 1889).

Apart from the cypresses, a traditional image of death associated with cemeteries, Vincent found himself obsessed by two further subjects connected with death or suffering. During the summer he had begun a study of the Reaper (plate 88) subject – a continuation of his Arles Sower preoccupations, but now with a completely conscious understanding of his own interpretation: 'Work is going pretty well – I am struggling with a canvas begun some days before my indisposition, a "Reaper"; the study is all yellow, terribly thickly painted, but the subject was fine and simple. For I see in this reaper – a vague figure fighting like a devil in the midst of the heat to get to the end of his task – I see in him the image of death, in the sense that humanity might be the wheat he is reaping. So it is – if you like – the opposite of that sower I tried to do before. But there's nothing sad in this death, it goes its way in broad daylight with a sun flooding everything with a light of pure gold.' (604, 4 or 5 September 1889). Of his other main subject, the olive groves of the area, he painted many studies (plate 89). Just before

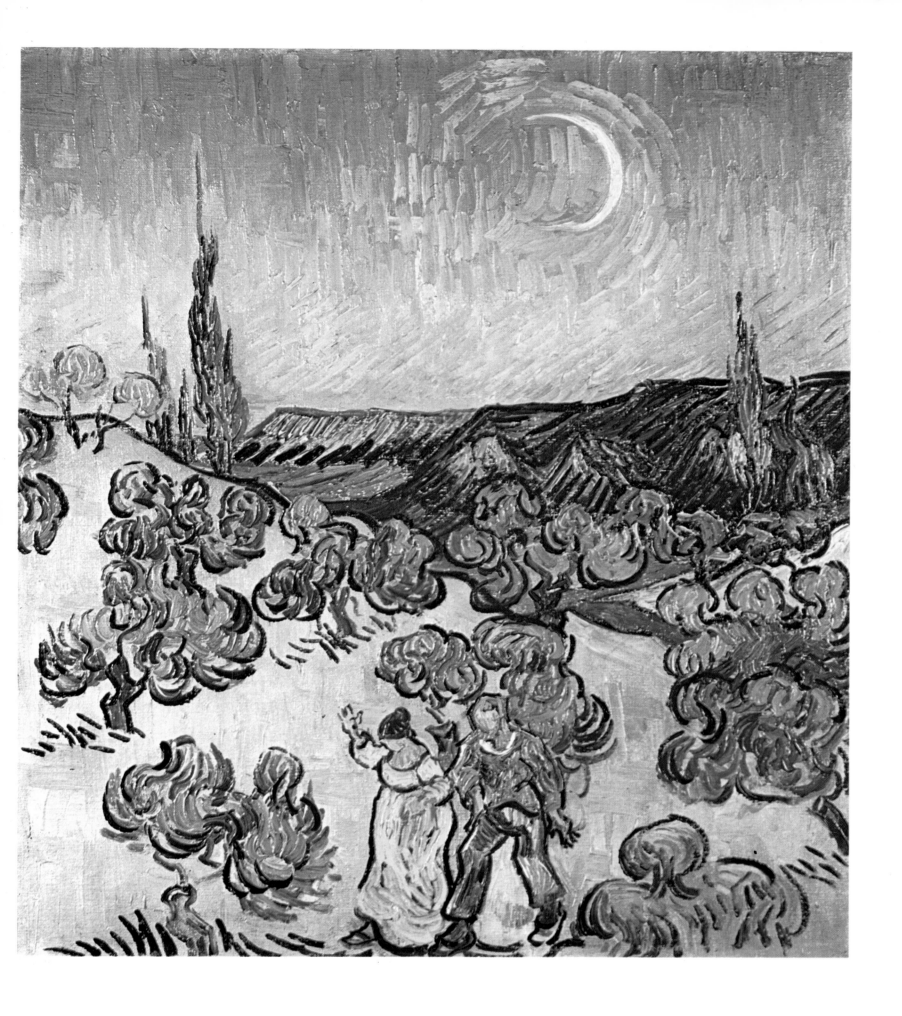

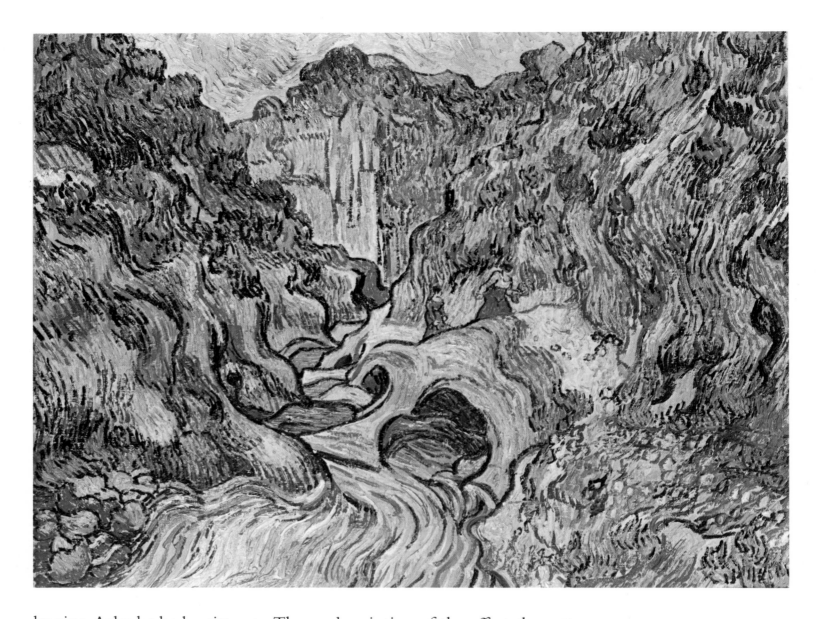

leaving Arles he had written to Theo a description of the effect the
olive groves had on him: 'Oh my dear Theo, if you saw the olives
just now . . . The leaves, old silver and silver turning to green
against the blue. And the orange-coloured ploughed earth. It is
something quite different from your idea of it in the North, the
tender beauty, the distinction! It is like the pollard willows of our
Dutch meadows or the oak bushes of our dunes, that is to say the
rustle of an olive grove has something very secret in it, and
immensely old. It is too beautiful for us to dare to paint it or be
able to imagine it.' (587, 28 April 1889). But the olive groves of
St-Rémy have a painfully twisted look, the old bent trunks and
swirling branches forming a band which separates the similarly
treated land and sky. The obvious symbolic link is with the
Gethsemane image, but Vincent was very scathing about the
sketch Gauguin sent him of his *Christ in the Garden of Olives*,
with Gauguin's self-portrait as Christ, and criticised his method of
synthesising reality with his egotistical interpretation. Vincent
preferred the interpretations of biblical subjects by Rembrandt and

Plate 91
Les Peiroulets: the Ravine F661
Saint-Rémy, December 1889
oil on canvas
$28\frac{1}{4} \times 36\frac{1}{4}$ in (72 × 92 cm)
Rijksmuseum Kröller-Müller, Otterlo

Plate 92
The Good Samaritan (after Delacroix)
F633
Saint-Rémy, May 1890
oil on canvas
$28\frac{3}{4} \times 23\frac{1}{2}$ in (73 × 60 cm)
Rijksmuseum Kröller-Müller, Otterlo

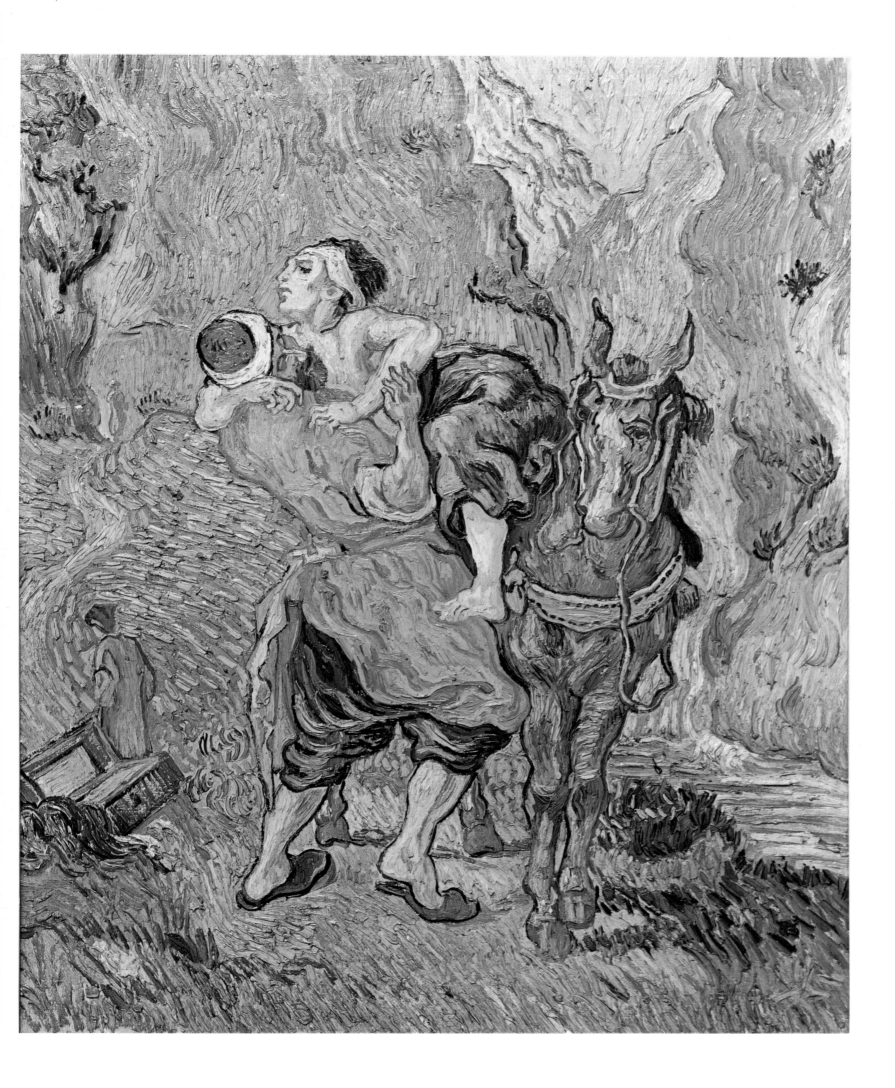

III

Delacroix, and declared: 'If I stay here, I shall not try to paint *Christ in the Garden of Olives*, but the glowing of the olives as you still see it . . .' (614, after 16 November 1889). There may even have been in Vincent's reaction a trace of shock at Gauguin's blasphemous self-portrayal.

The Evening Walk (plate 90), painted probably during October, a charming, joyful little painting of a pair of lovers walking together in the country, must have given Vincent a moment of release from the pessimism about his own condition that haunted him. The man is red-headed – the identification with Vincent may be fanciful, but the subject of lovers (or at least couples walking together) had recurred occasionally in his work in Arles, and he greatly admired Monticelli's paintings of scenes of lovers. There is something of the same anecdotal atmosphere in *The Ravine* (plate 91): two women scrambling up a stony path out of a deep little cleft in the mountains, while the mistral – that forced Vincent to hold down his easel with big stones – ripples violently over the rock surface. His technical discussion of the painting concentrated on its colour – the scattered notes of red, yellow, green and brown – but it is also a strikingly dramatic composition and illustrates very accurately the oppressive presence of the Alpilles.

One of his most constant techniques of self-medication – mental and aesthetic – during times when he felt threatened in one way or another was to copy from his masters Delacroix, Rembrandt and Millet. It was so now, during his recovery from the summer breakdown, and the autumn and winter at St-Rémy saw feverish work at copying. Millet's *Travaux des Champs*, Delacroix's *Pietà*, and in the spring Rembrandt's *Raising of Lazarus*, gave him the opportunity to rework compositions that had become part of the foundations of his artistic syntax, but now in terms that revealed what he had learnt about colour and form from his experience of the South. He saw it as a vital exercise in dealing with the figure, but the most important technical process was his translation of each work in his own colour terms: 'I improvise colour on it, not, you understand, altogether myself, but searching for memories of *their* pictures – but the memory, "the vague consonance of colours which are at least right in feeling" – that is my own interpretation. Many people do not copy, many others do – I started on it accidentally, and I find that it teaches me things, and above all it sometimes gives me consolation. And then my brush goes between my fingers as a bow would on the violin, and absolutely for my own pleasure.' (607, 19 September 1889). The final aim of the project was to assemble a large enough collection of these interpretive copies to present to a school – whether an art school or

Plate 93
The Plough and the Harrow (after Millet) F632
Saint-Rémy, January 1890
oil on canvas
$28\frac{1}{4} \times 36\frac{1}{4}$ in (72×92 cm)
Rijksmuseum Vincent van Gogh, Amsterdam

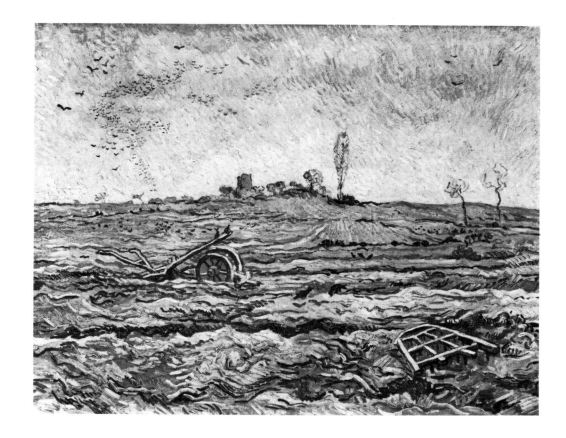

children's school, he does not say—so their purpose was not only self-instructive but didactic in a wider sense. It is tempting to relate the religious themes he chose very directly to his own situation: the Pietà, Lazarus, and, most poignantly, Delacroix's *The Good Samaritan* (plate 89). By the time he came to paint the Samaritan copy, just before his departure from St-Rémy in May 1890, the parable could not have been more apt for his own rescue from the asylum by Theo. While most of his copies were of figure compositions he did, in January 1890, make a translation of Millet's serene *Plough and the Harrow* (plate 93) from an etching. It is painted almost entirely in tones of grey-green, with a buttery glow in the sky, the deeper green accents marking the furrows and outlines of plough and harrow. The exceptions to these consoling subjects were a copy after Daumier's *The Topers* and another after Gustave Doré's *The Prison Court-Yard* (plate 94) painted at the same time. Both Daumier and Doré were brilliant draughtsmen, recorders of the harsh realities of life in the city, but neither Daumier's cynicism nor Doré's cold objectivity were as close to Vincent's heart as were Millet and Delacroix. Vincent had asked Theo to send him a wood engraving of a New York convict prison by an illustrator named Régamey, from an English magazine, but the Doré was sent by mistake. It shows the exercise yard of Newgate Prison in London and is a grim evocation of imprisonment—the parallels with Vincent's situation are obvious.

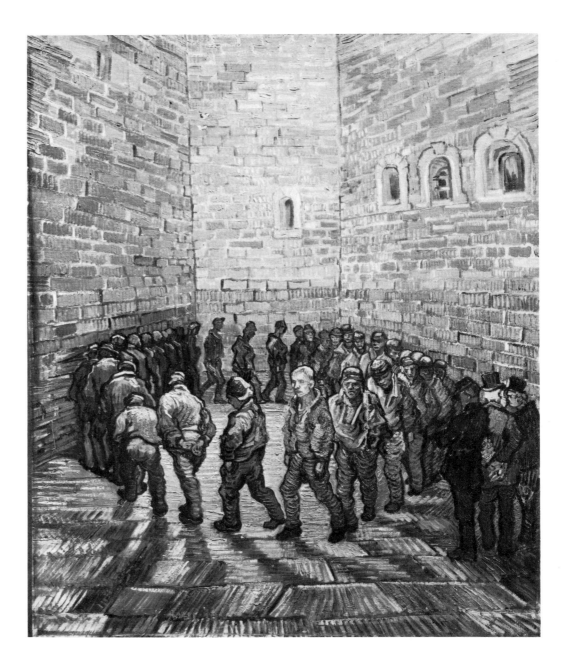

Plate 94
The Prison Court-Yard (after Gustave Doré) F669
Saint-Rémy, February 1890
oil on canvas
$31\frac{1}{2} \times 25\frac{1}{4}$ in (80 × 64 cm)
Pushkin Museum of Fine Arts, Moscow

Perhaps this reminder of London helped to turn his thoughts once more to the North, for during March and April he painted three canvases of *Reminiscences of the North*. Two, including *Thatched Huts in the Sunshine* (plate 95), show crooked old cottages lit by a lowering sun; the third is dominated by a vast, wintry sky hanging greyly over tiny, flattened hovels. In June he had written to Theo of his memory of the industriousness of most Northerners in comparison to the irritating languour of workers in the South, but the need to return to Northern themes was probably more directly connected to his recurrent urge 'to begin again with the same palette as in the North.' (601, about 17 August 1889). In Arles, under the overwhelming presence of Gauguin, he had relived *The Garden at Etten*, and while in Arles Hospital he had had vivid memories of the old family house at Zundert, taking him right back to his childhood.

Ideas of childhood and old age – birth and death – were much in

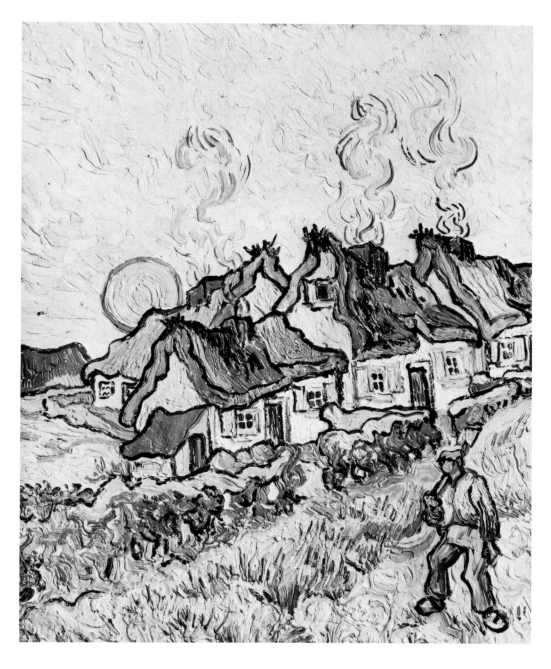

his mind at the beginning of 1890. Theo and Johanna's son, named Vincent after him, was born on 31 January and Vincent's letters were full of unqualified happiness for them and appreciation of his widowed mother's joy at a grandchild at last – Vincent had a dynastic sense of continuity that made him thoroughly a Van Gogh. He painted a study of a *Branch of an Almond Tree* (plate 96) in celebration of the birth – 'you will see that it was perhaps the best, the most patiently worked thing I had done, painted with calm and with a greater firmness of touch.' (628, mid-April 1889). The dark branches, stark against the sky, are softened by the pink-tinged petals of the blossom, and the whole composition is electrified by the blue of the sky, lighter than those of *The Yellow House* and *Poet*, and full of awakening energy.

But the attacks were inescapable, and a severe one immediately after the completion of the baby's painting and another trip to Arles brought him 'down like a brute' (628). During the following

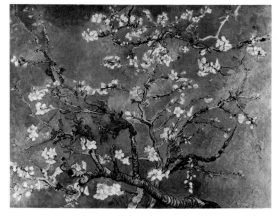

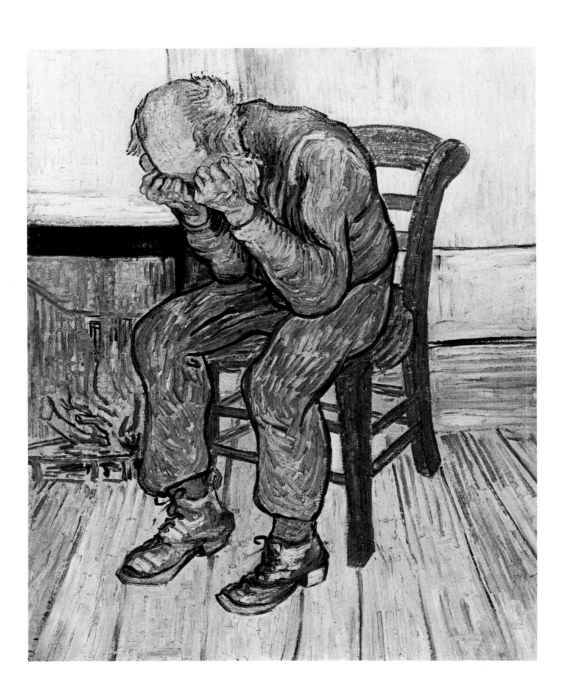

Plate 97
Worn Out: At Eternity's Gate F702
Saint-Rémy, May 1890
oil on canvas
32 × 25½ in (81 × 65 cm)
Rijksmuseum Kröller-Müller, Otterlo

month he reworked the theme of his Hague drawings and
lithograph of an old man with his head in his hands–*Worn Out:
At Eternity's Gate* (plate 97). Appropriate still to the St-Rémy
version are the words he wrote to Theo from The Hague, 'It
seems to me it's a painter's duty to try to put an idea into his
work . . . I have tried to express (but I cannot do it well or so
strikingly as it is in reality; this is merely a weak reflection in a
dark mirror) what seems to me one of the strongest proofs of the
existence of "quelque chose là-haut" in which Millet believed,
namely the existence of God and eternity–certainly in the
infinitely touching expression of such a little old man, which he
himself is perhaps unconscious of, when he is sitting quietly in his
corner by the fire. At the same time there is something noble,
something great, which cannot be destined for the worms.
Israels has painted it so beautifully . . . This is far from Theology,
simply the fact that the poorest little woodcutter or peasant on the

heath or miner can have moments of emotion and inspiration which give him a feeling of an eternal home, and of being close to it.' (248).

A work more representative of his St-Rémy paintings as a whole is *The Field Enclosure* (plate 98) of that spring. It sums up much of what he had painted in his landscapes of the previous year – the closely observed wheat and flowers of the foreground, the soaring line of the wall travelling up the slope, and the Alpilles in the distance. There is an intensity of observed reality, overlaid with his own exposed sensibilities, that is entirely typical.

Aurier's article, published in January 1890, troubled Vincent. He dreaded the publicity he felt it brought, and yet he sold a painting, for the first and only time in his life, at an exhibition of the avant-garde in Brussels, probably largely on account of the sympathetic notice of Aurier's article.

Theo had first proposed a move from St-Rémy in October 1889, but the continuing attacks Vincent suffered caused plans to be suspended until the spring. Vincent's unhappiness in the asylum and the thought that a change, and especially a move northwards, might calm him made Theo arrange for Vincent to move to a small village on the Oise river, not far from Paris – Auvers. A brief three days in Paris in the middle of May gave him time to begin readjustment to the outside world, after the institutionalised routine of St-Rémy. He met Theo's wife and new baby for the first time, and then left the hectic city with a sigh of relief, for the care of Dr Gachet, who had been recommended by Pissarro, at Auvers.

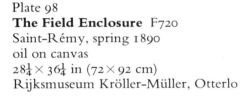

Plate 98
The Field Enclosure F720
Saint-Rémy, spring 1890
oil on canvas
28¼ × 36¼ in (72 × 92 cm)
Rijksmuseum Kröller-Müller, Otterlo

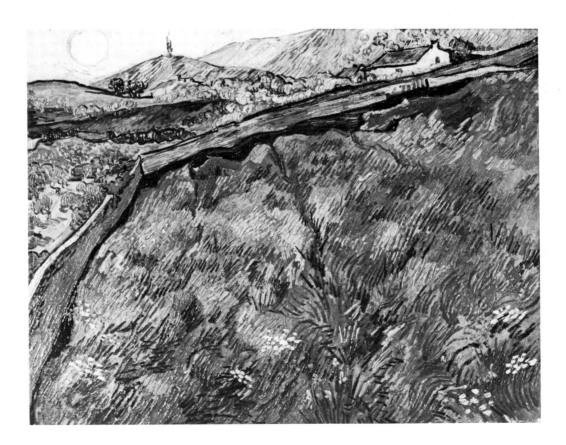

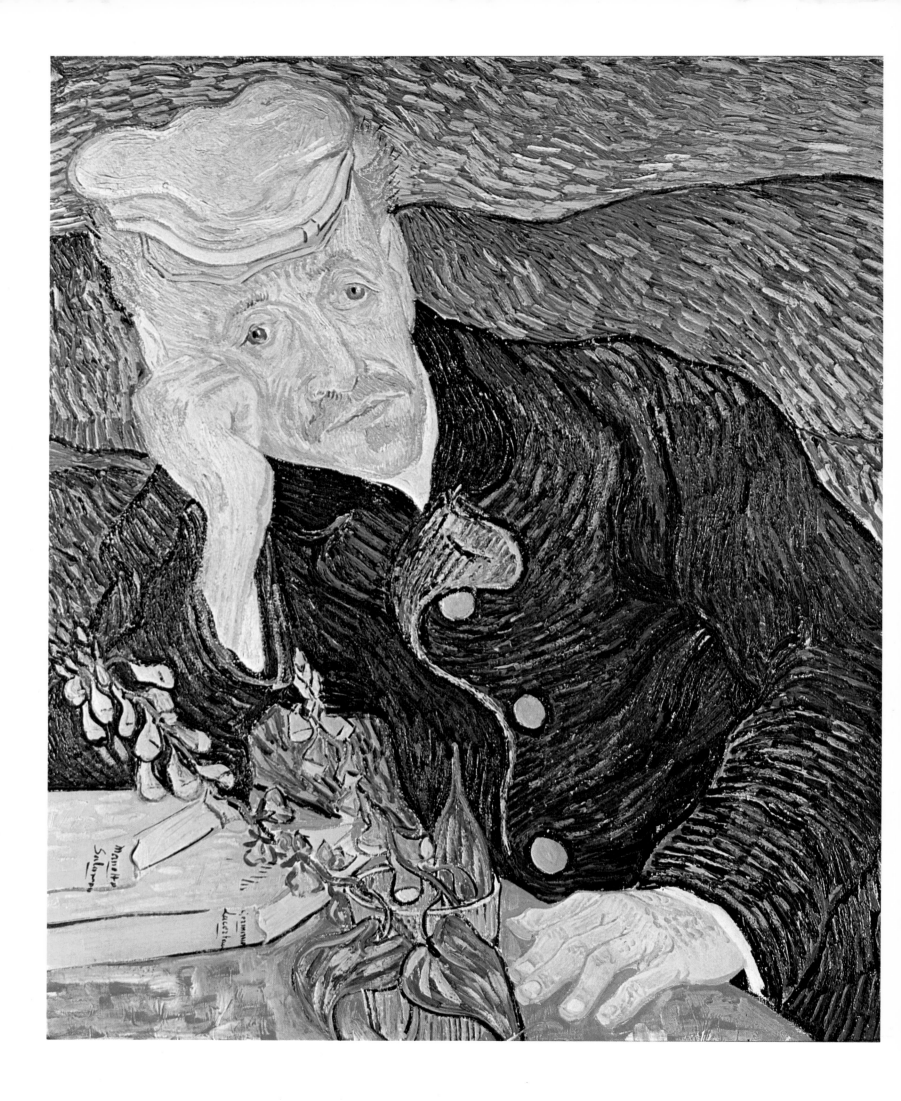

Auvers

Plate 99
Portrait of Dr Gachet F753
Auvers, June 1890
oil on canvas
26 × 22½ in (66 × 57 cm)
S. Kramarsky Trust Fund, New York

Vincent stayed at the inn on the Place de la Mairie and met Gachet. The doctor already had a notable collection of Impressionist paintings, amongst others by Pissarro and Cézanne, and the two men respected each other immediately, finding much in common on art. Vincent thought him 'something like another brother' (W22), and in June painted his portrait (plate 99) which, he wrote, had 'the same sentiment' (638, 3 June 1890) as his last St-Rémy self-portrait 'with the heart-broken expression of our time' (643, to Gauguin, between 16 and 23 June 1890). The liveliness of the brush marks around the man's form and on his clothes give a shimmer to the painting that contradict the melancholy of the subject, but his words indicate that there is much of Vincent himself projected into Gachet's portrait. Again, so many familiar elements from the past re-enter: 'a cobalt blue background, leaning on a red table, on which are a yellow book and a foxglove plant . . .' (638).

Within his first fortnight there he also painted *The Church at Auvers* (plate 100), revelling in the orgy of colour. He wrote to his sister Wil, 'once again it is nearly the same thing as the studies I did in Nuenen of the old tower[1] and the cemetery, only it is probable that now the colour is more expressive, more sumptuous.' (W22, about 3–8 June 1890). This colour was intensified by the paintings he had been doing in Gachet's garden; he had also discovered the garden of the house once owned by the Barbizon landscapist, Daubigny, and made three studies of it during June and July; it was a lush, flower-filled garden, with a large round bed in the middle of a sloping lawn which Vincent accentuated with his characteristic tilted perspective. The device recurs in *The Auvers Stairs with Five Figures* (plate 101), a painting that was still strong and convincing structurally, the paint firmly manipulated and the figures integrated into their surroundings. But many of the hundred works of this brief Auvers period reveal his lines falling and slipping apart, the paint applied with an only semi-controlled, desperate hand, the colours and forms losing their firmness. In a drawing of a *Wooded Landscape with Houses* (plate 102),

[1] See plate 15.

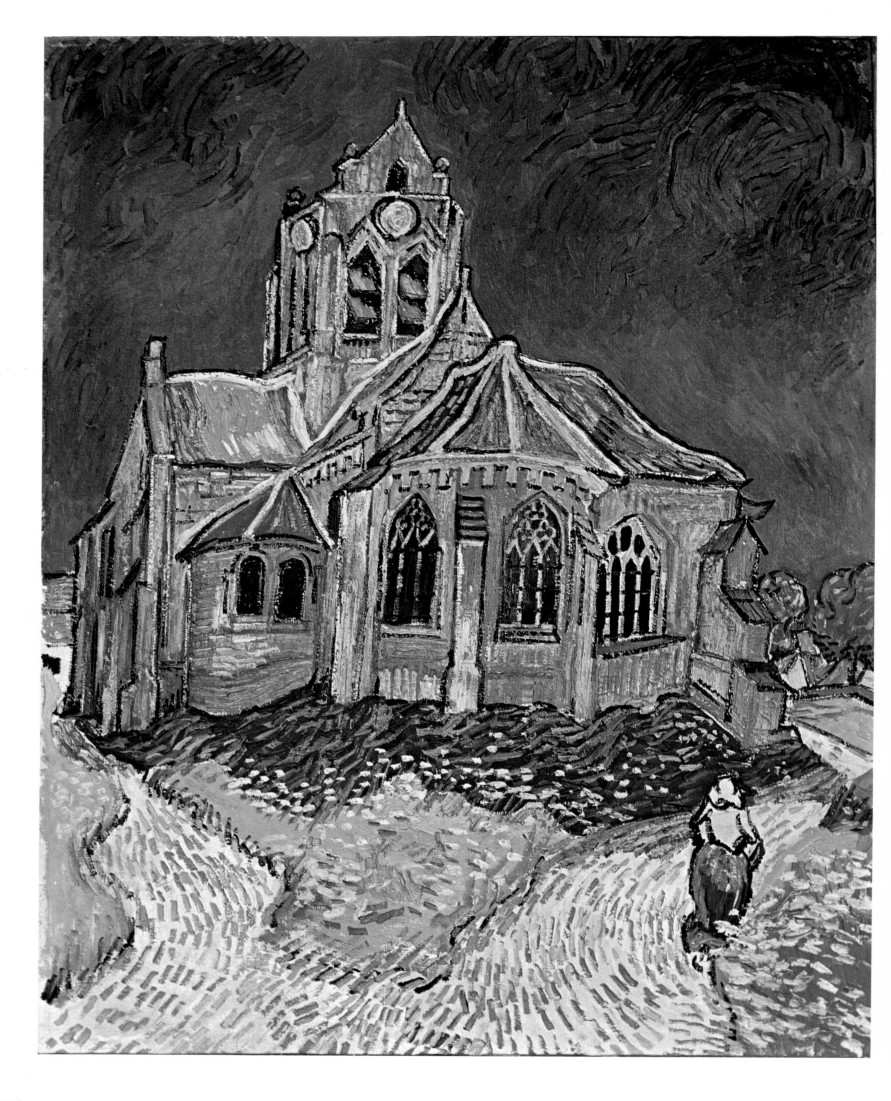

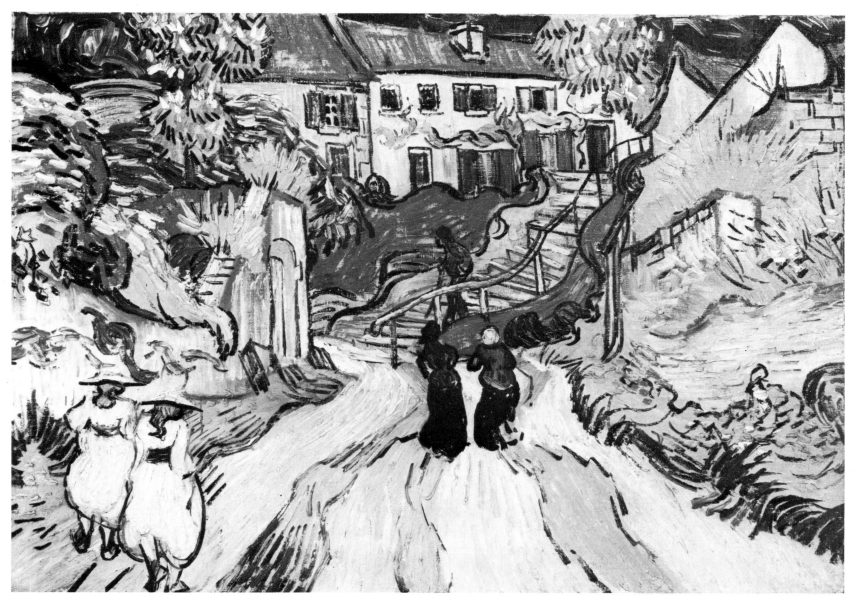

Plate 100
The Church at Auvers F789
Auvers, first week of June 1890
oil on canvas
37×29¼ in (94×74 cm)
Musée du Louvre, Paris

Plate 101
The Auvers Stair with Five Figures
F795
Auvers, July 1890
oil on canvas
20×28 in (51×71 cm)
St Louis Art Museum, St Louis,
Missouri

Plate 102
Wooded Landscape with Houses
F1640 recto
Auvers, July 1890
pencil, brush and blue watercolour
17¾×21½ in (45×54.5 cm)
Rijksmuseum Vincent van Gogh,
Amsterdam

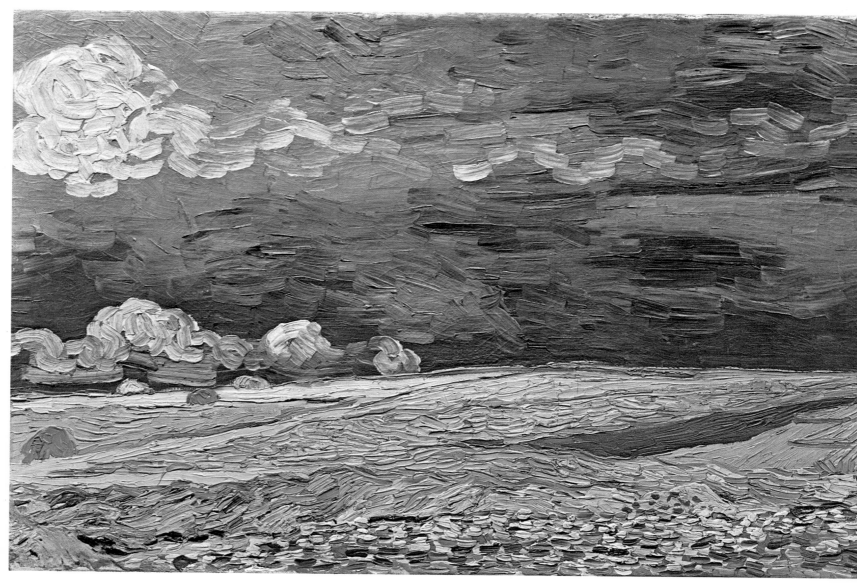

Plate 103
Field under Thunderclouds F778
Auvers, before 9 July 1890
oil on canvas
$19\frac{3}{4} \times 39\frac{1}{2}$ in (50 × 100 cm)
Rijksmuseum Vincent van Gogh,
Amsterdam

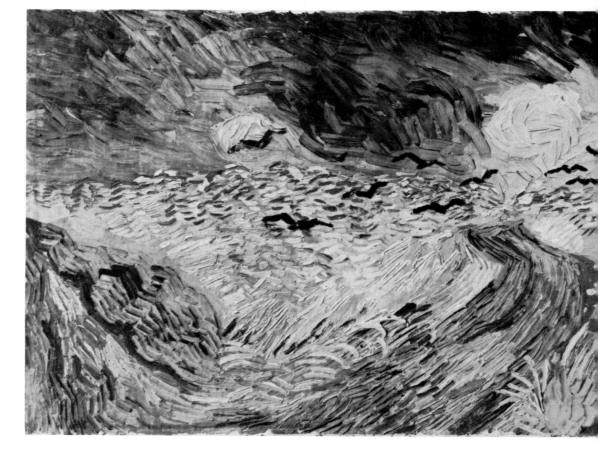

Plate 104
Crows in the Wheatfields F779
Auvers, before 9 July 1890
oil on canvas
$20 \times 39\frac{1}{2}$ in (50.5 × 100.5 cm)
Rijksmuseum Vincent van Gogh,
Amsterdam

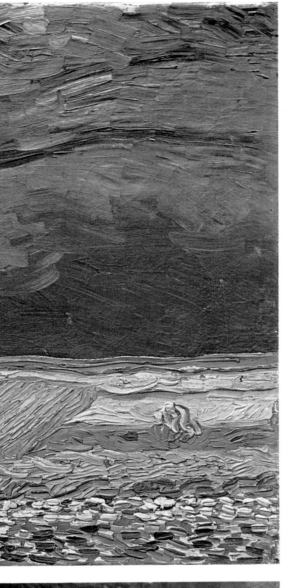

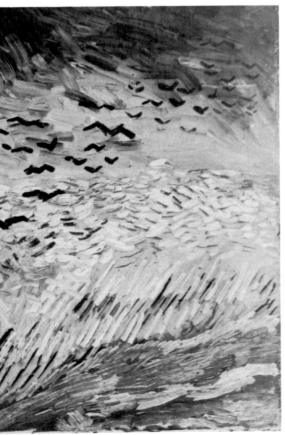

made in July, typical of several painted and drawn studies of the low, country cottages around Auvers, the buildings are sliding down the hill in a cascade of loose tumbling line, while the trees hang over them like giant waves. Again, in the drawing for a painting of *The Town Hall at Auvers*, the fragile little feather-duster trees are hardly more substantial than the dolls' town hall.

Theo and his family came to Auvers to see Vincent, spending an idyllic and peaceful day with the Gachets. Later, Vincent went to Paris and spent a hectic and exhausting day with them; many old friends came to see him again, but Theo and he had a misunderstanding over his allowance, harsh words were said, and Vincent came home early. On his return he painted three large canvases (*Daubigny's Garden* was one), including the *Field under Thunderclouds* (plate 103) – 'vast fields of wheat under troubled skies . . . I did not need to go out of my way to try to express sadness and extreme loneliness.' (649, about 9 July 1890). The superbly modulated blues, greens and yellows, offset by white clouds and scattered poppies belie the deserted landscape. His sanity was 'foundering' (648) – *Crows in the Wheatfields* (plate 104) is its tragic realisation. Black crows have replaced the lark of the Paris *Wheatfield* (plate 43) and hover over a landscape in turmoil; the field is torn violently into three segments by the cart-tracks that spring from the ground immediately beneath the painter's feet. He left no doubt that, as he told Theo and Jo, 'my life is threatened at the very root, and my steps are also wavering.' (649). His dread of being a burden on them had increased with his sight of their apartment, impossibly cramped by the accumulation of his work, and he repeatedly pressed them to leave Paris for the sake of their and the baby's health. This anxiety mounted over the succeeding three weeks.

On 27 July Vincent, while painting in the fields outside Auvers, shot himself. He was terribly wounded, but dragged himself home and sent for Dr Gachet. The Doctor's message reached Theo in Paris the next morning, and Theo travelled straight to Auvers. He wrote to Jo, 'He was glad that I came and we are together all the time . . . poor fellow, very little happiness fell to his share, and no illusions are left him. The burden grows too heavy at times, he feels so alone. He often asks after you and baby, and said that you could not imagine there was so much sorrow in life. Oh! if we could only give him some new courage to live.' His wound was too severe for any hope, and in the early morning of 29 July 1890 Vincent died. Theo wrote to Jo, 'He had found the rest he could not find on earth', and to his mother a despairing cry of grief, 'Oh Mother! he was so my own, own brother.' Theo's health collapsed after Vincent's death, and within six months he, too, was dead.

Chronology

1853 March 30: Vincent Willem, eldest surviving child of Theodorus and Anna van Gogh, born at the parsonage at Groot Zundert, Brabant, Holland.

1857 May 1: Birth of Vincent's brother, Theo.

1869 July 30: Vincent given a place at the Hague branch of his uncle's firm of art dealers, Goupil & Cie.

1873 May: Sent to Goupil's London branch. Lives adequately on £90 a year, first in Clapham, then in Lambeth (both southern suburbs of London), where he falls in love with his landlady's daughter, Ursula Loyer.

1875 May: Transferred to Goupil's headquarters in Paris. Increasingly dissatisfied with being a gallery salesman, discovers a religious commitment.

1876 March 31: Dismissed by the manager of Goupil's.
April 16: Obtains a job as a master at a school in Ramsgate for twenty-four boys, owned by a Mr Stokes. Vincent and a seventeen-year-old boy being the masters, Vincent teaches elementary French and general duties.
July: Moves to West London, working with a Congregational minister, Mr Jones, first in his school, then preaching in his chapel and is active in the church community.
December: Returns home, now at Etten, for Christmas and to consider his future with his family.

1877 January 21 – April 30: Works as a bookshop assistant at Dordrecht and develops an increasingly eccentric way of life.
May 9: Moves to Amsterdam planning to read theology at the university. Studies for his entrance, but finds the Classics irreconcilable with his idea of his vocation.

1878 August: After a brief holiday at home, and the intercession of Mr Jones with his parents, enters an evangelical training school in Brussels.
November: Volunteers to go to Wasmes, a village in the coal-mining area of the Borinage, South Belgium. Becomes a school teacher, Bible teacher and preacher to the impoverished miners of the area.

1879 July: Dismissed by the Brussels directors of the mission for his behaviour, of which they wholly disapproved. Stays in the area for over a year, gradually discovering that his most profound commitment is to art. Works on his drawing, and makes many copies after Millet, and from textbooks of drawing, anatomy and perspective.

1880 October: Spends six months in Brussels, taking lessons in anatomy and perspective. Meets fellow-student, Anton van Rappard (1858–92). Theo, now that he is working for Goupil's in Paris, is able to start sending him a small monthly allowance.

1881 April 12: Returns home to Etten and family disagreements over his career. Falls unhappily in love with his cousin, Kee Vos, then staying with his parents.
December: Leaves home, to escape the family's disapproval, for The Hague, where he works on oil paintings with his cousin, Anton Mauve. Collects English, French, American and German wood engraved magazine illustrations, and becomes acquainted with many members of the Hague School of artists.

1882 March: Brings the prostitute, Sien, and her child to live in his studio-room, so alienating most of the people he knows in The Hague, as well as his family.

1883 September: Leaves for Drenthe to escape Sien and find peace to work. Weather bad and work lonely and difficult.
December 2: Returns home to Nuenen, where his father's parish now is.

1884 Nurses his mother with great tenderness during an illness. Embarrassed by the middle-aged neighbour who declares herself devoted to him. Great disapproval of him by the local people.

1885 March: Death of Vincent's father.
May: Goes to live in his own rented studio in Nuenen to escape family pressures.
November 27/28: Moves to Antwerp; studies Rubens and Flemish art, and decorates his room with Japanese prints.

1886 January 18: Enters Antwerp Academy, but during his month there disagrees violently with his teachers.
February 27: Travels suddenly to Paris, where he arrives exhausted and weak. Invades Theo's tiny flat in the rue Laval.
Studies at the studio classes of the Salon painter, Cormon, where he meets Toulouse-Lautrec and Anquetin, and is fleetingly glimpsed by Bernard.
June: Moves to Montmartre with Theo, to a much larger apartment at 54 rue Lepic.

1887 Arranges exhibitions of Japanese prints, and of the work of Anquetin, Bernard, Lautrec and himself.
Paints in the suburbs of Paris and along the Seine, with Bernard, and Signac, whom he meets at Père Tanguy's colour shop.

1888 February 20: Moves to Arles to escape the pressures of Paris. Rents rooms near the station and later rents a studio in the Yellow House, 2 Place Lamartine.
March: Exhibits two landscapes at the Salon des Indépendants, Paris.
June 17–23: Visits Saintes-Maries-de-la-Mer, a small

medieval fishing village on the Mediterranean.

September 17: Finally able to furnish and equip the other rooms he had rented in the Yellow House, he moves in to prepare for the Studio of the South.

About October 25: Gauguin arrives in Arles to stay with Vincent, financed by Theo.

December 23: Vincent has a breakdown, involving the cutting of his ear. Theo is sent for and arrives in Arles to find Vincent in hospital. Theo returns to Paris after several days, taking Gauguin with him.

1889 January 7: Vincent returns to the Yellow House, but three further mental crises during February and March bring him back to hospital.

March 23: Is visited by Signac.

April 17: Theo marries Johanna van Bonger, to whom he has been engaged for four months.

May 8: Vincent is taken to the hospital of St-Paul-de-Mausole, at St-Rémy, by Pastor Salles.

July: Hears that Theo and Johanna are expecting their first child in the New Year. Travels back to Arles to collect paintings left at the Yellow House. Breaks down seriously on his return and cannot paint again until the end of August.

Vincent, unhappy at St-Rémy, wishes to leave and live nearer to Theo.

December–February: Three further breakdowns, which leave him completely lucid and articulate between attacks.

1890 January: Albert Aurier's article on Vincent is published in the *Mercure de France*.

January 31: Birth of Vincent's nephew, Vincent Willem.

March: First and only sale of a painting.

May 17: Travels by train to Paris, where he stays three days with Theo and Johanna.

May 20: Arrives at Auvers-sur-Oise to live under the medical supervision of Dr Gachet, a friend of several Impressionist painters.

July 6: Travels to Paris to see Theo and his family and friends, but returns upset after a disagreement. Increasingly depressed about his work and his life.

July 27: Shoots himself in the chest while painting. Theo is called to Auvers to be with him.

July 29: Vincent dies.

1891 January 21: Death of Theo. The brothers are buried in graves beside each other in the cemetery at Auvers.